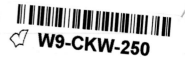

W9-CKW-250

Joe McDonald

# THE WILDLIFE PHOTOGRAPHER'S FIELD MANUAL

## Capturing Wildlife in Photographs

Copyright 1992 by Joe McDonald
All rights reserved.
All photographs by the author.

Published by:
Amherst Media
418 Homecrest Dr.
Amherst, NY 14226

No part of this book shall be reproduced, stored in a retrieval system, or transmitted by electronic, mechanical, photocopying, recording or otherwise, without written permission from the publisher. While every precaution has been taken in the preparation of this book, the publisher and author assume no responsibility for damages resulting from the use of the information contained herein.

ISBN: 0-936262-07-9
Library of Congress Catalog Card Number: 91-076630

Publisher: Craig Alesse
Design: Mary E. Siener
Indexer: Tana Patterson

Printed in the United States of America

**For Mom & Mary**

# CONTENTS

# Foreword

Nature photography is fast becoming one of the most popular pursuits of outdoor people. The subject matter is virtually limitless, and the possibility of combining art, exercise, study, and technical mastery in one discipline is hard to surpass. In the last few years a number of excellent books have been written which address the techniques of filming nature, making anyone who seriously reads these books a more competent camera handler.

Wildlife and nature photography are much the same, the former being simply a division of the latter. Both require the same skills, yet considered separately each has advantages and disadvantages. Nature photography may encompass wildlife, wild-flowers, scenic, and macro. Wildlife photography, as a sub-unit, may include anything that moves, from a macro mite roaming the feathers of a bird, to a huge elephant crashing through brush in an East African park. We generally don't consider the underwater photography of fish in this division since the techniques and tools are so specialized and different, and we will not do so here.

The question sometimes arises as to which is easier: nature or wildlife photography. General nature subjects are easier to find, since one is not limited to creatures but has, instead, flowers, mosses, bark, bugs, grand landscapes or macro mini-scapes within easy reach. In contrast, finding wildlife subjects can be difficult and a very real aspect of becoming a wildlife photographer involves simply finding, and getting close to, your subject. That accomplished, however, the wildlife photographer then has a decided advantage over his competition, since his subjects, by their nature, are usually interesting. Photographs of flowers, or scenics, or macro mushrooms, as typical examples of nature subjects, require a sensitivity, thoughtfulness, and technical mastery that, unfortunately, many wildlife photographers overlook. Some of the latter incorrectly believe that all they need to do is get close, focus sharply, and expose film. That'll work, if your goal is to 'take pictures,' but won't if you hope to 'make photographs.'

This book is devoted to the pursuit and filming of terrestrial, swimming, and airborne wild animal subjects. This is a technical book, filled with useful tips on finding your subject, obtaining quick and reliable exposures, and using the best method to film each. Unlike a coffee-table book produced to be admired, and perhaps to serve as inspiration and motivation, this practical text was written to actually be read and has been designed for easy reference and fast use.

# Introduction

Hundreds of thousands of people take pictures of wildlife each year. With air travel available to virtually everyone, thousands of dedicated photographers travel millions of collective miles to see and photograph species they'd always dreamt about. Walruses hauled out on remote Alaskan islands, harp seals birthing on frigid Canadian ice floes, cheetahs perching on rounded termite mounds in Kenya, or penguins parading in Antarctica, these and other similarly remote destinations are visited by increasing numbers of tourists whose sole purpose is to photograph wildlife.

Observe any local state or national park and undoubtedly you'll find someone toting a camera, stalking birds or mammals for a photograph. Some of these stalkers will be disappointed, as their animal subjects continually elude them. Others, exhilarated with the success of finding and filming their quest, suffer later disappointment when they review their work. Too few are the lucky who both find their subjects and leave with great photographs.

Those lonely few don't have to be so scarce. Success, both in finding your subject and in filming it, need not be a matter of luck or the lifelong dedication of the serious hobbyist or the mystical professional. In many situations, success does not require a great amount of equipment; however, the more subjects you wish to photograph will entail more gear to do the job. Of course, at times successful wildlife photography does involve luck, time, and the proper equipment, but any one, or all, will not guarantee a great wildlife photograph. Two photographs with the same subject, camera, lens, and film can produce images spectrums apart. One image may belong in the trash, while the other demands a magazine cover. The difference in the images lies not with the equipment but with the person behind the lens, for it is he that makes the image.

Like any manual, this one is designed to be used and referred to constantly. The topics are arranged sequentially, from the basics of exposure and equipment selection to the specifics of filming the diverse world of animal life. Wildlife photography is a wonderful pursuit guaranteed to fascinate, challenge, frustrate, and reward those who explore it further. I hope that this guide book will serve you well in this unparalled adventure.

# SECTION I
# THE BASICS

Mastery of all four ingredients is essential for effective photography. For this stop-action photo of a screech owl leaving its nest, high speed flash, a remote sensor called the Dalebeam, a pre-focused camera, and long hours of observation were required

# CHAPTER 1

# The Three Essentials

There are three essential ingredients to successful wildlife photography. As in any recipe, each complements the other two and is necessary for the final product. Let's discuss each of these vital areas at length.

### 1. Equipment Competency

Even with the best of equipment it's still quite easy to take awful wildlife photos. A thousand dollar camera outfit will do little good if you're not completely competent with the equipment. Handling your gear must become second nature. You should be able to work your controls, change lenses, adjust apertures, and do just about anything in complete darkness if necessary. Learn to operate your equipment almost by reflex. Some shots will demand it.

### 2. Patience

I'll be the first to admit that luck has frequently made the difference between an average and a spectacular shot for me. Unlike other pursuits where luck may play a part, in wildlife photography one can make his own luck or at least give it a good chance to come into play by being patient. The longer you can wait something out, the greater the chance that you'll "get lucky."

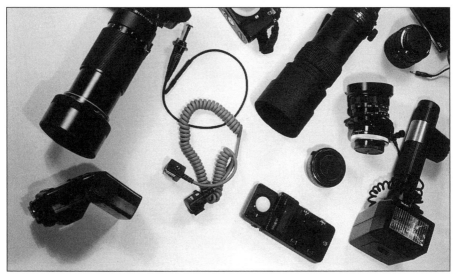

A well-rounded wildlife photographer may require a large assortment of lenses and gear to capture everything from macro insects to room-size elephants. Start with a few basic lenses, learn to use them properly, and add to your gear from there.

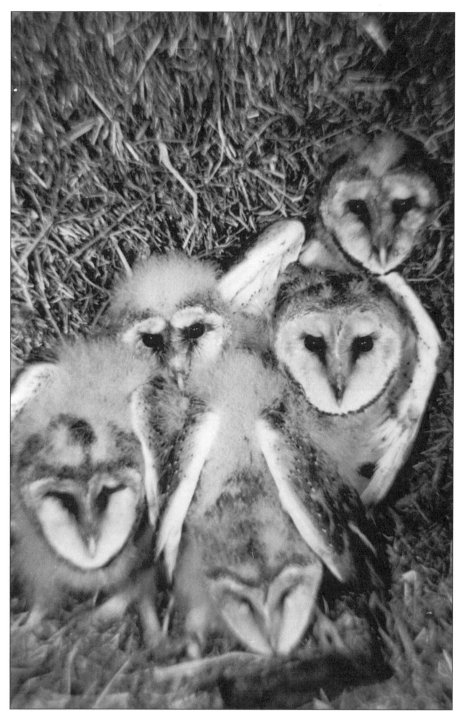

Understanding your subject may not only allow you to obtain great photos but may also will allow you to do so without harming your subject. Young barn owls are fairly tolerant of intruders, but too close an approach could cause them harm.

*"...being patient may be the single most important attribute distinguishing a good photographer from a great one."*

Luck doesn't make the great photographer, but being there and being prepared when something extraordinary occurs may. Your patient waiting will soon be apparent in your photos. You'll find you're capturing poses and documenting activities that the "snap-shooting" photographer won't even see. It's real work sometimes, and it's certainly a lot easier to just shoot a couple of quick pictures and be done with it. For some, that might be all right, but it's not for the serious photographer concerned with doing the best job he can. You'll find that being patient may be the single most important attribute distinguishing a good photographer from a great one.

Spend as much time as is reasonable, or that you can afford, on all of your subjects. If it's necessary and you can, return again and again to the same area as long as there's a chance of finally capturing what you want. Many professionals on photography expedition/vacations will spend days or weeks at one locale if they discover a particular photo opportunity, even if that means foregoing other portions of their itinerary.

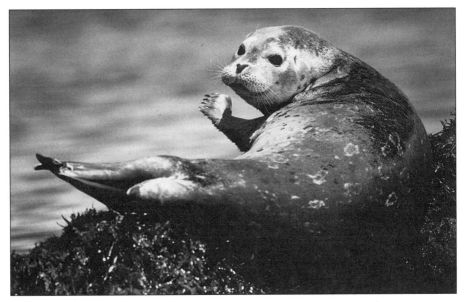

Finding a fantastic harbor seal haulout was as simple as asking the locals at a Pacific coast restaurant where a postcard had been taken. When scouting a new area, don't be afraid to ask anyone—hikers, bird watchers, fellow photographers, policemen, anyone, what they may know about the area.

I learned the hard way. Most of my early trips and efforts had too much emphasis on seeing and doing as much as I could without any concern for quality. Now, as opportunities arise, I make the most of each, remaining in an area as long as necessary. The difference in my picture quality now reflects this change, and it will in your work, too.

## 3. Understanding Your Subject

You may have the patience to watch a redwood tree grow old, yet still find that good wildlife photos elude you. You may be patient, lucky, and an excellent technician, but without a subject you can't be a wildlife photographer!

The more you know about a particular animal, the greater your chances are of photographing it. This should be obvious but it isn't to some. Many would-be wildlife photographers know very little about their intended subjects.

Knowledge of your subject is vital in order to plan for particular pictures. Although lucky 'grab-shots' happen occasionally, most good photographs are the result of prior planning. This planning doesn't have to be extensive. It may be little more than knowing that at a particular time of year a certain mudflat can be counted on to attract a large congregation of swallowtail butterflies. Knowing this, you could equip yourself with macro lens and flash gear and have a fairly good chance of capturing the scene you had envisioned. You didn't stumble upon this photo opportunity; you anticipated it.

Every bit of information collected about a subject may prove useful. This can be done in a number of ways. The most pleasant and rewarding would be through your own field experience. Previous observations can play an important role in planning later pictures. Keep a journal, for these diaries could become your best reference source. Periodically updated, perhaps indexed, a journal record will tell you the best times to find those congregating butterflies, roosting owls, or nesting birds.

Reading about your subject is also essential. Professional wildlife photographers are near-experts on the species with which they're presently working. There are a thousand things learned through reading that you'd never guess or ever stumble upon and see. Through reading you can intelligently evaluate your chances of capturing particular behaviors, actions, and even subjects.

Park naturalists, bird watchers, hobbyists, and local residents may have information that could make your photography much easier. Seek out their help and ask intelligent questions. Don't try to play at being an expert if you're not.

I once asked an Audubon lecturer how he was able to get the cooperation he did in many of the national wildlife refuges. He advised me to "press the flesh" with the personnel. Make yourself known by introducing yourself, he advised, shaking hands, being helpful and, by all means, being humble. Chances are, he assured me, a friendly introduction on your part will result in valuable cooperation from them.

Always be appreciative. A letter of thanks, perhaps including a photo, sent upon your return home won't go unnoticed. You'll have a good chance for future cooperation, perhaps even starting the seed of a long friendship. Bad manners, on the other hand, will not only hurt you but any deserving individuals who have the bad luck to come after you.

## 4. Ethics

As someone interested in photographing wildlife, you must ask yourself why you are following this pursuit. The answer, I hope, will reflect your pure love of nature and your desire to be close to, or experience more thoroughly, the wildlife you enjoy. The

purpose of your photography should not be to win photo competitions, or to become rich as a wildlife photographer, or to earn fame as an adventurous outdoorsman. If any of these result from your avocation or passion, that's wonderful, but it should not be the motivation behind your pursuit.

This is important, because selfish motivation and a real appreciation and respect for your wildlife subjects are not compatible. Too little has yet been written about the ethics of wildlife and nature photography, and even when that is done, there will be little or any enforcement of these principles. It will be as it is now, an individual matter left to the conscience and morals of the photographer.

Your objectives as a wildlife photographer must be two-fold. One, you will have some desire to photograph your subject in as interesting a manner as is possible. That might imply a dynamic composition, an interesting pose or behavior, or a specific and often close distance to the subject. Your other objective, the safe treatment of your subject so that no harm comes from its association with you, must be of equal importance.

Unfortunately, this is not always the case. Far too often (and just one case is enough) animals are stressed or victimized by zealous photographers whose sole goal is to get a photograph. The abuse is diverse and most readers have heard or read of chilling amphibians or reptiles to slow them down, or cutting obstructing, but concealing, branches away from nests, or running down predators with dogs or ATVs. Not only are these three examples cruel and insensitive, they are also ineffective. A chilled reptile appears dead; a bird nest is a visual cliche; and an exhausted, terrified fox or cougar's image mirrors its emotions. Yet animals suffer, nests are destroyed and others die as unthinking, or worse, uncaring individuals seek success at any cost.

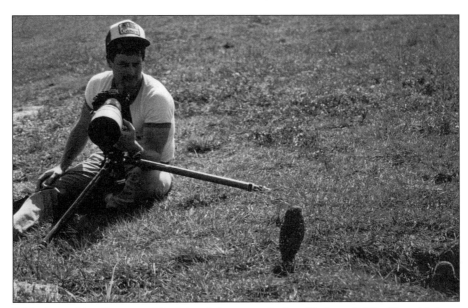

**Ethical considerations must be taken into account when filming wildlife. Many birds would desert a nest if closely approached by man, but these owls in southern Florida are completely habituated, living on a vacant lot in a rapidly growing neighborhood.**

As a wildlife photographer it is paramount that the welfare of your subject comes first. If you find that your activity disturbs your subject, you must change that activity, for if you don't, your subject may die.

Writing this text, I was placed in the ticklish position of outlining or describing a number of ways to photograph a wide variety of subjects. As an example, I described a number of safe ways to film a bird nest. However, bear in mind that a far more dynamic image will be made of feeding, singing, bathing, or flying birds, for it is these postures that are more difficult to film, and hold a higher interest. With that in mind, I'd strongly recommend that photographers seek the more challenging and dynamic image than attempt the 'sure thing,' the bird tied to a nest by parental instincts.

As wildlife photography has become increasingly popular, the ethical responsibility of the serious has become more visible and necessary. Quite frankly, too many species of bird and animal are under sufficient pressure from habitat loss to accommodate or absorb the additional pressure of those professing to love wildlife. As you photograph, be aware of your subject's needs. If you're required to capture a treefrog for a studio setup, read about the animal first, and be prepared to provide for its care while in your keeping. If you're filming an antelope fawn in the prairie, keep far enough away that your scent doesn't act as a directional arrow for a predator, nor your presence spook the fawn into fleeing for its life. I think I receive my greatest enjoyment when, after working within yards of a skittish, wary animal, I'm able to leave with equal deliberation. Your last minutes with your subject should be the most rewarding, and shouldn't be ruined by the animal terminating the session by suddenly running off. It won't, provided you don't push the extra foot, or stand up, breaking the cover you've maintained as you stalk close. Leave as carefully as you came, and you may find your subject even more approachable the next time you visit.

# CHAPTER *2*

# The Basic Principles

In the previous chapter I discussed the necessity of equipment competency. For the beginning photographer, or even those whose experience has been limited to using an automatic SLR, certain basic principles may be unclear or unknown. In this section I'll discuss these principles, covering the interrelationships of films and shutter speeds, aperture openings, lens magnifications, fields of view, and other points necessary for competent camera work.

## 1. Film ISO

A film's ISO (International Standards Organization) rating designates its sensitivity to light. Smaller numbered films are less sensitive to light than are the larger numbered films. Less light-sensitive films are termed "slower;" more sensitive films are "faster." A film's sensitivity to light is halved or doubled as the ISO ratings halve or double. A slow film is best used in bright sunlight or with electronic flash. It's least practical in shaded or other low-light situations, where fast films are useful. Fast films, higher shutter speeds, smaller aperture openings, or combinations of the three can be used. Fast films usually produce images that aren't quite as sharp as those of slow-films. This shows up under magnification or extreme enlargement, giving fast films a spotty or grainy appearance. The slower color and black and white films are nearly grainless, allowing enlargements to nearly any size.

Most professional wildlife photographers stick with the slow film speeds, especially for their color work. Most use one of the two Kodachrome slide films, with ISO ratings of 25 and 64. Magazine and book editors generally prefer this film and you should too, if you are thinking about shooting professionally or desire high quality photographs. Nearly all professional work is done by slide film, not print. However, should you wish to convert a particular slide to a print for display, it's an inexpensive and easy procedure. The difference in graininess between the two speeds of Kodachrome are so slight that most pros use 64 for the little extra speed.

In black and white photography the same generalizations hold. The slower films provide the least amount of grain and best image quality. Plus X, ISO 125, Tri-X, ISO 400, or their equivalents are the standard speeds for most black and white wildlife work.

Certain shooting requirements or lighting situations demand a specific film speed. To determine how much speed may be needed, remember that a film's sensitivity is halved or doubled as the ISO ratings halve or double. Thus film with an ISO of 100 is twice as sensitive to light as one of ISO 50. This permits a faster shutter speed or a smaller aperture.

# Example

ISO 5O 1/125 at f 5.6
ISO 100 1/250 at f 5.6
or
1/125 at f 8

## 2. Shutter Speeds

Just as film speeds are termed fast or slow, so too are shutter speeds. Here it refers to how long light strikes the film. Fast shutter speeds allow light to strike the film for very short durations, slow speeds for long periods. Fast speeds stop action since only a mere instant of activity imprints itself onto the film's emulsion. Slow speeds cannot. The subject may go through a whole range of motion while light pours onto the film at a slow shutter speed.

Smaller fractions of a second, such as 1/250th, 1/500th, or smaller, denote faster speeds. If there's any confusion here, just remember that the larger the denominator (the bottom number on the fraction), the faster the shutter speed. A 1/1,000th shutter speed is faster than one of 1/125th.

In general, fast shutter speeds are desirable for wildlife photography because they stop action and freeze distracting movement. Even the fastest speeds won't stop all types of movement if taken at particular angles or distances. It's more difficult to stop motion when something is close to the camera than when farther away, and easier when the movement is coming towards the camera than when moving across the viewfinder.

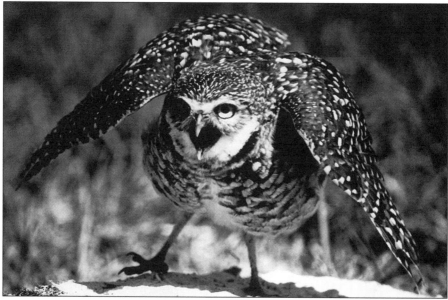

A high shutter speed was necessary to stop the action of this burrowing owl in a threat display. A wandering dog neared the nest, eliciting the owl's defensive posture before she lost her nerve and flew to the top of a nearby stop sign. The dog left the nest hole unharmed.

Fast shutter speeds also provide for sharper images. Any camera or lens movement caused by the photographer may not show up on the film when using faster shutter speeds. I don't recommend hand-holding your camera if possible, but if you must, follow this rule: Do not use a shutter speed whose denominator is smaller than the millimeter of the lens in use. Thus 1/60th or faster can be used with a 50mm lens, but 1/30th should not. In either case, I recommend using a tripod. Wildlife isn't shot solely at fast shutter speeds. Some excellent work can and sometimes must be done at the slower shutter speeds.

Low light conditions, panning to convey the sense of movement, and the need for greater depths-of-field, may all require using slower shutter speeds.

Just as halving or doubling a film's ISO decreases or increases its light sensitivity by the same factor, so it is with shutter speeds. Each time a shutter speed is increased or decreased, the light reaching the film is doubled or halved. A shutter speed of 1/250th of a second strikes the film only half as long as 1/125th would. This cuts the amount of light necessary for the proper exposure by half. A speed of 1/60th is twice as long, with twice the amount of light, as that of 1/125th.

As you'll see shortly, the ISO, shutter speed, and aperture all interact to produce not only the proper exposure but also the desired photographic effect.

### 3. Aperture Openings

An aperture is an opening through which light passes. Beginners sometimes find the aperture designations, or f-stops, confusing because of the inverse relationship between the size of the number and the size of the aperture. A small number, such as 2 (f2), refers to an aperture with a large diameter while a large number, such as 22 (f22), refers to a small opening.

You should memorize the international standard for aperture openings found on today's lenses. Depending upon the largest and smallest aperture, the following numbers will appear on the lens. They are: 1.4, 2, 2.8, 4, 5.6, 8, 11, 16, 22, 32, 64. A slow lens may have a relatively small f5.6 or f8 as its widest aperture. A fast lens, especially some of the 50mm lenses, may have a f1.2 or f1.4 lens aperture. The terms "fast" or "slow" refer to how much light the lens will transmit at its widest aperture. It is relative for each lens. A f4 is slow for a 50mm lens but would be very fast for a 400mm lens. Each successive f-stop identifies an opening approximately half as large as the f-stop preceding it. Thus the amount of light is reduced by half each time a smaller aperture, or larger f-number, is used. At f8 there's only one half the amount of light passing through the lens as at f5.6.

Since f-numbers correspond to particular diameters for each focal length, and vary in size with the lens, it follows that a given f-stop transmits an equal quantity of light regardless of the lens used.

### Example

Using a 400mm lens, the correct exposure for a subject is 1/250th at f5.6. Using a 50mm lens, the exposure would be exactly the same provided that the subject occupied the same proportion of the picture with the smaller lens as it did with the telephoto.

Whereas shutter speeds determine how long light will strike the film, aperture size determines how much light will do so while the shutter is open. This time interval (the shutter speed) must be balanced with the quantity of light (via the aperture) to achieve a proper exposure for a given film's ISO rating.

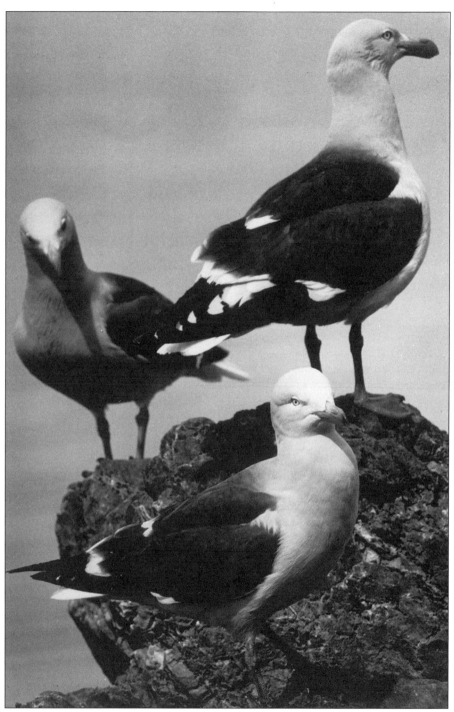

Telephoto lens and relatively close working distances combine to provide a very shallow depth of field which can be distracting. To achieve sufficient depth to cover all three birds I used the slowest shutter speed possible to obtain an f/8 aperture.

## 4. Shutter Speed and Aperture Relationships

For a given film speed, a certain amount of light must reach the film to produce a proper exposure. This is done by permitting more light to pass through the lens by opening up the aperture or by increasing the amount of time light strikes the film by slowing the shutter speed.

At the proper exposure, there is an inverse relationship between the two. Increasing the shutter speed requires a decrease in the f-stop number, thus opening up the aperture. Decreasing the shutter speed requires an increase in the f-number, which closes the aperture to a smaller diameter. The terms "opening up" or "closing down" should be added to your photography lexicon since they will be frequently used when referring to the widening or narrowing of the aperture. Any number of shutter speed and aperture opening combinations can be used to achieve the perfect balance for the ideal exposure as the following example will show.

## Example

At ISO 64 a subject requires an exposure of 1/250th at f5.6. The following combinations would yield the same exposure, although depth of field and action stopping capabilities would certainly differ with each.

> 1/1,000th at f 2.8
> 1/500th at f 4
> 1/250th at f 5.6
> 1/125th at f 8
> 1/60th at f 11
> 1/30th at f16
> 1/15th at f 22

Some subjects require particular shutter speeds or apertures. When photographing movement, a faster shutter at the expense of having to use a wider aperture is required. Small apertures and slow shutter speeds can be used for motionless objects or with scenics. As you'll see in a moment, large f-numbers provide for the greatest depth of field at any given shutter speed regardless of the lens. By visualizing a chart similar to the one above, you may be able to strike the perfect balance where there's sufficient speed to stop action while preserving some focusing depth.

## 5. Depth of Field

The distance from the camera to where an object remains in focus defines the depth of field. This may be as little as a few millimeters or as large as parts of a mile. How great the depth depends upon a number of factors: the focal length of the lens, the distance the object is from the lens, and the aperture in use. Shutter speed alone has no effect upon depth. It merely governs what aperture is required. This depth, or zone of focus where everything looks reasonably sharp, extends both in front of and behind the actual distance set on the lens. For most lenses this is to the amount of 1/3 in front, 2/3 in back. With every lens, greater depth results from smaller apertures. Thus f22 provides for a larger zone of focus than does f4. Shorter lenses such as the wide angles offer greater depth at every aperture than longer lenses such as telephotos. Finally, subjects requiring shorter focusing distances provide for less depth than subjects farther away.

Depth of field is always important, although the exact depth required for a satisfactory photograph will vary. Subjects such as spiders, insects, reptiles, and

amphibians will benefit from larger depths of field. It's unsightly and distracting to have sections of legs, antennae, or scales dissolve into out-of-focus blurs. Some subjects can yield aesthetically pleasing shots with very limited depth, but this is the exception not the rule.

To achieve greater depth in any picture, use the smallest aperture for the lens in use as your first and most logical choice. Frequently, the small size of wildlife subjects demands close focusing or the use of telephoto lenses. Small apertures may require slow shutter speeds which could result in blurring because of subject movement or camera vibrations. These can be eliminated by the use of electronic flash, where sufficient light is available to close down the lens for greater depth of field without the risk of subject movement.

Determining the best depth for a photograph is not a matter of guesswork. Precise depth can be found by manually closing down the lens prior to exposure via the camera's depth-of-field preview button.

Depth can also be determined by reading the depth of field scale found on nearly all lenses. The scale is located behind the focusing ring of the lens. It consists of pairs of numbers representing f-stops on either side of the focusing mark. The small f-numbers (if they are marked) will be closest to the distance index. The large f-numbers, representing greatest depth of field, will be spaced farthest away. The area in focus will be defined by these numbers on either side of the distance index.

Check out a lens and determine this for yourself. You'll find that depth of field is shallowest when the focusing distance is short and the aperture is wide open. Depth will be deepest when the lens is focused at or near infinity (or at the hyperfocal distance, page 19) with the aperture stopped down to its smallest opening.

Identical distance settings and aperture numbers on different focal length lenses, however, will result in significant differences in depth of field. Given the above conditions, a wide-angle lens will always provide greater depth of field than would a telephoto.

Depth of field is important. Good photographers determine the area that will be in focus and manipulate this if necessary to achieve the desired results. How this is accomplished is explained in the following section .

## Example

Referring back to the chart on page 14, a synopsis of the interrelationships between shutter speed and aperture openings can be given at this time.

| | |
|---|---|
| 1/1,000th at f2.8 | Stops action |
| | Poor depth of field |
| 1/500th at f4 | |
| | These two combinations |
| 1/250th at f5.6 | are excellent compromise |
| 1/125th at f8 | settings offering sufficient |
| | action-stopping abilities |
| 1/60th at f11 | and fair depth of field. |
| | |
| 1/30th at f16 | |
| | Cannot stop motion |
| 1/15th at f22 | Excellent depth of field |

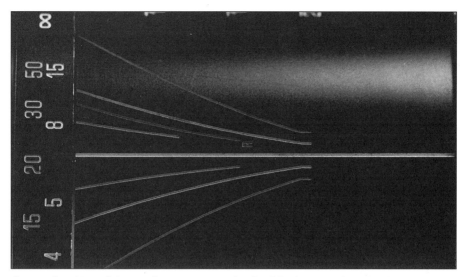

Larger focal length lenses have narrower depth of field scales than do short, or wide-angle lenses. However, depth of field in your finished photograph will be identical if the actual image size of your subject is the same and taken at the same aperture with either a long or a short lens.

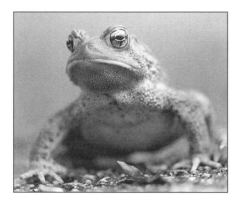 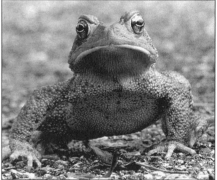

American Toad - In these comparison photos, an aperture of f4 and of f22 were used. Although the depth of field is greater in the image made at f22, there is also a far greater chance of blur at the slow shutter speed required. Both images were made with a 200mm macro lens.

If a long telephoto lens is focused on the subject's eyes, depth of field may be too shallow to provide any detail in the subject's muzzle. If the lens is focused in front of the eyes as shown, the zone of focus will include the animal's muzzle as well as its eyes, resulting in a better photograph.

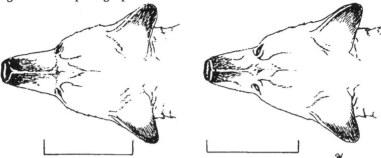

## 6. Manipulating for Depth

Most wildlife subjects, because of the close-up or telephoto equipment required, generally suffer from a shallow zone of focus. Regardless of any problem with depth, always try to keep the subject's eye in focus. A sharp eye frequently is enough to make a photo "acceptable." Sometimes, especially when shooting long- snouted subjects that are facing the camera, this "eyes sharp" rule creates a problem. The focusing depth may be so shallow that the front end of the animal's muzzle may be so out of focus that it ruins the picture. Remember a point made earlier: there's 2/3 more depth behind a focusing point than there is in front with most lenses.

Such pictures may be salvaged by focusing a short distance in front of the eye. You'll have to check the depth of field button to be sure the eye remains in focus once the lens is stopped down, but by doing this you may add enough detail to the front end of the subject to salvage the photo.

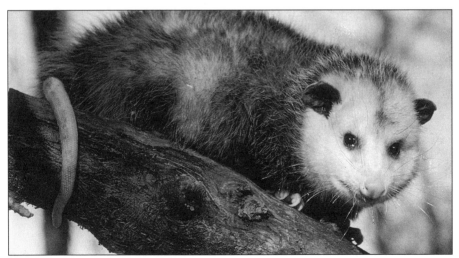

**In the evening light of a spring woods, a wide aperture was required for the shutter speed used. The shallow depth of field that resulted, however, helped separate the opossum form an otherwise busy background of silhouetted tree branches.**

## 7. Hyperfocal Distance

There's a point of focus on every lens at every aperture where depth of field extends from half the distance of the focusing point to infinity. This is called the hyperfocal distance. Longer lenses or larger aperture openings place the hyperfocal distance farther from the camera than do wide-angle lenses or small apertures.

## Example

With a 50mm lens, the hyperfocal distance would be approximately seven feet to infinity at f22 and twelve feet to infinity at f11. With a 24mm lens, sharp focus would be obtained from 2.3 feet to infinity at f16, nine feet at f4. With a 400mm lens, the hyperfocal distance would not be reached until approximately 250 feet at f16.

| Lens | Aperture | Depth of Focus | Infinity |
|------|----------|----------------|----------|
| 50mm | f4 | 50-60' ———————————— | ∞ |
| | f8 | 30' ————————————————— | ∞ |
| | f11 | 12-13' ——————————————— | ∞ |
| | f16 | 8' —————————————————— | ∞ |
| 24mm | f4 | 9' —————————————————— | ∞ |
| | f16 | 2.3' ————————————————— | ∞ |
| 400mm | f4 | —— | ∞ |
| | f8 | ———— | ∞ |
| | f16 | 250' ———————————— | ∞ |

## 8. Basic Exposures

Most 35mm single-lens-reflexes (SLRs) made today are equipped with some form of behind-the-lens exposure meter. These meters are frequently identified with the initials BTL or TTL (through-the-lens). Regardless of type, each agrees in metering with at least a part of the actual picture area. In natural light an accurate light reading with a BTL exposure meter is possible whether you're using a bellows, telescope, or standard 50mm lens. Most photographs are best exposed when appearing neither too light nor too dark but a pleasing compromise between these two contrasting tones. Thinking in terms of black and white, as an exposure meter does, this compromise is gray. Any well-exposed black and white photo will illustrate this. Unfortunately, meters 'read' to make a subject gray whether it should be or not. To a meter, a bright white or pitch black surface should appear gray if it is properly exposed. For an effective photograph, some areas, perhaps quite extensive areas, should be slightly over- or under-exposed to be accurately represented.

Contrasting light can fool a meter, requiring the photographer to intentionally disregard a suggested exposure. An easy way to solve this problem is to use a Kodak gray card. By metering off the gray side of the card (the back of the hand can be used in its place) in the same light that strikes your subject, an accurate exposure can be made. Of course, the camera's built-in exposure meter should be able to handle any exposure problem. How best to use this meter will be explained in the following section.

## 9. Behind the Lens Exposure Meters

Most cameras have either a 'spot' or an 'averaging' system which reads the light directly through the lens. In spot metering systems, three to fifteen percent of the picture area is used to determine an exposure. Spot meters are especially helpful with telephoto lenses when the subject may be some distance from the camera and may occupy a small portion of the picture area.

Averaging meters read the entire picture area. Some are 'center-weighted,' meaning that more input is taken from the central section of the screen than the edges.

An averaging meter can be used as a spot meter. To spot read through a camera with an averaging system, the area you wish to read must fill the entire frame. This can be done by physically bringing your camera up close to your subject, taking care to neither refocus or cast a shadow upon your subject as you do so. Refocusing may change the length of your lens, since most lenses grow longer as they reach their minimum focus, and this increase in size reduces the amount of light passing through. A subject in shadow will be overexposed if it's then photographed in unshaded light.

## 10. Expose for the Brightest Areas

As a general rule for most lighting conditions using color film, expose for the brightest areas within the picture. There are exceptions, notably snow and clouds, but for most circumstances the rule will apply. Color film washes out and loses all detail in over-exposed areas, yet retains detail that the eye can perceive in under-exposed areas.

With black and white film, the opposite is true. Exposures should be based upon the darker areas so that detail is recorded. Under-exposed areas would register as light tones on the negative and lack sufficient detail to be conveyed onto the paper print.

## 11. Think Before You Meter

Before you depress the shutter button, consider the limitations of both the film and of the programming that governs your exposure meter. As noted, there will be exceptions to the "expose for the brightest area" rule with some subjects requiring a moment of thought before a decision is made on the proper exposure.

If large white clouds occupy a significant area of the picture, some exposure compensation must be made. Expose for the brightest areas of the scene (except the clouds), then close down half an f-stop to tone down the cloud brightness. If the clouds occupy an insignificant amount of space, they can be ignored for the exposure.

When there's water, there may be a chance that severe under-exposure could occur if the exposure is influenced by sunlight sparkling off the water's surface. Meter either the water or the subject in an area where these sparkling points are absent. They will be over-exposed in the photo, as they should be.

Some of the most difficult exposure problems occur when the subject is in deep shade but is surrounded by large sun-lit areas. The following will illustrate two solutions to such a problem.

Another method to solve exposure problems is to simply estimate the correct exposure. This isn't especially difficult to do if your subject is in bright sunlight. You may be familiar with the 'sunny 16' rule, which states that the correct exposure for average toned subjects can be made by setting your aperture at f16, the 'sunny 16', and your shutter speed at the reciprocal of your film's ISO number, providing that your subject is in direct, over-the-shoulder light.

Your film's data sheet will suggest an exposure similar to this, although the recommended exposures will undoubtably reflect the shutter speed and aperture combinations necessary for most subjects. For example, Kodachrome 64's exposure for 'sunny 16' conditions is 1/125th at f11, a fair compromise offering a better shutter speed for amateurs hand-holding their camera while still maintaining adequate depth of field. This follows the 'sunny 16' rule, of course, since that's the same exposure as 1/60th at f16.

White subjects, reflecting far more light than an average toned subject, require compensation. Kodak suggests doubling the shutter speed, or 1/250th at f11, for such conditions. An equivalent exposure is 1/60th at f22, or 'sunny 22.'

Black subjects reflect less light. A 'sunny 11' exposure, based upon 1/60th at f11, will provide the increased exposure necessary to reveal detail in this darker area. Of course, active wildlife subjects will probably require shutter speeds faster than 1/60th (with ISO 64 film), but clicking to a faster shutter speed while opening up the aperture to the required larger f-stop will yield a correct exposure quite rapidly.

To simplify this even further, I've memorized the equivalent shutter speed and aperture combinations for my film in use for average white and black subjects. With ISO 64, 1/60th at f-16 is 1/500th at 5.6 for average subjects, 1/60th at f22 is 1/500th at f8 for white, and 1/60th at f11 is 1/250th at f5.6 for dark subjects.

Remember, however, that the 'sunny' rules work under sunny, over-the-shoulder conditions. If it's cloudy bright or deep overcast, side-lit or back-lit, the rules don't apply without modification. You'll lose one stop (either in terms of shutter speed or aperture) less light under cloudy bright conditions, two stops for cloudy conditions, and at least

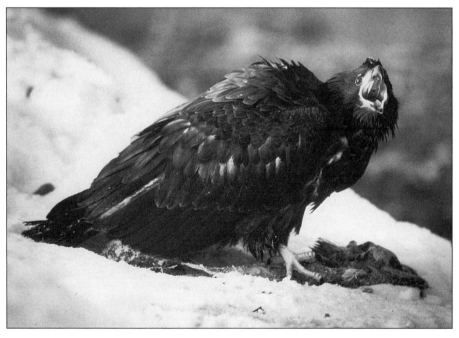

**An immature bald eagle mantles the frozen remains of a salmon on the Chilkat River. Most of the area around the bird is either bright snow or the dark river shallows. The blackish colored bird, nearly full frame in the viewfinder, is darker than a gray card.**

**Metering the snow and the eagle reveals a four stop difference between the two. Setting the aperture for the snow would block out all detail in the eagle. Exposing for the eagle would wash out the snow.**

**Some averaging is required to obtain a proper exposure. Your eye can 'open up' slightly to gather in details on the dark eagle, and both your eye and the narrow exposure latitude of color slide film can accept some underexposure. Snow, if metered, would appear gray, but opening up or over-exposing by 1 1/2 f-stops will bring back the whiteness while producing some detail in the eagle.**

21

three stops under heavy overcast light. Likewise, you'll lose a stop of light for side-lit subjects and about two for backlighted subjects. These further light losses are in addition to any loss of light due to cloud cover.

For the best possible exposures, a certain amount of thinking is required. Understanding the basic principles, from lighting to film tolerances to lens choices, are important in order to capture exactly what you wish. These examples are commonplace, and I'm sure you'll run into your own variation of each. I suggest that you review these examples occasionally to stay aware of future exposure dilemmas.

## 12. Bracketing

Bracketing refers to the practice of taking one or more exposures on either side of the suggested f-stop or shutter speed. In tricky situations or when using an unreliable meter, this insures that at least one of the exposures made will be suitable.

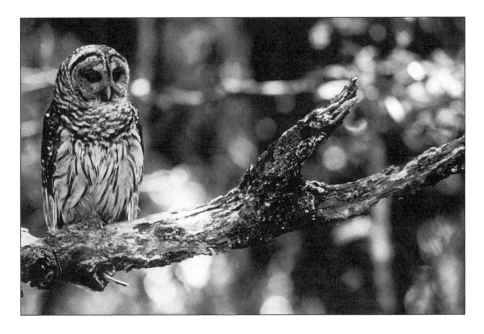

A barred owl sits astride a weathered mahogany limb deep in an Everglades hammock. The owl sits in the shade, but much of the foliage behind the bird is illuminated by the harsh light of the midday sun. There is a seven f-stop difference between sun-lit portions of the foliage and the shaded owl, far too large an exposure difference to permit effective averaging.

To obtain a usable photo, one of two methods could be used. The owl could be photographed with a long telephoto lens, where the narrow angle of view reduces or eliminates the contrasting light of the surrounding foliage. This would require a long exposure, and there'd be a large risk of camera or subject movement.

A better solution would be to use fill-in flash to illuminate the dark owl. A flash could produce an f-stop equal to, one stop less, or one stop more light than that of the surrounding foliage. A flash will also produce a sparkle in the owl's eye, although care must be taken not to catch an unnatural eye-shine. Results can be outstanding. This fill-in flash technique will be explained in greater detail in Chapter 7.

> *"Bracketing refers to the practice of taking one or more exposures on either side of the suggested f-stop or shutter speed."*

Bracketing can waste film, but there's no better means to guarantee proper exposures in critical situations. Develop your metering competency to the point where bracketing is usually not necessary, but for those once-in-a-lifetime shots, bracket if it is required!

Bracketing is especially useful in some types of electronic flash photography. Sometimes as many as four extra exposures must be made, two to each side of the suggested f-stop. Daylight usually only requires one exposure either way, although bracketing can occur either above or below the suggested aperture. A good flashmeter (discussed in Chapter 7), a reliable spot meter, and some thinking should eliminate most of your need to bracket.

### 13. About Lenses

Despite their name, single-lens-reflexes are not limited to a single lens. They get their name because the same lens is used for viewing and for taking pictures. That lens can be changed for others offering greater or lesser magnification.

### 14. Magnification and mm

Most SLRs come equipped with a standard or "normal" 50 or 55 millimeter lens. This measurement is based on the distance from the front element of the lens to the film plan (called the focal length) when the lens is focused at infinity. Fifty and 55 mm lenses are standard because they approximate what the eye sees, neither reducing nor magnifying. Lenses with a longer focal length magnify and those smaller than 50mm reduce.

Powers of magnification can be determined by dividing 50 into the millimeter of a lens. A 150mm lens is 150/50 = 3, a small telephoto capable of magnifying three times. A 400mm is eight power, considered a long telephoto; a 24mm is 1/2 power, or a wide-angle lens which reduces the size of the subject in the viewfinder.

### 15. Magnification and Angle of View

As magnification increases, the amount within the picture decreases. Not only does the subject grow larger, but so does the background, limiting its amount within the picture. Longer lenses also compress the elements contained within their field of view, making things look closer together than they actually are. Wide-angles do the reverse, offering large fields of view or backgrounds. They tend to distort distances, making objects look farther away.

Identical film images can be made at quite different camera-to-subject distances as these photographs illustrate. For example, a mule deer fills the frame from five feet with a 24mm, or sixty feet with a 300mm. You could tell which lens was used by looking

at the background in each picture. The wide-angle's background would be sharp and expansive, the telephoto's would be out of focus, compressed and quite limited.

## 16. Magnification and Composition

Remember, the larger the lens the smaller the depth of field for any given f-stop. Wide-angles offer the greatest depth, long telephotos the shallowest. A telephoto's limited depth of field and narrow angle of view can be very useful in wildlife photography, allowing you to eliminate distracting backgrounds or areas adjacent to the subject. I've taken some very 'wild' looking photos in zoos, backyards, and picnic areas, sometimes literally aiming my 400mm lens between someone's legs.

Telephotos can be impractical if the background is impressive and an important element to the picture. Although the background will look closer, it will probably be blurred. A shorter telephoto, between 100 and 200mm, might provide adequate subject size while providing some depth and field of view. Normal and wide angle lenses are far better suited for this, although animal subjects may appear too small in the viewfinder.

You can solve all of these problems by photographing your subject up close with a small lens, provided it isn't dangerous. If it is, you'll have a whole new set of problems with which to contend.

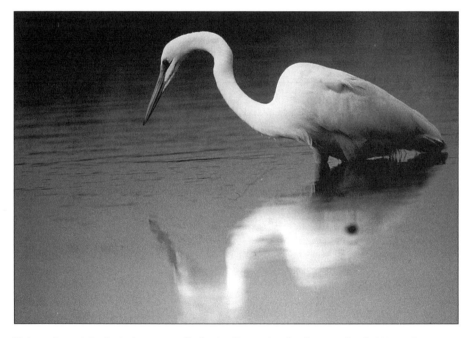

Using a long telephoto lens can eliminate distracting backgrounds. A 400mm lens on this great egret eliminated the blurred white shapes of the reflections of other egrets feeding in the background of this south Florida pond.

# SECTION II
# THE EQUIPMENT

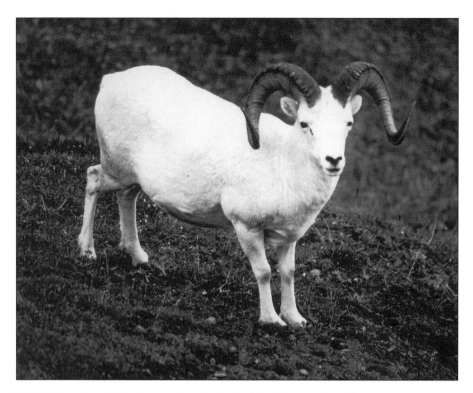

This light-colored dall sheep set against a dark background could create enormous exposure problems. A manually-operated camera, or an automatic set to its manual mode, will yield the best exposures.

# CHAPTER *3*

# The Camera

A single-lens-reflex (the SLR) and its many accessories offers the greatest versatility under the most diverse conditions for the wildlife photographer. In this chapter I'll introduce the SLR system, noting the most useful cameras and accessories.

The array of equipment is almost bewildering. Today's photographer can choose from a wide variety of cameras, all seeming to offer something unique over their competitors. Fortunately, SLRs can be divided into two types, being either manual or automatic in their operation. Until recently the term 'automatic' referred to exposure control only. Now SLRs are being introduced with automatic focusing as well. How far this automation will go is a question best left to the designers.

### 1. Manual Cameras

In manual SLRs, the photographer sets the exposure controls. Both aperture and shutter speed must be individually set by the photographer to adjust for the proper exposure.

Manual cameras require the photographer to think. Although an understanding

The 35mm single-lens-reflex is the standard for wildlife photographers. New techno-logical advances seem to appear monthly, but mastering the basics of manual operation may insure the most reliable exposures and compositions.

of the basic principles is important for any photographer (Chapter 2), it's absolutely mandatory for the owner of a manual camera. Because of this, manual cameras offer little appeal to the non-professional today. They are growing scarce, with most manufacturers offering only one or two different models.

## 2. Automatic Cameras

Automatic cameras control the exposure setting. The proper shutter speed and/or aperture are determined by the light intensity and film speed in one of three ways. There are shutter-priority, aperture-priority, and completely automatic systems.

In shutter-priority systems, the photographer sets the shutter speed and the camera selects the proper aperture. I usually recommend this system to beginning photographers. With it, a novice can be reasonably assured of obtaining good pictures even before he understands all of photography's basic principles.

Stopping action is the prime consideration when photographing wildlife, and shutter-priority cameras are best for this. The photographer chooses the shutter speed required for that subject, and as long as there's enough light, he'll get a picture. The photographer isn't locked into using the fastest speed necessary, and if he uses the minimum speed required to stop the motion of his subject, he'll maximize the depth of field he has with which to work.

Aperture-priority systems do the reverse. The photographer chooses the desired aperture and the camera selects the shutter speed. Although some excellent wildlife photographers choose this system, I wouldn't recommend it. The shutter speed selected could be too slow to stop the subject, and the aperture would have to be reset until a sufficient shutter speed is indicated in the viewfinder. That's a slower procedure than that offered in shutter-priority cameras.

Centered, flying birds crossing your line of sight are relatively easy for an autofocus camera to lock on to. But the white plumage of a northern gannet against an overcast sky may fool an automatic camera into underexposing. In such tricky situations, meter on a gray tone and close down one f-stop to compensate for the bright birds.

Completely automatic systems select both shutter speed and aperture. There's little to recommend this system for wildlife photography.

All automatic systems have one disadvantage. They can't think. They're programmed for a situation and will work fairly well according to that program. But this can lead to trouble under certain circumstances. Some situations can trick the program, resulting in a poor photograph. If the photographer recognizes these problems, however, he could switch to manual mode, provided he knows how to solve it.

My only hesitation in recommending any automatic system is the fear that a beginning photographer may grow lazy and become completely dependent upon the automatic operation. If he does, he'll be losing picture opportunities and his over-all quality will probably suffer.

### 3. Autofocus Cameras

Within the last few years this almost undreamt of camera innovation has exploded onto the scene. Various autofocus systems are available, and all offer accurate focusing for those who are incapable or erratic in their efforts to accomplish the same. Autofocus cameras have been toted as the answer to all focusing problems, suggesting that difficult subjects will always be rendered sharp.

That simply isn't the case. Autofocus works well on subjects possessing some contrast, allowing the autofocus sensor to indeed function. If the subject lacks contrast, as plain fur may, the sensor may track aimlessly seeking the subject. The placement of the small rectangular sensor offers some problems too, since it is centered in the viewfinder. Care must be taken that your composition does not consistently reflect that sensor's position. Most cameras offer a focus-lock which permits the user to recompose after the focus has been set. Unfortunately, however, if your subject moves after you've

A rapidly moving, non-centered subject is difficult to focus upon with an autofocus camera. Most autofocus cameras require aligning a small rectangle upon your subject, which centers it in your composition. Lock focus permits you to change compositions, but if your subject moves, it may be out of focus. The simple solution is to switch to manual focus and compose freely.

recomposed, the subject is no longer in focus!

Subjects kept within the sensing area may also move out of focus once the camera shutter is fired. More sophisticated autofocus cameras offer a 'tracking' system that may follow a consistently moving subject after the camera's mirror cuts off the sensor. This works if your subject is not erratically moving. If it is, as a shorebird will when flying, then autofocus offers no more success than a traditional manual focus camera will.

Don't consider autofocus cameras the solution to your focusing woes. The system is, despite all advertising claims, still new and under development. If you have real problems with focusing, and if adding diopters or other aids won't help, then an autofocus camera may be your solution.

A final consideration is that all autofocus cameras, with the exception of Nikon's, require autofocus lenses. Manually focused lenses won't work. Adding just one autofocus camera to your gadget bag may, in time, see the addition of a number of new lenses that duplicate the focal length of your existing lenses.

## 4. Other Considerations

As a photographer's skills and ambitions grow, he may wish to expand his photography to encompass much of what will be outlined in this book. He may require a motor drive, special viewfinders, and sophisticated flash equipment. It would be unfortunate if the camera system he's using would not provide for that expansion.

When choosing a camera, consider the entire system. Generally, the less expensive cameras have fewer accessories available. Although you might not need them at the moment, it may be wise to spend the extra dollars so that you could use additional items at some future time.

Another point to consider is the camera's focusing screen. Probably the most annoying aspect of many SLRs is the microprism or split-image rangefinder located in the center of the focusing-screen. This section usually darkens at smaller f-stops, making it difficult or impossible to use for focusing. Macro accessories and telephotos, which reduce the amount of light reaching the focusing screen, have the same effect.

Before purchasing a camera, I'd suggest placing a telephoto lens on the camera to determine if this will be a problem. If it is, then I'd suggest considering a different camera, unless the option of changing focusing screens is available.

Flash photography probably lies in your future and the easiest, most fool-proof systems presently offered are called 'dedicated' TTC flash. These function similarly to behind the lens exposure meters, reading the required flash output from the film plane. I'll say much more about this in Chapter 7.

You may have to read promotional literature on a lot of different camera makes and models before you can decide which is best for you. To help you with your decision, I'll offer some equipment suggestions for both beginners and advanced photographers at the conclusion of each chapter dealing with a specific photo subject.

# CHAPTER 4

# Lenses

SLRs weren't designed to be used with just a 'single lens,' and few SLR owners stay with only one. For practical wildlife photography you can't, for one lens won't do it all.

## 1. Choosing Lenses

There's such a bewildering array of focal lengths, close-focusing features, lens speeds, zoom ratios, macro capabilities, and prices, that choosing the right lens can be very confusing. To make an intelligent choice, you must assess your needs.

You may wish to consider the following questions before deciding upon the lenses for you: What do you hope to photograph? How much can you afford? Do you plan on pursuing photography as a hobby or as a profession? An honest answer to these questions will start you on your decision-making process.

Let's look at these questions more closely. A lens will determine what you can photograph; therefore, you should have some idea what animals you'll be seeking. Your subjects may be so specialized that just one lens is needed, or they may be so diverse

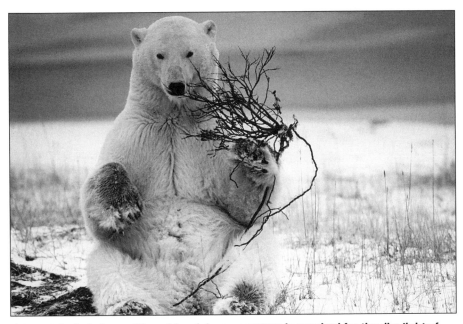

A long telephoto lens with a wide minimum aperture is required for the dim light of the arctic in autumn. A 300mm lens provided a large image size while keeping the photographer safe and its fast f2.8 aperture allowed a shutter speed of 1/250th, sufficient to stop the motion of this polar bear playing with a willow tree.

that a number of lenses may be required. Each lens has its limits and a lens suitable for photographing birds may be impractical for shooting insects. I'll recommend appropriate lenses for a variety of subjects in later chapters.

Once a basic lens type is determined, you'll find a bewildering variety of prices. When deciding how much you can afford, remember that you generally get what you pay for. However, you may not require an expensive lens for your photography.

Determining your objectives in photography will guide you in deciding how much to spend. If photography is a casual hobby, then a less expensive lens will suffice. If your budget can afford the luxury, you might opt for a lens in the middle price range. However, if you plan to shoot professionally, then buy the best lens that you can afford. On this level, the difference in lens quality is detectable.

## 2. The Starting Three

When buying a camera, consider purchasing it without a lens. In this way, you can select exactly the right lens or lenses for your needs. Supply houses and catalog stores frequently offer "body only" cameras.

I recommend this because the most infrequently used lens is the 50mm, the lens that comes with the camera! Fast 50mm lenses are useful for specialty work but will have limited application in wildlife photography. You'd be far better off equipping your lens-less camera with one or more good zooms.

The quality of zoom lenses has increased dramatically in the 1980's. Unfortunately, some manufacturers stretch the definition of 'macro' when they advertise some lenses as 'macro zooms,' but a close focusing, multiple focal length lens is a real advantage in composing photographs. Regardless of the order in which they're purchased, I'd recommend stocking your gadget bag with the following three lenses, covering at least part of the range of focal lengths:

1. An 80-200 zoom. If the lens focuses close, or if you equip one with accessories to achieve a closer focus, this focal length zoom will become indispensible for all but your most distant subjects. Zoomed to 200mm you'll have a 4X lens, and used with closeup lenses or extension tubes (see Chapter 10) you'll have a great macro lens. As you'll soon learn, most wildlife photographs are made with either a macro or a telephoto lens, and a good zoom will sufficiently cover the former. The average maximum aperture is f4 or f4.5, but more expensive modes offer an f2.8 opening. These are heavy and expensive, and because of their weight it's prudent to choose one with its own tripod collar and to mount it on a tripod via that collar!

2. A 24 to 35mm wide-angle, either a fixed focal length within that range or a zoom. You won't use a wide-angle lens very frequently in wildlife photography, but it will come in handy for odd 'effect shots' when you wish to obtain not only a large image of your subject but also wish to include the background. Because a wide-angle actually reduces the apparent size of the subject, making it look smaller in the viewfinder than it does in life, you'll have to get close.

You might consider a zoom lens in the 35-70mm range. This will prove especially handy if you're interested in family, vacation, or other general purposes. At 35mm you won't have the unusual perspective possible of a 24 or 28, but the zoom will include the 50mm focal length and offer, at 70, some slight magnification.

3. A telephoto, covering 300, 400, or 500mm, or a zoom telephoto incorporating those focal lengths. If you plan on photographing wild birds and mammals, you'll need a long telephoto, the longer the better. The 400mm lens may be the ideal compromise in terms of length, weight, and cost. Some excellent 500mm are available, but those that

Although both of these lenses are 300mm, offering 6X magnification, they differ in the amount of light which passes through each at their minimum aperture. The larger lens is an f2.8, the smaller an f5.6. Under identical lighting conditions, the one using the f2.8 lens could use a shutter speed two times faster than the one using the 'slow' f5.6 lens. This could make the difference in stopping the motion of a mule deer filmed in a winter drizzle in late afternoon.

Larger and heavier lenses usually have a built-in tripod collar on the lens barrel. This not only provides better balance, but also allows the camera to rotate to vertical without changing the position of the lens. With lenses lacking a tripod collar, as with the 300mm f5.6, the entire camera and tripod head must be moved to swing to vertical. This takes time, and requires recomposing after doing so.

focus close are expensive. Lenses longer than 500mm are impractical for most nature work, since they're heavy, unstable, and generally lack close-focusing capabilities.

### 3. Other Lenses

As a general rule, additional lenses to your system should either double or halve the focal length of your other lenes. In the examples given above, you might be covered with a 35-70, 80-200, and 400mm lens. These three lenses follow the 'doubling rule,' with 40mm (on the zoom) one-half the power of the 80 (on the larger zoom), and 200 one-half the power of the 400mm telephoto.

What lenes you select must be determined by what you enjoy photographing. A 24mm wide-angle will offer unusual perspective but will have limited wildlife usage. A better choice might be duplicating a focal length in the zoom range by adding a true macro lens. Macro lenses focus to 1/2 or life-size. I'd suggest a 200mm macro, because it offers a 4X magnification. Most offer a tripod collar to provide greater stability.

### 4. Very Long Lenses

Lenses over 500mm are sometimes called super telephotos. They include conventional lenses as well as catadioptric mirror lenses and spotting scopes adapted for a camera. Magnification ranges from 10X with 500mm lenses to 24X or more in spotting scopes.

There's a tendency to think bigger is better when considering telephotos, especially for distant subjects that have always eluded you. Some wildlife subjects just can't be taken with a 400mm, or so it seems.

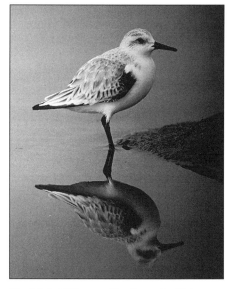

Low light, deep woods, and a drizzling rain would seem to combine to make photoraphy impossible. A sturdy tripod, a temporarily motionless mule deer buck, and a fast 300mm f2.8 lens makes the impossible attainable.

The high 10X magnification of a 500mm telephoto produced a large image of this sparrow-size sanderling while still a dozen feet away. The low angle was achieved by placing the tripod low to the ground, which had the added benefit of reducing the wind on the blowing Pacific shoreline.

A super telephoto may not be the answer either. Image size still may be disappointingly small. Even when not, the problems associated with very long lenses may discourage their frequent use.

Size, weight, and bulk may be so great that they're too awkward for convenient field use. Because of their powerful magnification, they're extremely sensitive to vibration. Slight but image-ruining blurs are likely unless both the camera and lens are rock steady. Any number of factors, including wind, bumping the tripod, or the mirror flipping up, may be enough to cause a vibration that will ruin a photo.

Even when there's sufficient image size, distant subjects may be impossible to photograph because rising heat waves twist and distort the image. Very long lenses are usually slow, with small maximum apertures. Fast films must be used, even though slow, fine-grained films would yield a better image. Because of the risk of vibration, fast shutter speeds are needed, restricting potential depth of field.

Actually, the wildlife subjects you've thought so elusive have quite frequently been photographed with lenses of modest lengths of 400mm or less. Special techniques, discussed later in this book, do a far better job than long lenses, and I'd suggest you try some of these before investing in a long and impractical supertelephoto or spotting scope.

## 5. Mirror Lenses

As their name implies, these lenses have a catadioptric mirror that reflects light within the lens barrel, shortening their over-all length. They focus to a much closer distance than conventional lenses, frequently have extremely sharp optics, and are light in weight. They're generally available in focal lengths of 500mm and greater.

Mirror lenses have all the problems of conventional telephotos, as well as some unique to themselves. They have a fixed aperture, usually f8 or smaller, and exposure adjustments must be made by changing shutter speeds. Mirror lenses are character-ized by little rings or bubble-like circles in the out-of-focus areas. When first introduced these rings were something of a novelty, but many photographers who own mirror lenses find that the effect quickly becomes a bore. Mirror lenses are squat in appearance, and carrying one that's not mounted on a tripod is akin to carrying a little beer keg. Only the smallest mirror lenses will fit in conventional gadget bags.

I think the disadvantages outweigh the positive aspects of the mirror lenses, and I would not recommend them for photography.

## 6. Zoom Lenses

Zoom lenses offer the versatility of varying focal lengths and perspectives in a single lens. They offer many conveniences fixed focal length lenses cannot. Three zooms could span the entire focal range from 28mm to 400mm, not only hitting the three lenses I suggested for getting into wildlife photography, but every length between those three as well.

Some zoom lenses also have macro capabilities. A few focus to closer than one foot and offer magnification ratios of 1:4, where the film's image is one-fourth life size. Zoom lenses purchased from independent lens companies are inexpensive, too, rarely as costly as a fixed focal length lens from a camera manufacturer and far less expensive than buying two or three fixed length lenses of any brand.

On the negative side, zoom lenses are typically slower than conventional lenses. The optics usually aren't quite as sharp as those found in the latter, either. It's for this reason that many professionals do not use them. For the amateur concerned with

making the most of his money and saving weight in his gadget bag, zooms are perfectly adequate. They're fine for making a personal collection of wildlife photos and offer sufficient optical quality to be usable in slide shows.

Check out a few by focusing the lens on objects of exacting detail at varying distances from a tripod-mounted camera. This is especially important when using the macro setting on zooms with this feature.

If you're building an outfit for professional use, then limit yourself to the camera manufacturer's brand when testing a lens. Professional-quality photos require images of the most exacting specifications.

## 7. IF, AF, APO, L, LD, and ED

Today's lens shopper is faced with a confusing array of letters following the focal length of a given lens. Like an advanced degree, the addition of a set of letters generally reflects a greater dollar investment and a finer lens.

The letters 'AF' refer to 'auto-focus' lenses. Usually these lenses are mated to specific auto-focus cameras, although Nikon's AF lenses can be focused manually on non-AF cameras. AF lenses can be focused manually, and as we discussed earlier, they may be better used in that mode.

The letters 'IF' refer to 'internal focus,' meaning that the elements inside the lens barrel 'float' free, moving forward or back as the lens is focused, without changing the actual length of the lens. IF lenses are especially useful in blinds, since the lens won't appear to grow as they're focused close. They are very useful in macro photography also, since a constant length lens will not require any exposure compensation. As a lens lengthens, less light reaches the film, and unless you're shooting in an automatic mode you'll have to constantly remeter as you focus.

The letters APO, L, ID, or ED are used by different manufacturers to denote apochromatically corrected, low-light dispersion glass. Such glass is color-coated to

A 200mm macro lens was used to create this frog's eye portrait. The lens was positioned directly above the duckweed. For more information about macro lenses, see Chapter 10.

## "What lens you select must be determined by what you enjoy photographing."

focus each color wavelength at the same focal point, unlike less expensive glass where variation may occur. Because of the focused light and the integrity of the light passing through the glass, images produced through this glass are excellent. If picture quality is your primary concern, choose an APO, L, or ED lens over a non-lettered lens with a faster aperture. Ideally, pick a lens with both!

### 8. Tele-extenders

Tele-extenders, also known as doublers or multipliers, increase the focal length of a lens by a specific factor, either 1.4X, 2X, or 3X. With an extender, a 300mm lens would be converted to a 420mm (with the 1.4X), and 600mm (with the 2X), and a 900mm lens (with the 3X).

This sounds great, but there are some disadvantages. Chief amongst these is an equal loss in lens speed. A 1.4X reduces the amount of light reaching your film by a factor of 1.4, or one f-stop, the 2X by two stops, and the 3X by three stops. Although a 300mm f4 lens and a 1.4X would become a 420 f5.6 lens, which may be quite adequate, the 2X would yield a slow f8 600mm lens, and a very slow f11 900mm lens.

Further, the image quality lessens as magnification increases. There's very little loss in quality with a 1.4X, but most 2X converters, and virtually all 3X converters, degrade the image. Keep in mind, also, that your camera handling techniques must change when using the converter. A 300mm can be hand-held if absolutely necessary, but a 600mm (300 and 2X) cannot. The latter demands a rock steady tripod for usable photos.

I'd recommend limiting yourself to 1.4X converters specifically matched for the lens you're using. Don't mix Tamron converters with Vivitar lenses; use Tamron with Tamron, Nikon with Nikon, etc.

### 9. Expensive "Brand Names" Vs. Inexpensive "Independents"

Identical focal length lenses may differ in price by thousands of dollars. A quick glance at a retail price list may, for example, list various 400mm lenses ranging from under $300 to over $5,000! Are they equally good?

Of course not, but what you spend should depend upon what you can afford and what you hope to do with the lens, as we've discussed earlier. Today's computer designed optics, multi-coated, apochromatically correct, low dispersion, internal focused lenses are quite different from lenses sold just ten years earlier. There are a couple of questions you might ask yourself when considering which lens to buy.

1. What can you afford, and how seriously do you take your photography? If you can't afford an expensive lens, but you know 'this' is your hobby, and you foresee photographing into the distant future, then beg, borrow, or work until you can afford

the lens you want. A $300 lens, used once or twice a year until another whim strikes, may be a great investment for the less serious. In contrast, a $3,000 lens used on a couple of weekends, a couple of trips a year, over ten years will represent just $300 a year over that time. I'd suggest you spend the money if you know you're going to use it.

2. What features do you need? You may not need an IF lens if you shoot on automatic or discipline yourself to take an exposure reading right before you fire the camera. You may use faster films, or shoot subjects that simply don't require the speed, and weight, and expense of a 'fast' f2.8 telephoto. Conversely, if you shoot slow speed films, work the magic light of dawn or dusk, or regularly try for action shots, a fast lens is mandatory.

3. How rough are you on gear? As a general rule, name brand lenses are better built than those made by the independents. The mounts on independent lenses may work loose, since they're not built into the lens but added on. Glues, screws, and mounts might be weaker, and repeated shakes, or drops, may cripple the independent lens sooner. However, if you baby your gear, if your '56 Chevy is still in mint condition, and you're careful, the better built lenses won't matter. And, drop any lens on a sharp rock and the glass will scratch or shatter, regardless of the manufacturer.

4. What are your goals? Although professional wildlife photography is depressingly competitive, many photographers aspire to sell photos. If you're in that group, buy the best lens you can, for your competition is sure to be using the best!

# CHAPTER 5

# Other Accessories

## 1. Focusing Screens

Reference was made in Chapter 3 for the need of a usable focusing screen. Screens supplied with the camera usually present problems when using macro or telephoto equipment, and it was suggested that the camera be checked out with that equipment prior to purchase.

The ideal screen for wildlife photography is a matte screen. Found on most screens, it's the clear area surrounding the useless central microprism or rangefinder. Matte screens remain bright regardless of the lenses used, making them ideal for use with the above equipment.

You might wish to combine the advantages of a matte screen with that of a grid or architectural grid screen. Grid screens have both horizontal and vertical lines etched into the glass and are useful for keeping buildings straight, or documents square, when copying. They're great for keeping a horizon level, too, in nature photography, and the lines form a handy reference point to assure that a tree stands straight, rather than leans, or that a duck swims on a level pond, and not a tilted, uphill flowing stream. The lines are not distracting, and it's easy to train yourself to look right passed them until they're needed. Cameras aren't supplied with all matte or grid screens as a standard feature, so I make it a practice to order one when purchasing a new camera.

## 2. Viewfinders

A few cameras of professional grade offer interchangeable viewfinders, providing easier photography for certain specialized tasks. Viewfinders aren't as critical as focusing screens when considering a camera, but they are useful, especially when shooting ground-level subjects or when working from a photo blind.

The viewfinders most applicable to wildlife work are the action, speed, or sport finders. They permit the eye to be held a few inches from the eyepiece, which is not only an aid to eyeglass wearers but also a convenience when in a photo blind, If the finder can switch from eye-level to waist-level viewing by rotating the back piece, most of your viewfinder requirements will be met.

Waist-level viewfinders are helpful in copy work and in shooting ground-level subjects. The camera can be placed on or near the ground without requiring the photographer to lie prone behind it.

Some cameras have an accessory to attach a waist level attachment directly on the rear of the viewfinder's eyepiece. This accomplishes the same goal as a separate viewfinder but is much cheaper.

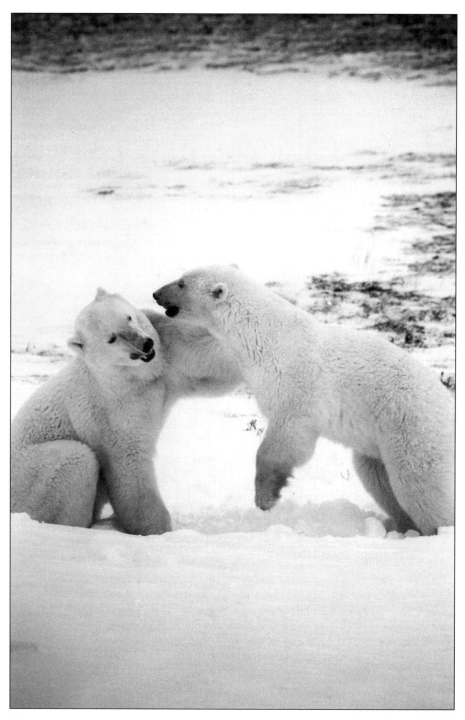

An all-matte grid focusing screen kept the horizon level while a motor driven camera advanced film rapidly enough to capture the paw-by-paw wrestling match between these young male polar bears.

## 3. Motor Drives and Winders

Both of these accessories advance film mechanically at rates equalling or exceeding that possible with manual operation. Many of today's cameras, including most autofocus cameras and some manual cameras, like the Canon T-90, offer built-in motor drives or power winders. Built-in drives and winders aren't as fast as those that are added on, with the exception of the most expensive professional grade cameras.

Motor drives are faster than winders, advancing film as quickly as six frames per second. Drives are also more expensive, sometimes costing three times the price of a brand name's winder. Some winders advance film at a rate hardly better than what a fast thumb permits, but it does so without any effort on the photographer's part, other than depression of the index finger or cable release. There's an advantage to this, since the camera can be kept to the eye continuously, something difficult to do when advancing film via your thumb.

Both drives and winders are useful for action work, although the faster motor drives do a better job of insuring that the proper pose is captured. Neither will guarantee you'll catch peak action, and if you rely solely on a fast-firing motor drive to do so, you'll probably miss. Drives and winders advance film; you must anticipate and react to capture either one or multiple peak actions. Doing so properly, however, may enable you to catch a number of important poses or actions. Nevertheless, both accessories permit remote photography via light-tripping mechanisms, infrared or radio remotes, air cable releases, or other forms of unmanned photography.

Neither, however, may be for you. If you're a hobbyist shooting pictures just a couple of times a year, the cost of a unit, especially the motor drive, may not be worth it. The same applies if you rarely photograph birds or mammals. Studio set-ups, insects, or other macro subjects where flash is required, have little need for these drives and winders since the recycling time of the electronic flash usually determines the rate of film exposure.

**Although motor drives and power winders advance the film more rapidly than a manual camera can, they do not guarantee that you'll capture peak action. They also consume batteries, so be sure to carry extras when far afield.**

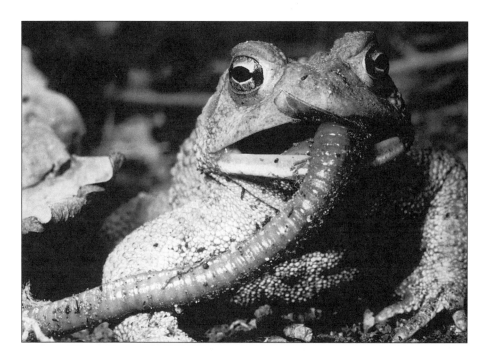

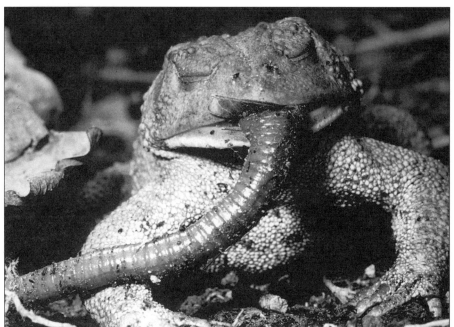

A motor driven camera kept pace with the humorous poses adopted by this American toad swallowing an earthworm. An electronic flash provided the illumination, stopped the action, and provided a small aperture for maximum depth of field. For more on flash, see Chapter 7.

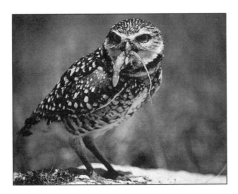

This burrowing owl captured an anole lizard in a nearby field. After returning to its nest, the owl paused repeatedly as it carried its catch into the hole. A motor driven camera allowed me to catch each step of the process.

Don't expect to just fire a motor drive and capture peak action. You won't. Film may be advancing to the next frame each time this Unita ground squirrel barks. To capture peak action, anticipate and fire as it occurs.

A sturdy tripod insures sharpness, especially at the slow shutter speeds necessary for small apertures and great depth of field. This is especially important when adrenaline pumps high, as it may when working with a venomous snake.

# CHAPTER *6*

# Tripods

For consistently sharp photos, use a tripod. Regardless of the shutter speed or lens length, a tripod-mounted camera will produce a better quality photograph than a hand-held camera.

Using a tripod is work. It's frequently inconvenient to carry and time-consuming to use. Often it places the photographer in an awkward or uncomfortable position.

Initially it may slow down your photography, but this will discourage taking 'snap-shots' or poorly composed or thought-out photos. In wildlife photography, once a tripod is in position it allows the photographer to maintain a fairly effortless and constant state of readiness.

Quite often, a tripod makes the difference between taking just a good photograph and capturing a great one.

## 1. Considerations

Since a tripod is just a three-legged camera support, it would seem that there shouldn't be too much variety or difficulty in selecting the right one. Unfortunately that's not the case; there is a bewildering array of tripods available and most of these, for the wildlife photographer, are impractical.

The 'typical' tripod may not be able to do everything, especially if your wildlife subjects are fairly diverse. Some photos must be taken at ground-level, others a number of feet above the ground. Few tripods allow this flexibility, but a few models by Bogan (the 3021 and 3022 models) and Gitzo (226, 320, and 410) do. Before you purchase your next tripod, keep in mind the following considerations:

1. Minimum and maximum extensions. For comfortably operating a camera when standing upright, a tripod should extend beyond sixty inches in height for most people. Some do accomplish this by extending the center column which lessens the stability of the camera support. Look for a tripod that reaches to your eye-level without resorting to the center column.

Many tall tripods are impractical for ground-level work. Some tripods require reversing the center column, and literally using the camera upside down to shoot at a low level. This requires you to fit between the tripods legs, which may be difficult for a big person or one bundled in heavy winter gear. Others have a separate screw on one of the legs where the tripod head can be attached. This proves cumbersome and time consuming. Both Gitzo and Bogan tripods permit ground level work by releasing the legs to a full-spread position, although removal or replacement of the center column is required in both.

You may also accomplish ground-level shooting by resorting to a small table-top tripod, although you'll be limited as to the weight of a lens these little tripods can

support. If you don't anticipate shooting at ground level often, you may get by with simply resting your camera on a beanbag, log, shoe, or gadget bag for support. This works especially well for horizontal images, but is difficult to keep steady when doing a vertical format.

2. Sturdiness. Regardless of its length, the tripod must be sturdy. There should be absolutely no rocking or wiggling when the various locks are tightly secured. The tripod head should be sturdy at whatever angle or tilt it's positioned. A separate handle for both tilt and horizontal movement is well worth the price and added bulk for the additional strength and working ease it provides. A far better solution is to use a ball head which allows the most freedom of movement in all planes, horizontal, vertical, and pan. With ball heads, one locking mechanism controls almost all camera movements, and a slight loosening from full lock permits both steadiness and camera movement.

3. Leg-locking mechanisms. The legs of the tripod should lock securely throughout their extension range. If your subjects are diverse, you may find yourself photographing in waist-deep swamp water one season and in desert sands the next. Water, silt, sand, or mud can ruin a tripod by fouling the lock-up mechanisms or the sliding action of its legs. If you anticipate using a tripod in such conditions, consider one with weather-resistant legs. External locking levers or screws are more easily freed of potentially ruinous debris than are other types.

Experiment in a camera store with the various locking mechanisms found on tripods. Work the legs and locks from a shooting position, either crouching or squatting, and note whether the legs extend, retract, and lock in place securely and without effort.

4. Pan, tilt, and level controls. Tripods with ball heads are by far the easiest to use in the field. Some photographers prefer tripod heads with separate locking handles for panning and tilting, since one movement can be made while another axis is kept locked.

A sturdy tripod is especially important when using long lenses. The legs of this Gitzo tripod are wrapped in pipe insulation to protect the hands in frigid weather. The tripod foot of the lens has been modified by Forster's Photo Accessories, HCR 62, Box 20, Blakeslee, PA 18610, to provide greater balance and stability.

L.L. Rue's well designed camera gunstock is a fine alternative when using a boat or canoe. Gunstocks are also useful when panning flying birds.

Using Nature's Reflections lightweight shoulderstock and a 200mm lens, Mary is braced against a tree for additional support. Off-tripod shooting is always less stable than when using a tripod, but bracing, or resting upon a rock or limb, will minimize the chance of a blurred image.

Beanbags are great supports for shooting from a car or a safari vehicle, as shown here.

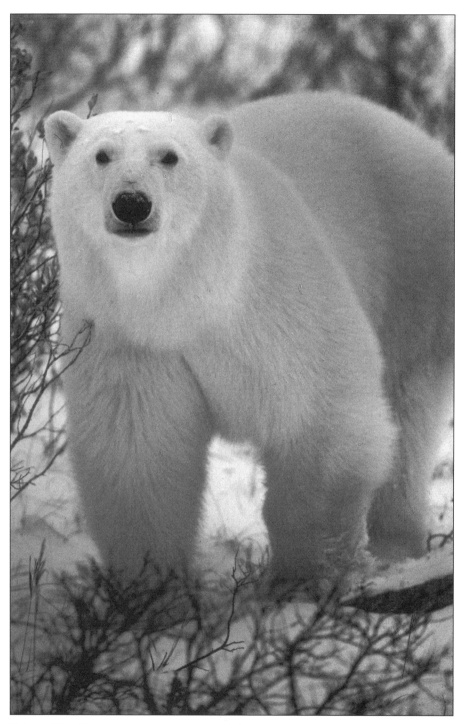

Using a tripod in a crowded tundra buggy is impossible. I rested my 300mm f2.8 lens upon a heavy sweater I draped over an open window. When I wasn't watching, the bear reached up and pulled the sweater out!

This can be useful for macro work, although I found that with practice a good ball head works almost as well. Avoid tripods with a locking knob for vertical tilt. The teeth in these knobs may wear down in time or may catch mid-way, only to slip to an improper angle once shooting begins.

Some tripods have built in levels to check the angle of both vertical and horizontal shots. You may wish to consider this if your vertical-format shots look as if the tripod was falling sideways when you shot the picture. A level, available at a hardware store for around fifty cents, will do the same job if properly used.

5. Table-top or mini-tripods. These small tripods offer a relatively inexpensive means to shoot at ground level, although their light weight doesn't offer much support for heavier lenses. Good table-top tripods are equipped with a small ball head to control pan and tilt, and a locking lever to hold the legs in position. When not in use, this tripod folds flat, taking up very little space.

The head on all mini-tripods must be sturdy and capable of locking firmly even when supporting a camera and long macro lens or bellows system. Pfeiffer (see Suggested Readings) offers some suggestions on building your own ground-level tripod that incorporates a ball head with a platform that extends from one to ten inches high.

## 2. Improvising

1. Extending for height. For some bird nests, your tripod may be too short. A nest might be just out of range at eight or nine feet, and although the camera could be tilted upward, the best photos are taken from the bird's level. A tripod's height can be extended by two to five feet by attaching sturdy furring strips, 1" x 2"s, or pipes onto its legs via hose clamps. Two or three hose clamps per leg make a firm attachment. These clamps are available at any hardware store.

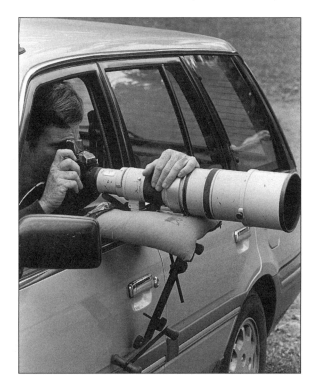

Rue's Groofwin is the sturdiest commercial mount for shooting from a car. Although a tripod head can be mounted, a beanbag rest forms a rock solid brace atop the Groofwin. It can be mounted on a window, braced on a car roof, or used upon the ground, hence its unusual name, ground-roof-window-pod.

With the additional height, the innate sturdiness of your tripod may be lost. A canvas knapsack weighed down with ten or twenty pounds of rock and hung from the central post of the tripod will add sturdiness.

Of course, to use the viewfinder a stepladder may be required.

2. Extra sturdiness. Even at normal operating heights, a tripod may require additional weight to maintain a firm support. This is especially true when using long lenses in gusty winds. Add the weight to the camera or lens' center of gravity by laying a beanbag, the strap of your camera bag, or even the doubled-over sleeves of a photo vest over the camera-lens where it's mounted to the tripod. It does little good to attach to the tripod alone, since a strong wind would still shake the lens. Make sure you place the additional weight directly above the tripod mount, otherwise you might stress the tripod- or lens-mount.

3. Reducing camera-induced vibrations. Some subjects can be photographed at very slow shutter speeds, permitting small apertures for maximum depth of field. Unfortunately, shutter speeds of less than 1/30th may cause image blur, especially with the longer focal length lenses or macro accessories. Frequently this is a result of vibration caused by the camera's operation.

To avoid this, not only must the camera be tripod mounted, but a number of other procedures must also be followed. Vibration can be caused by the mirror flipping up out of the way the instant prior to the exposure. Locking the mirror up prior to the exposure will eliminate this. A finger depressing the shutter button can cause movement and vibration that a cable release can easily eliminate. So, too, will using the camera's self-timer, since approximately eight seconds will elapse before the shutter is opened, providing sufficient time for any finger-induced vibration to dissipate.

For best results, use all three suggestions concurrently. By doing so, exposures at 1/15th of a second at f4.5 with a 400mm lens are possible without the threat of blur caused by camera movement.

4. Shooting without a tripod. When a tripod is not available, I recommend using some sort of camera support. The roof or hood of a car, a fallen log, a forked branch, anything that will support the camera or lens should be used. If possible, the camera should be supported by this means only, since a photographer hand-holding one end may induce some movement.

On one occasion I supported a 400mm lens and camera body for an exposure of 1/15th of a second at f4.5. The subject, a red fox, was lying in deep shade around thirty feet away. By supporting the lens and the camera with two piles of river stone and following the procedures explained in 2-3, I obtained whisker-sharp detail of this cooperative subject.

## 2. Shooting from a Car Window

When photographing from an opened car window, Bushnell's mount is quite handy. Mounted onto the window's glass via a padded plastic clamp, this sturdy tripod head will hold a camera and 400mm lens. You're limited to a horizontal format if you mount the clamp to the camera. To shoot vertically requires mounting a lens to the clamp via a tripod collar that permits the lens to swing to either shooting position.

A more expensive but far sturdier support is a contraption called a Groofwin Pod, designed and marketed by venerable Leonard Lee Rue, III. This ground, roof, or window support mounts to the side of a car door and can be used in conjunction with a tripod head or with bean bags. I prefer the latter, simply resting my lens on one or more beanbags to provide an extremely sturdy camera support. Again, horizontal format is easier to shoot than vertical, but this can be accomplished without too much trouble.

Shooting from a car window not only can provide a razor-sharp image if done from a groofwin pod and beanbag, but also has the additional advantage of the mobility of a portable blind, your vehicle. Many animals that would flee at the approach of man will ignore a car or van, permitting you to get great closeup pictures.

Flash photography can be used in a variety of applications, from remote work to macro. This red fox was photographed with two manual strobes and a slave tripper to yield the pleasant lighting.

# CHAPTER 7

# The Electronic Flash

There are four essential items that should be a part of every wildlife photographer's equipment. They are the camera, lens, tripod, and electronic flash. Unfortunately, many photographers find the electronic flash intimidating and never use it to its full potential.

As you'll soon see, it doesn't have to be this way. Electronic flash techniques can become an invaluable and creative tool for a variety of different subjects.

## 1. Advantages

Images made by an electronic flash are bright and incredibly sharp, offering an exciting "snap" found through no other light source. Using more than one flash unit at a time, it's possible to create an almost unlimited range of lighting effects.

The duration of an electronic flash's light output is quite fast, where even the slowest units emit bursts of light at 1/400th of a second or faster. Some exceed 1/50,000th of a second (one small automatic claims 1/100,000th) which is fast enough to freeze a bullet in mid-flight.

Action-stopping photography of flying insects, striking rattlesnakes, and other subjects may be beyond the range of most photographers because of the need for synchronization equipment. However, in less demanding situations, a flash will freeze subject (or camera-induced) movement, insuring sharper film images.

Units range in price from less than fifty dollars to several hundred. Larger, more expensive units generally offer the greatest versatility, although even low-priced models are useful for some subjects, especially in macro work. Electronic flash has additional advantages. The short duration of an electronic flash's light is especially useful since very little heat is produced, providing no danger to a subject even at close distances. It occurs so quickly that most animals grow accustomed to the flash without any show of alarm after just a few exposures.

## 2. Disadvantages

There are very few disadvantages to using electronic flash and none that can't be solved with just a minimum of effort. Probably the biggest handicap is the inability to see what the lighting effect will be, increasing the chance that a very unnatural-looking image will result.

Harsh shadows, highlights, glares, and other problems may not be detected until the film is processed. A modeling light solves this, duplicating the effect of the flash. Should a glare or harsh shadow be present, the modeling light can be moved until that problem is eliminated. The flash unit is then placed at the modeling light's new position. Some heavy studio flash units have built-in modeling lights useful for portrait work.

One can be improvised by placing a flashlight at the electronic flash's position. This doesn't work very well in bright light, of course, but once experience is gathered, lighting can be accurately predicted without the need of a modeling light.

Another problem is "ghost image," where the sharp flash image is shadowed by another produced by ambient light registering the subject's image on the film. This results in a blur that detracts from the quality of the picture.

Ghost images are caused by the slow shutter speeds necessary to synch some cameras to an electronic flash. Except for the most modern cameras and systems, which frequently synch at 1/250th, many camera models synch at 1/60th or 1/90th of a second. This isn't a problem in dim light or at night, but can be if you're using fill-in flash to eliminate shadows.

If your camera has a slow synch speed, use a smaller aperture so that the flash's intensity overpowers the ambient light and thus reduce the ghost image. You may also be forced to restrict fill-in flash to relatively still subjects when in bright light. Ghosting can be practically eliminated if your camera has 1/250th flash synch speed and it's fired at that shutter speed since the flash will either overpower the ambient light (if used close up) or will only serve as a weak fill (if the subject is some distance away).

### 3. Red Eye

Red eye, where the subject's eyes glow an unnatural red (or other color), is common with flash equipment. It's the same phenomenon almost everyone has experienced when spotting the cool red glow of a deer's or rabbit's eyes in a car's headlights. These odd colored eyes occur when a light passing through the expanded pupils of a nocturnal animal reflects off a layer of colored cells at the back of an animal's eyes.

It's simple to prevent. If the flash is held some distance from the camera lens the light reflected back towards the flash will be at such an angle that it won't strike the film.

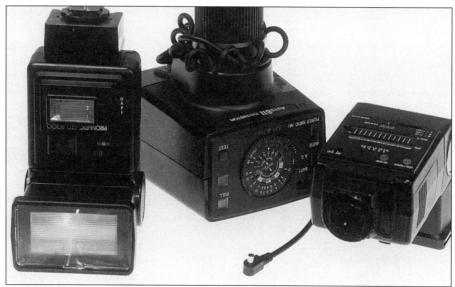

**There is a bewildering assortment of flash units available. Camera systems offering TTL flash are the easiest to use; while flash units with high guide numbers and variable powers are the most versatile.**

## "Red eye...is common with flash equipment. It occurs with flash bulb as well as electronic flash."

The camera will record the normal color of the eye. Red eye is most common with flash units that mount on a camera's hot shoe since the flash is positioned just a few inches above the lens. Extensions to the hot-shoe or mounting the flash on a special bracket will place the flash high enough to eliminate most cases of red eye.

You can determine the distance between camera lens and flash necessary to eliminate red eye with many subjects. If you're working at night, keep your eyes just above the camera and place your flashlight at its normal shooting position. If red eye is visible, move the flashlight away from the camera without moving from your original line of sight. When the red eyes disappear, you have the distance you'll need to place the flash from the camera. With some subjects, this can literally be an arm's length away, and it may require someone holding a flashlight or flash unit at the proper distance while you remain at the camera's position.

This is difficult to do with nocturnal animals illuminated with flash during daylight hours since a flashlight beam won't be visible. You might see red eye, or its absence, by firing the 'test' button of your flash unit at varying distances until the red eye glow disappears.

### 4. Guide Number

The guide number rates the light intensity or power of the electronic flash. Larger numbers, frequently associated with more expensive flash units, indicate a greater light output, which can be used for greater flash-to-subject distances or smaller apertures. Smaller guide numbers indicate less powerful units.

Although there sometimes appears to be a parallel between film ISO and the guide number (GN), usually the two numbers aren't the same. Most units are given a GN based upon an ISO of 25 or 100, and while the two numbers may match, they do so only by coincidence. Powerful portable flash units will have GNs of 120 to 200 for ISO 100 film.

Consideration should be given to the guide number when buying a flash. Large GNs are especially important for bird nests and for many mammals since the flash-to-subject distance may be great. Smaller GNs are most applicable for short distances, especially with macro photography. As a general rule, the higher the GN the more versatile the unit, since a powerful unit can be used at close distances as well as far ones. A less powerful unit, in contrast, usually can't be used beyond 20 or 25 feet with most color films.

Guide numbers are important when calculating aperture, necessary in some manual units or when using multiple flash. The correct f-stop is found by dividing the guide number by the flash-to-subject distance. This is the distance from the flash to the

subject, NOT the distance from the subject to the camera. The distance between the flash and the camera may vary greatly, and the camera's position has no effect upon the amount of light falling on the subject. Only the flash's distance determines the needed aperture.

Use the following formula to determine aperture when GN and flash-to-subject distance are known:

$$f\text{-stop} = \frac{\text{guide number}}{\text{F to S distance}}$$

This formula will be especially important when working out the needed apertures for some of the lighting techniques offered on pages 64 to 67.  Some photographers are under the mistaken impression that a large distance separating the camera and flash will influence the exposure. It does not. If a flash-to-subject distance requires an aperture of f8, it doesn't matter if the camera is positioned three feet from the subject or thirty feet. Thus a bird's nest can be illuminated by one or more flash units positioned fairly close to the nest while the camera is operated some distance away. A long PC cord would be needed to connect the camera to at least one flash, unless a slave relay is used (section 7-9). Positioning the flash units close to the subject provides for smaller apertures and better depth of field.

Inaccurate exposures can be made using the above formula if the subject or its background varies significantly from the ideal 'gray tone.' Very dark subjects, or those with dark or very distant backgrounds, may require opening the lens up 1 or 1 1/2 f stops. The reverse is true for very light-colored subjects and backgrounds.

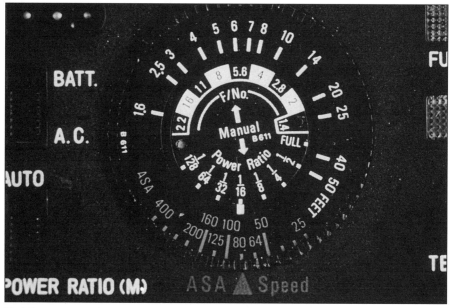

**Variable power ratio on some flash units offer a number of features. The short flash duration at low power freezes most natural movement, while the short recycling time recharges the flash within seconds. Dialed to a low power, the flash can also be closer to the subject in macro photography, and at high power the same flash can be used for distant birds.**

56

## 5. TTL or OTF Flash

State of the art camera flash systems have adopted a nearly fool-proof flash system variously called TTL (Through the Lens) or OTF (Off The Film). In these, a flash metering sensor reads the flash's light that actually passes through the image-taking lens, often after it strikes and reflects 'off the film' itself. The sensor reads the amount of light necessary for the aperture in use and shuts off the flash automatically when sufficient light is produced.

It is a nearly fool-proof system, enabling photographers to use telephotos, macro lenses, extension tubes, off-camera flash techniques, bounce flash, and even firing through aquarium glass. Like any exposure meter, however, compensations must be made for very dark or very light subjects and the TTL flash must be tricked to produce the correct exposure for these tones. Your manual will explain how, and usually there are a couple of possible ways. One of the easiest is to simply change the ISO dial to a higher number (often double) when filming a dark subject, and halving the ISO for light subjects. In the former, this will result in only one half the amount of light necessary to 'properly' expose for black, yielding an underexposed, but natural-looking exposure. In the case of light subjects, twice as much light is actually emitted than seemingly would be necessary, resulting in an 'overexposure,' or lighter than gray subject. Make sure you reset the ISO dial the correct number for the film you're using after shooting!

Most TTL systems are designed to be most easily used from a hot-shoe mounted position. This is fine for many subjects, especially when used solely as fill in light, but will produce red-eye for nocturnal subjects. Accessory cords are available to permit off-camera flash.

## 6. Automatic Flash

Today's most popular flash units determine the correct exposure automatically. They're distinguished by having some type of light-sensitive sensor, usually built into the unit. An f-stop is selected and the correct amount of light necessary for that subject is produced, provided it's within the working distance of the unit for that f-stop. It's a fast and usually pretty accurate system.

The sensor characterizing all automatic units "reads" the reflected light off of the subject and automatically shuts off the flash at the proper time. Some units with built-in sensors cannot be used in the automatic mode when using bounce or umbrella lighting since the sensor reads the light from the reflector and not the subject. Units can be used if the lens head rotates, permitting the sensor to face the subject independently of the position of the flash lens or if a remote sensor is involved.

More expensive flash units have sensors that can be detached from the flash when necessary. These "remote sensors" are especially well suited for off-camera flash and for bounce and diffused lighting. The remote sensor can be mounted on the camera, insuring that the correct amount of light reaches the camera. Automatic units have limitations on their flash-to-subject distances, however, and these cannot be exceeded.

Probably the best system currently available is the true "dedicated' flash. Here the flash sensor is located inside the camera body near the film plane. In this position the sensor offers "through the lens" flash metering not unlike the conventional metering used to determine daylight exposures.

Not every make and model offers a "dedicated" system at this time, but the system is so accurate under so many conditions that all probably will in the near future. With a dedicated flash, accessories like bellows and extension tubes, and difficult lighting arrangements using bounces, diffusers, and other off-camera techniques, can be used

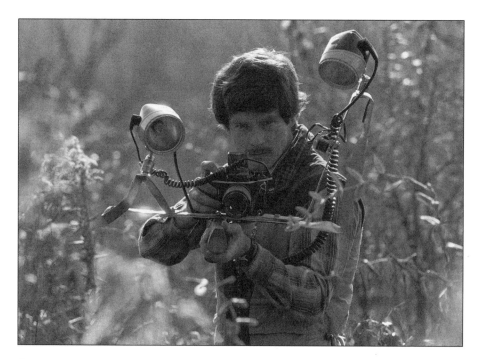

Two flash units will produce a more pleasing light, eliminating possible contrasting shadows. The headlamp does not affect exposure, but functions as a handy focusing light while supporting a camera system with both hands.

with a far greater chance of obtaining an accurate exposure.

### 7. Manual Flash

Manual units lack a sensor. In most units exposures are determined by rotating a dial that matches the flash-to-subject distance with the aperture required for the film's ISO.

A manual flash is just about as accurate as that of an automatic flash exposure, but determining that exposure takes a little longer. One has to check the focusing ring to determine distance, then rotate the flash's dial to find the aperture, and set that on the lens. In all, it may take a few seconds to carry out the entire process.

That's not very much work, and in most situations it's not especially inconvenient to carry out. In fact, for a great variety of wildlife subjects, a manual flash unit is the best type to use. Field conditions frequently offer such clutter or unusual conditions that an automatic flash's sensor can be fooled. This is also true with multiple electronic flash techniques, since the flash sensor will read the light of the other flash units, not that which is bouncing off the subject. For multiple flash, manual is required.

Since all but the cheaper automatic units have the option to switch to manual, it would be wise to buy an automatic flash with optional manual mode for a first flash.

### 8. Variable Power Ratios

Variable power ratios, a feature found on some manual flash units, control the light output by lengthening or shortening the duration of the flash. When set at its lowest power, the flash's speed increases, some to as fast as 1/50,000th of a second. This is fast enough to stop a hummingbird's wings, a flying insect, or a striking rattlesnake. The use of a Dalebeam (see page 111) might be needed to trigger the flash with such fast moving subjects. Nevertheless, incredible stop-action high speed photography is possible.

Variable power ratios have other advantages. At lower power the unit's recycling time (the time required to recharge a flash unit's capacitors) shortens, providing for rapid flash sequences while prolonging battery life. It allows flash-to-subject distances normally thought too close for the flash. An exact f-stop can be dialed in by adjusting the power ratio, making these units especially useful for fill-in flash techniques. Fill-in flash, as you'll see next, creates more appealing lighting than either flash or ambient light alone.

### 9. Fill-in Flash

Natural lighting can cast distracting shadows on your subject and many photographs would be improved if these shadowed areas were lightened. This is easily done by a technique called fill-in flash.

To use fill-in flash, the camera's shutter must be set at the flash synch speed, ranging from 1/25th to 1/60th in most models. Then an exposure reading is taken from the brighter or high-lighted areas of the subject. This f-value will be the one used on the lens aperture.

Next, the flash-to-subject distance is found and the proper f-stop determined. This should be a smaller f-number (or a wider aperture) than that needed for the natural light. Ideally, it should be about one f-stop less.

If the difference is greater than 1 or 1 1/2 f-stops, the flash could be moved in closer to the subject or the power ratio (on units with that feature) could be dialed higher.

Special care must be taken that the flash isn't too close and actually overpowers

the natural light. If it does, dial down to a lower power ratio, move the flash further back, or reduce the guide number by diffusing or bouncing the flash to the subject.

An added benefit of fill-in flash is the pleasing highlight or sparkle it puts into the subject's eye. For dark-colored animals this is especially valuable since the eye may otherwise be inconspicuous and the resulting photo unattractive.

Fill-in flash with TTL systems is easy. Put your camera on a shutter-priority or aperture priority setting, rather than a programmed mode. I'd recommend shutter priority. Next, take an exposure reading for the highlighted areas of your subject, those illuminated by natural light. Set your aperture and shutter speeds based upon that reading. Then, double the ISO (Note: this is a suggested starting point. You might want to only increase the ISO by 1/3 or 1/2 stop, to achieve greater fill, or increase the ISO even further to reduce the fill-effect) on your camera's ISO dial. The flash illumination will be less than that actually needed for the subject and should not overpower the natural light.

## 10. Multiple Electronic Flash

Outstanding wildlife photos are possible by using two or more flash units together. A variety of lighting techniques can be created, from shadow elimination to back-lighting.

In multiple flash photography, the units must be set on manual and must fire simultaneously. Automatic units won't work since they tend to "read" each other's light and shutdown prematurely, resulting in under-exposures. Simultaneous firing is necessary to eliminate the possibility of a "ghost image" caused by the second flash.

Simultaneous flash firing is easy through an inexpensive accessory commonly called a slave or flash trigger. The "master" flash is connected to the camera via a PC cord, and other flash units are connected to slave triggers. When the master flash is fired, the slave sends out an electrical impulse which triggers the other units.

Some flash units have a slave feature built in, but most do not. I'd recommend purchasing a flash tripper for each 'slave' flash rather than bothering with multiple PC cords and jacks, as this will provide you with the most freedom in flash placement without the worry of entangling or tripping over cords. Slave trippers can cost less than $30 or well over $100, but most require no electricity and the better ones usually react only to electronic flash light. Poor quality (inexpensive) slave trippers may only work well in subdued light and may be tricked into firing a flash when used in sunlight. If you're shooting multiple flash in bright, sunlight conditions, and you're using cheap slave trippers, your only choice may, in fact, be to 'hard wire' two or more flashes together via extension cords and a multiple PC jack. Be careful not to trip over one cord and have the entire flash setup come crashing down.

Slave trippers are also useful for triggering a flash some distance from the camera. A slave relay could be made when a flash tripped by the camera's shutter triggers distant units connected to slave trippers. I've used this technique successfully on bird nests where my principle light sources were positioned close to the nest while I operated the camera and "master" flash some distance away. Remember, exposure calculations are based on flash-to-subject distance, not upon camera-to-subject distances. This permits small apertures with long lenses some distance from the subject.

## 11. Flash Meters

Flash meters act as an exposure meter for the light produced by electronic flashes. Most are incident meters and must be held at the subject's position. They range in price from around $50 to several hundred dollars and are extremely handy for double-checking the light output of both automatic and manual units.

Some flash meters can double as standard exposure meters, which may come in handy should your camera's built-in meter malfunction. The flash meter is excellent for checking the true light value required for fill-in flash and in studio set-ups where a number of units are used.

## 12. Ring Flashes

Ring flashes (or ring lights) have a circular flash tube that mounts on the front of the camera lens. They provide virtually shadowless photography and are useful in many forms of macro work. The guide number of ring flashes is low, but that's all that's needed for the flash-to-subject distances required in close-up photography.

I wouldn't recommend a ring flash on an animal whose eyes can reflect the light, since the circular ring is quite unnatural-looking. Ring flashes work well with insects, spiders, and other animals with small or multi-faceted eyes but do not produce satisfactory shots of frogs or snakes where the flash source may be detected in their eyes.

## 13. Other Flash Accessories

Besides the basic equipment described above, there are a number of accessories helpful in wildlife photography. They include some of the following:

1. PC extension cords. In both studio and field work one or more flash units may be positioned some distance from the camera. PC cords (connecting camera to flash) are available in both coiled and straight varieties. I recommend using the straight cords since they won't snag on brush or gear as easily. Although having a few of varying lengths is helpful, if you're only getting one, buy the longest available. Long PC cords are especially helpful when photographing bird nests and mammals.

Ring flashes are often used in macro photography, but they create unnatural eye highlights and are expensive. A single flash unit mounted directly above a lens works equally well and saves you the cost of a special flash for macro. This one is mounted on a flash bracket sold by Kirk Enterprises of Angola, Indiana.

2. AC adapter cords. Useful in studio-based photography only, an AC adapter saves battery power and provides a constant recycling time.

3. Flash power packs. Although many units are powered by replaceable batteries (ranging from size AA to C), some offer optional power packs for faster recycling time and extended flash use. Power packs are extremely helpful in bird nest photography since the unit can be kept on for long periods without significant loss of power. If a long cord is available to connect the flash to the power pack, the batteries can be kept with the photographer and turned on only when needed.

4. Flash brackets. These flash supports hold the flash a few inches from the camera, usually far enough so that red eye is prevented. Better brackets will have adjustable arms to permit precise positioning of the flash. Two brackets may be screwed together at the camera mounting sockets to form a crude but effective dual flash frame.

5. Studio light stands. These tripod-like supports are equally useful in the studio and in the field for mounting and positioning electronic flash units. Although they vary in height, taller models are best since they're useful for bird nesting work.

All light stands come equipped with a standard (1/4-20) tripod screw where a flash could be directly mounted or, for greater versatility, a ball and socket could be attached with the flash mounted to this.

As their name implies, stands are especially useful in studios. They can be angled over a studio set up to provide back- or over-head lighting without fear of having the support appear in the picture.

6. Bounce Flash Kits. Some flash models (Vivitar's popular 283, for example) offer a bracket accessory to permit bounce flash effects. A Kodak gray card is placed in the bracket with its white side facing the flash lens ("gray" cards have a white side, too). The light is softer and more natural-looking than in typical flash illumination.

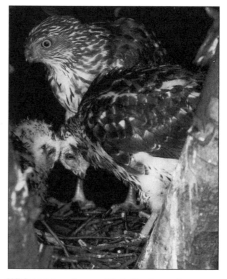

Fresnel lens mounted in front of a small flash unit will increase the flash's guide number 3 or 4 times. This fresnel system, offered by Nature's Reflections of Rescue, California, couples with my TTL flash for perfect fill-in light when filming birds in mixed brush.

Without two fresnel teleflash systems attached, it would have been difficult to obtain the required small aperture to have some sharpness on both the adult and fledgling Cooper's hawks.

## "A fill light is less powerful than the key...A very effective fill is produced by bounce or diffuse flash techniques"

Bounce flash can be done with any unit by simply pointing the flash at a reflecting surface. Automatic exposure control continues if the sensor faces the subject, not the reflecting surface. This is possible with units that have a rotating lens head, a detachable flash sensor, or are "dedicated" to a particular camera.

When using a manual unit, provisions must be made for the new flash-to-subject distance. There's only a 1/2 to 1 f-stop difference when the reflector is just inches from the flash, but there could be significant differences if it is some distance away. When it is, the flash-to-subject distance must include both the distance of the flash to the reflector and the distance of the reflector to the subject. An aperture setting can be determined in the usual way, either by dividing the distance into the guide number or by checking the flash dial. Since the reflecting surface absorbs some of the light, a further adjustment must be made. For subjects with a total flash-to-subject distance less than five feet, the aperture should be opened up one f-stop. From five to fifteen feet, it should be at least two f-stops. Nevertheless, bracketing is advised for important shots.

As you can see, using a bounce flash significantly reduces a flash's light output. Although this has some disadvantages, this does allow the use of powerful flash units at closer distances than would normally be possible, with the added benefit of creating more natural lighting. I'd recommend using this technique with white reflecting surfaces only, within ten feet of the subject, and only with bracketing to insure obtaining a proper exposure, unless a flash meter is used to determine the exact light output.

7. Umbrella reflectors. Umbrellas function similarly to bounce attachments and the same exposure considerations must be made. Umbrellas produce a soft and even light useful for studio work. Because of their large size, however, they're rather unwieldy and impractical in the field.

8. Diffusion attachments. Unlike the preceding two, light travels through the diffuser rather than being bounced off it. A variety of types are available, generically considered 'soft boxes' since the light passing through is 'softened,' producing soft rather than harsh shadows. Doing so reduces the flash's intensity, thus lowering the guide number. Diffusers or soft boxes either mount directly over the flash head or mount a few inches in front of it.

Diffusers work well with TTL flash systems since the reduced light is automatically read by the sensors inside the camera. They work well with automatic and programmed units provided that the light sensor reads the light striking the subject and not the diffuser. With manual units an exposure correction must be made. This is generally provided with commercially produced diffusers but must be guessed at with home-made versions unless a flash meter is used.

A crinkled, smokey-looking plastic sandwich bag, or a thickness of white tissue or handkerchief makes a cheap diffuser. Approximately a one f-stop compensation is needed for each layer of handkerchief used, but until you standardize this for yourself, bracket or use a flash meter.

Diffusers are especially helpful in macro photography not only because they soften the light, but also because they permit the use of larger units at close flash-to-subject distances.

## 14. Telephoto Flash

The range of electronic flash units is governed by the guide number for the film in use. All have a finite limit which is often too short for wildlife subjects. The working distance of a flash can be extended in some models by special tele-flash attachments. These are special fresnel lenses or even separate flash heads that serve to channel the broad beam of a flash into a more tightly focused, and thus more concentrated flash beam. This increases the guide number and therefore, the flash-to-subject distances.

Even flash units without tele-flash capabilities can be used in this way via special fresnel lenses and brackets that are available. You could make your own, or go the faster and far more reliable way by ordering a special tele-flash bracket. Jack Wilburn (Nature Reflections) offers a variety of tele-flash brackets compatible with most shoe mounted flash units. Fresnel lenses are available for 3 and 4 f-stop increases in exposure, in effect increasing the guide number by an equivalent factor. Wilburn's brackets mount either on a gunstock or on a tripod, although I'd suggest using the tripod bracket whenever possible for greatest image sharpness.

For example, with a 3 f-stop fresnel screen, a flash with a guide number of 110 (ISO 100) would have a guide number of 330. At a flash-to-subject distance of twenty feet the effective aperture would be f16! If your flash has TTL or variable power settings, a larger aperture than f16 could be used, which would reduce the drain on the battery, providing more flashes and faster recycling times. If a subject is some distance from the camera, however, full flash power might be necessary. At one hundred feet an f 2.8-4 aperture could be used with the 3-stop fresnel and GN 110 flash.

Wilburn's fresnel flash system can also be used for photographing at short distances. The bracket has a distance scale ranging from 45 feet down to 1.5 feet. Using the tele-flash system at short flash-to-subject distances permits smaller apertures at

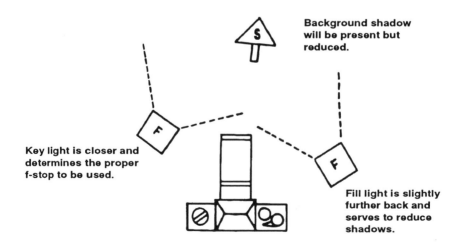

Background shadow will be present but reduced.

Key light is closer and determines the proper f-stop to be used.

Fill light is slightly further back and serves to reduce shadows.

lower power settings than would be possible otherwise, a useful feature when short recycling times are needed or your battery power is getting weak.

Tele-flash coupled with TTL flash systems and the latest camera models which offer synchronization speeds of 1/125th or 1/250th now offer the exciting possibility of fill-flash photography for telephoto wildlife subjects. The possibilities are exciting.

Night photography of mammals is also possible. The greater problem here is not in having ample flash power but in being able to focus the lens on these intelligent, wary animals. A red lens placed over a head lamp or large flash light will act as a focusing aid without alarming the animal, since most mammals cannot see red light.

## 15. Lighting Terminology

The following terms are frequently used when describing lighting and flash techniques. By applying these terms, a variety of lighting arrangements are possible.

1. Backlighting. Backlighting occurs when the main or only light source is located behind the subject. Silhouette or rim-lighting is produced.

In flash photography, the light source is typically positioned behind and a few inches above the subject. It's especially effective for creating highlights on the subject where the areas in shadow will be lightened by a fill-in flash.

2. Key Light. The key light is the main source of light. Except for some backlighting effects, the key light determines the required f- stop. When using more than one flash, the key light is either the more powerful of the two units (if positioned equidistant from the subject) or the one closer to the subject (if the units are of equal power). The effect is the same, with the key's light creating the brighter, high-lighted areas.

In fill-in flash techniques, the natural light acts as the key and the flash as a fill, as discussed below.

3. Fill light. The flash that lightens the shadowed areas caused by the key light is called the fill. Except in some backlighted subjects, exposures are not usually determined by the fill light.

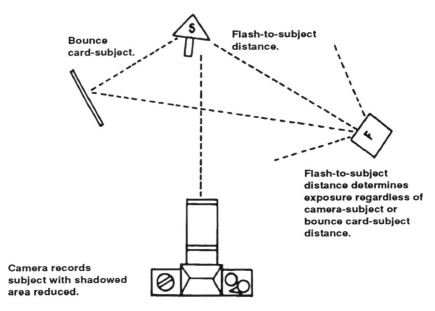

Bounce
card-subject.

Flash-to-subject
distance.

Flash-to-subject
distance determines
exposure regardless of
camera-subject or
bounce card-subject
distance.

Camera records
subject with shadowed
area reduced.

A fill light is less powerful than the key or is positioned farther from the subject. A very effective fill is produced by bounce or diffuse flash techniques.

## 16. Using Two Flashes

Some very effective multiple flash set-ups can be made with as few as two flashes. A variety of lighting techniques are possible for both field and studio use, with the flashes mounted on- or off-camera. By using some of the suggestions made earlier, two units of equal power can be used to serve as the key and fill lights.

The simplest way to use two flashes is by mounting one on either side of the camera. This is most easily accomplished by screwing one flash bracket into another at the camera-mounting socket.

My all-purpose camera/flash mount is a gun stock with angle aluminum bent and bolted in place to support the flash heads. It's crude looking but very sturdy, and it permits me to keep the entire set-up in a "ready" position for long periods of time. A ball and socket mount screws into the top of each brace, giving each flash head complete rotational mobility. With the versatile Graphlite, I can use a single flash at 40 feet, or two heads within twelve inches of the subject. Unfortunately, the device has a vague resemblance to a crossbow and it's caused me some awkward moments at airport boarding terminals on a few occasions (see page 59).

## 17. Suggested Flash Set-Ups

The following suggestions can be used in both field and studio photography. You may use these as a starting point for your own flash inventiveness, although I've found that these few examples have been sufficient to provide my flash photography with enough variety to satisfy most requirements.

1. Direct flash, two units: A flash is mounted on either side of the camera by bracket, gunstock mount, or other device. Distances can be adjusted for each flash (with some mounts), or diffusion material can be placed over a flash to create key and fill lighting.

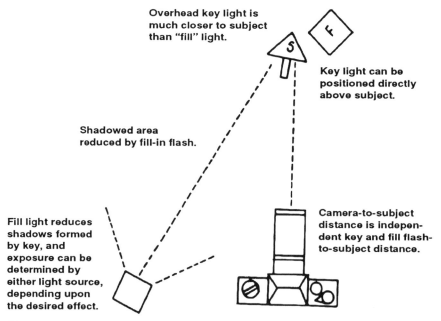

Overhead key light is much closer to subject than "fill" light.

Key light can be positioned directly above subject.

Shadowed area reduced by fill-in flash.

Camera-to-subject distance is independent key and fill flash-to-subject distance.

Fill light reduces shadows formed by key, and exposure can be determined by either light source, depending upon the desired effect.

There should be some difference in guide number between the two flashes if they're mounted equidistant from the subject; otherwise, distracting cross-shadows may occur in the background.

This technique is the easiest to use, especially in the field, and works well with a wide variety of subjects.

2. One flash, with fill-in bounce card: When only one flash is available, the following technique can be used to produce key and fill effects. A white card (crinkled aluminum foil can also be used for greater reflectability) is placed outside of the picture area and angled to catch the flash's light and bounce it back towards the subject. If this is done in a studio situation, you can check the bounce by dimming the lights and using a flashlight as a modeling light. Sufficient light will bounce from the card to reveal if the reflector is aimed properly.

The exposure is determined by the flash-to-subject distance of the flash. Shadows cast by the flash will be lightened by the reflector. The closer the reflector is placed to the subject the greater the fill-in effect will be.

3. Two flashes, overhead key, front fill: Subjects found in forested or brushy areas are frequently illuminated from directly overhead. This effect can be produced without creating distracting shadows beneath the subject by placing the key light above the subject and the fill light near the camera lens. To preserve the effect of overhead lighting, a two f-stop difference between key and fill lights is suggested.

Placing some brush, ferns, or leaves midway between the over-head flash and the subject creates a filtered effect that gives the appearance of sunlight filtering down through vegetation.

4. Backlighting, two flashes: Because most of the subject facing the camera is illuminated by the fill light, I'd suggest the aperture be set for the fill flash. The backlight (the key light) will rim or highlight the subject, slightly over-exposing it in those areas. For best results, these over-exposed areas should make up a small proportion of the picture area.

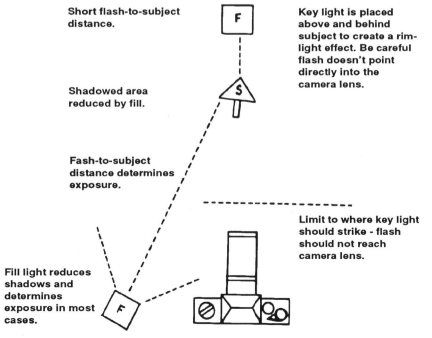

Short flash-to-subject distance.

Shadowed area reduced by fill.

Fash-to-subject distance determines exposure.

Fill light reduces shadows and determines exposure in most cases.

Key light is placed above and behind subject to create a rim-light effect. Be careful flash doesn't point directly into the camera lens.

Limit to where key light should strike - flash should not reach camera lens.

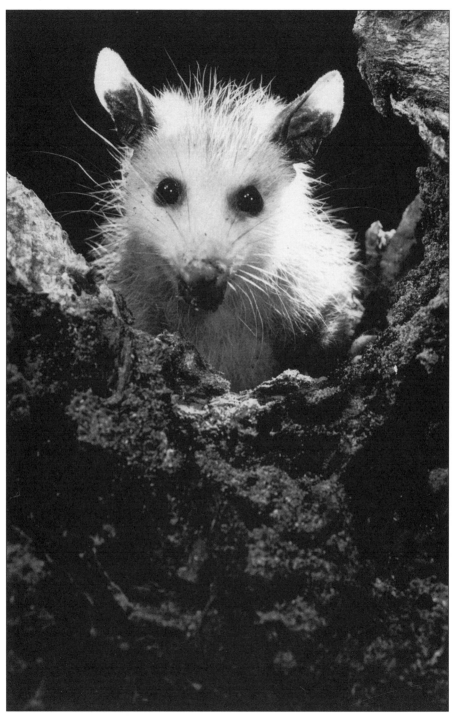

This portrait of a young opossum is a typical multiple flash setup, with two lights in front and another placed close, and behind, the animal to create a distinctive, attractive backlighted effect.

# SECTION *III*
# SPECIAL PROBLEMS
# AND APPLICATIONS

Blinds are not only useful for rare or elusive subjects, but for many common and often neglected animals as well. This cardinal was photographed at fifteen feet as it perched a few inches above a pile of sunflower seeds.

# CHAPTER 8

# The Photo Blind

Blinds, or "hides" as they are more aptly called in Europe, conceal the photographer. They allow you to work close to a subject unobserved. Blinds vary, being little more than a camouflage net draped over a bush to elaborate steel scaffolds supporting pop tents a hundred feet above the ground. Your subject, its habitat, and your time and finances determine the type of blind that can be used.

## 1. Value

A blind is invaluable in certain situations, and for some subjects or activities where a photograph could be obtained no other way. Since close observation of your subject is possible, certain actions, poses, and behaviors can be anticipated with a much greater likelihood of capturing the event on film. A great deal of creative control is possible, and unlike other methods that could be employed for wary subjects, a blind permits the photographer to change lenses, films, or do virtually anything that's required to get exactly what he wants.

A blind teaches, or rather enforces, patience. Although the rewards for working in a blind are great, they're not without a price. Long, boring, uncomfortable hours may be spent fruitlessly on an uncooperative subject. Heat, cold, biting insects, inquisitive snakes, lavatory-seeking birds - all these and more may be a part of your photo blind experiences.

But it's worth it in the long run. Not only are great pictures possible, but a blind further benefits a photographer by revealing to him activities and behaviors he'd otherwise not see. These experiences may be put to use in later projects.

## 2. Prior Planning

Blinds aren't very effective if set up without a definite objective in mind. This may be to photograph deer as they pass down a game trail on their way to water, or to document the activities of a coyote family at its den.

In nearly all cases, both the subject and the specific site must be selected before a blind is placed. Consideration must be made for each individual animal's wariness. Some animals will accept very conspicuous structures immediately, while others must be conditioned to the most natural-looking blind over a period of days or weeks.

Factors to consider prior to erecting a blind include how closely it can be placed, whether an assistant is needed as a decoy, and when the greatest amount of activity will occur.

You should read about the animals that you intend to photograph from a blind. Other photographers' experiences are especially helpful. Personal observations are just as important, of course, and may reveal that a particular animal is so accustomed

to people or odd objects that using a blind will be both fast and easy. Other observations will undoubtedly prove the opposite.

### 3. Situations Requiring a Blind

There are many situations that require a blind and others where using one will result in better pictures. Although the following examples are not all-inclusive, they will provide guide lines for using one effectively.

1. Bird feeders. The easiest place to begin is a backyard birdfeeder. Some texts suggest shooting birdfeeders from inside the home, and that's fine for certain circumstances. However, for rewarding work that will also prepare both you and your equipment for future, more demanding tasks, use a blind.

There's a definite advantage to this. The blind can be moved as necessary to obtain better lighting or backgrounds. Of course, it's far less comfortable inside a blind than inside the house, where you can shoot through a window effortlessly. Exactly how uncomfortable, and what changes may be required to make your blind functional, however, are more easily discovered in the backyard than in the field, when it may be too late to change.

If there's a wild area nearby where you could bait birds and animals on a daily basis, consider doing so. A feeding station in an area more remote than a backyard bird feeder provides a far greater variety of subjects. Here you may opt to erect a permanent blind, especially if mammals will be visiting your baits. Although most birds will accept a foreign structure after only a few hours, most mammals require a much longer time.

If a permanent blind is made, place it in an area where vandalism is unlikely. These blinds can be conspicuous and may attract the less savory members of our own species.

In the desert, water or a halved grapefruit or orange will attract a number of bird species. This house finch accepted my blind within minutes of my erecting it.

2. Bait sites. Unlike permanent feeders, bait sites are effective without prior conditioning for your subject. Baits will work especially well with meat-eating animals since their diet requires them to constantly search for food over large areas. Whereas herbivores (such as deer and turkey) are best attracted to permanent stations, carnivores and scavengers are not. Most meat-eaters locate their food by smell and may find your bait within hours of it being placed.

Carnivores and scavengers are far warier than most herbivores, and a photo blind must be as inconspicuous as possible. Suggestions for such blinds are offered in the following section.

Generally, the larger the bait the better it attracts animals. Deer carcasses are the perfect bait for most North American animals, attracting everything from bald eagles and wolves to shrews and cougars. Your best, and possibly your only, source for a deer is through your local game warden or conservation officer. He may supply you with a road-kill should one become available.

Other road-kills (such as groundhogs, opossums, snakes) or livestock that have died in the field are useful baits and may be more accessible.

3. Water holes. Especially in arid environments, water sources attract a wide variety of life. By day, birds such as quail visit to bathe and drink. At dawn, dusk, and throughout the night, mammals are common. Activity is nearly guaranteed, but this is unpredictable and on a bad day nothing may appear.

Since most water holes are visited regularly, a blind must be well camouflaged to avoid arousing suspicion. In times of extreme water scarcity, care must be taken that thirsty animals aren't alarmed and forced from their vital water sources. It's advisable to "work" a water hole for only a few hours and not on consecutive nights, since many mammals may be too alarmed by your scent or your electronic flash's lights to return while you're there.

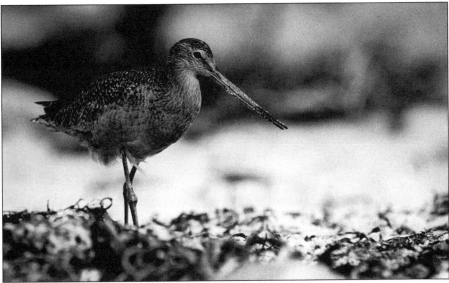

**Shorebirds can be extremely wary of an approaching human but show little fear of inanimate objects. This marbled godwit foraged within a dozen feet of my blind, a camouflaged tarp that covered my lying in the sand.**

4. Natural feeding congregations. Natural feeding areas work best where large numbers of animals congregate. Something, such as an eruption of a local food source or migratory conditions, must attract the animals on a regular basis. The more individuals that are there, the greater your chances that some will wander within camera range.

Should you discover a feeding area, take advantage of it. It may be only transitory and the conditions may never be repeated. I'll always regret the time I passed up the opportunity to photograph hundreds of wood storks and egrets feeding at a central Florida slough. I was pressed for time and without a blind, but I'm certain that had I built one and obtained the landowner's permission, I'd have some great pictures today.

Opportunities are too diverse to list here, but the following could serve as examples to illustrate the multitude available. In the Northwestern states and coastal Alaska, the salmon spawning grounds are great for fish-eaters like bears, wolves, eagles, and gulls. In coastal areas of the country, isolated pools, beaches, or sand spits may attract birds by the hundreds. Cape May, New Jersey, attracts thousands of migrating knots, a type of shorebird, when horseshoe crabs breed upon these beaches.   Since you may be working in an area quite familiar to your subject, use a well-camouflaged blind. It may be necessary to put the blind in place a few days prior to manning it in order for the animals to resume their normal feeding habits.

5. Dens or nest areas for mammals. Because of the young's need for parental care, most mammals occupy a specific den or nest site for a length of time each year. This provides an excellent opportunity for photography. Working with some species can be quite easy, while working with others is definitely not.

Best results generally occur by placing the blind, or a replica, some distance from the den and moving it closer each day. There's also a greater likelihood of success with game animals if you photograph in a park or preserve. Then, should your subject observe you moving the blind daily, it may lose its fear and resume normal activity more quickly after you've "disappeared" into the blind. However, when the blind is close enough to permit photography, an assistant will be required (page 83) to trick the animal into thinking that you've gone.

Most altricial herbivores (those whose young are poorly developed at birth) accept a blind quickly. By adding bait as well, ground squirrels, pikas, muskrats, and other small mammals may grow so tame that the blind becomes unnecessary.

Carnivores are far more difficult. Many prepare more than one den in the event that the one occupied is disturbed. Those photographers who've successfully worked with predators at den sites usually rely on well camouflaged blinds. One photographer used a portable "hay-stack" to move closer to a fox den each day.

6. Perches. Sometimes a particular branch, rock, log, or mudflat is attractive to an individual animal. This "perch" may be used as a sunning area or perhaps as a hunting post, and may be visited at a specific time each day or at infrequent intervals throughout the day.

Repeated observations are required to determine whether there's a chance that the perch will be revisited. After a few days of observation, you can decide if setting up a blind will be worthwhile.

How quickly you can place a blind and what type you can use depends upon the animal species. Some animals, such as turtles, alligators, and certain birds, may visit a special rock or log each day and show little concern if a blind suddenly appears nearby. Other blinds must be inconspicuous, blending so well into the surrounding area that they will go unnoticed. Since the animal is familiar with the surrounding area,

however, it's wise in every case to use a well-camouflaged blind. This doesn't have to be elaborate; a camouflage net may provide sufficient concealment (page 78).

7. Bird nests. There are two practical methods to photograph bird nests. One involves operating a camera remotely and will be discussed in Chapter 15. The other method, and one far more satisfying, is from a blind.

Either method can present grave risks to a bird's nesting success if done improperly. A bird disturbed by a photographer's activities may desert the nest or visit it so infrequently that the clutch dies. No photograph is worth that price. The procedures necessary for safe, successful bird nest photography will be discussed in Chapter 15.

Most birds will tolerate conspicuous, unnatural-looking blinds provided that they conceal the photographer and his actions. A blind cannot be placed at the nest immediately, but must be moved to the proper location over a period of a few days. If a blind must be constructed or placed in a nearby tree, work should be done in ten to fifteen minute intervals so that the birds aren't kept from the nest a dangerously long time.

Placing a blind in this way allows the bird to grow accustomed to the unusual activity and unfamiliar structure gradually and with little risk to the nest.

## 4. Types of Blinds

Since a blind conceals the photographer and his actions, it can take on many forms. Fake cows, walking haystacks, and man-size geese are just a few of the innovative disguises photographers have used to get close to their subjects.

The examples that follow aren't as elaborate as those, but nevertheless work. They range from the simplest to use, camouflage clothing, to the more specialized and elaborate float blind.

**The carrion-eating birds are among the easiest to lure into the range of a blind. This Turkey Vulture was baited down with a dead groundhog.**

1. Camouflage clothing. Full camouflage, from headnet and gloves to shirt and pants, and remaining absolutely motionless are all that is needed for closeup photography of some animal subjects.

Camouflage breaks up a form's outline. To accomplish this, the photographer should sit tightly against a bush or shrub where light patterns and haphazard angles in the background blend in with his clothing. Remaining motionless is essential. Even with a headnet, the movement of your eyes may be detected by birds and cause alarm. Operating the camera requires some motion, of course, but this can be kept to a minimum by slow, deliberate finger movements. A power winder or motor drive and a shutter-priority automatic camera are especially helpful here.

This "blind" is quite useful when game-calling (Chapter 9), since an animal's attention is directed to your tape-player or loudspeaker. It's perfect for predator calling since it frees the photographer to move to new calling sites if necessary.

A problem arises if your subject appears out of the camera's field of view. Obviously the camera must be moved, but by doing so the subject may be spooked. Although many animals cannot recognize a motionless object, nearly all are keenly aware of movement.

If there's a wind stirring the vegetation, changing the camera's position may be ignored by the animal. More than likely, however, the vegetation will be still and any action conspicuous. Any move must then be imperceptibly slow and must stop should your subject look your way.

If you're detected, the animal may flee. It almost certainly will should you move again, no matter how small that movement might be. Under these circumstances I'd recommend going for the whole pie and finishing your action, no matter how dramatic the position shift may be. There's nothing to lose, and there's always the chance that the animal may hesitate out of curiosity, surprise, or shock, giving you time to refocus and shoot a few exposures.

2. Camouflage netting: Some of the best and most versatile blinds available are nets sold under product names like "camou cover" and "naturalflage." These aren't like the old-style green mosquito netting. Instead, they are composed of sturdy nylon strands and a camouflage-patterned material cut to resemble natural vegetation. This zig-zag camouflage material is reversible, offering both a green and a brown-shaded side.

The nets are shapeless and drape over a photographer and tripod-mounted camera to create a natural, brush-like appearance. For best results the photographer should wear complete camouflage, including headnet, and sit against or within the foliage and branches of a shrub.

Camou nets average about five by seven feet long, weigh less than a pound, fold into a tight, portable bundle, and cost $20 or less. No poles or other supports are needed, and their drab, outline-breaking shape works well in a variety of habitats.

This netting is my favorite blind for use at bait sites, feeding stations, and when game-calling. Although the photographer must remain motionless, more hand and camera movement is possible beneath the cover of the net than with camouflage clothing alone.

I wouldn't recommend these nets for bird nests or mammal dens, however, since it would be difficult to condition the subject to the blind prior to use. Especially around a nest, sharp-eyed birds may see through the gaps of the netting, detect motion, and grow alarmed.

Leonard Rue Enterprises offers a handy refinement of this idea. Called the 'pocket blind,' the blind covers the photographer and camera. It has a lens opening and eye

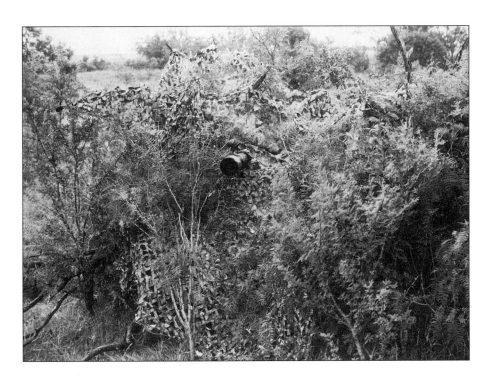

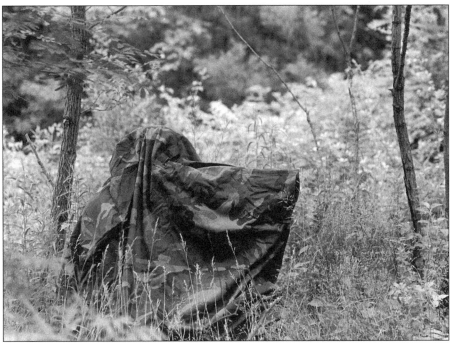

Sporting good and hunting stores and catalog companies supply an incised camouflage netting that works well as a simple, portable blind. Product names vary, but most end in 'flage' and all look like nets. To work, the photographer must remain motionless once inside, since the openess of the netting makes movements visible.

holes for viewing, while still providing a complete covering. Like the net camouflage covers, the pocket blind requires you to sit nearly motionless, so as to not shake the blind, but its heavier cover allows more freedom than a net does for limited movement.

3. Vehicles. A car or other vehicle makes an excellent photo blind under certain circumstances. Many animals view a vehicle fearlessly, especially in state and national parks.

There are a few precautions to follow when using a car for a blind. Don't slam on the brakes and come to an abrupt stop when an animal is spotted. You may alarm the animal since many animals are only accustomed to moving vehicles. Even if it means driving past your subject and making a U-turn, do so, then coast to a gentle stop with your engine turned off. Having the motor off prevents vibrations that would ruin a photo, and doing so prior to stopping lessens the chances of causing alarm.

Since using a tripod is impractical, some other camera support must be used. You could rest a lens over a sandbag or beanbag that's draped over a windowsill. It works, but using slow shutter speeds are difficult since the photographer is required to hold up the camera end. I've shot a 200mm lens at 1/15th of a second off a bean bag, but I held my breath, pressed my body tightly against the lens-camera assembly and door, and squeezed off gently. The images were sharp.

However, a far better solution might be to use Rue's Groofwin Pod onto which a beanbag could be rested or a ball head could be mounted. Any camera will move should you or your passengers shift about at the moment of exposure. This can be especially troublesome in a safari van when three or more other photographers may be getting into position, firing frames, or changing film. Under such conditions, it's best to prepare everyone to be as motionless as possible when everyone's shooting. "Shooting" or "Moving" serve to alert others of your actions. By cooperating, a group of four photographers can all get razor-sharp images from a safari vehicle.

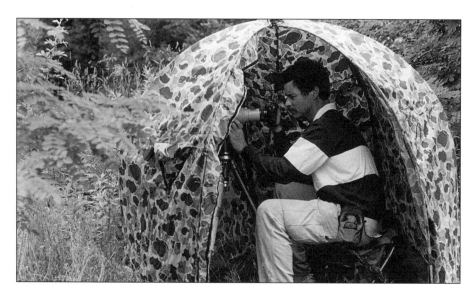

My favorite blind is called the ultimate blind marketed by L.L. Rue. It erects in seconds, is lightweight, and provides enough room inside for extra gear, books, and a stool.

## "Fake cows, walking haystacks, and man-size geese are just a few of the innovative disguises photographers have used..."

4. Pop tents. These free-standing tents can be erected or "popped up" practically anywhere. They're supported by internal aluminum rods or fiberglass poles which bend to form a dome or igloo shaped structure.

A few manufacturers occasionally offer a special photography version equipped with extra zippered lens portholes. Rue Enterprises offers a double snout model in a variety of camouflage patterns that permits the user to mount two lenses, or to swing from one porthole to another fairly easily. Rue's blind is light and erects faster than any other I've encountered.

Even with camouflage, pop tent blinds are difficult to disguise. Camouflage may serve to make the blind less noticeable to human passersby, but your subjects will be aware of the new structure. For this reason, pop tent blinds are best used at bird feeders and some nests, and at baiting sites and perches.

Pop tents are frequently used atop platforms and scaffolds. They're not very useful in windy areas, however, since the tent walls act like a sail and shake and buffet the camera lens with every gust. Although guide wires could be used to secure the blind, a better choice would be using the "box" blind discussed later in this section.

5. Float blinds. As its name implies, this blind is used on water. The stablest version I've seen consists of two 4 or 5 foot long pontoons made of styrofoam and wood covered by an exterior plywood deck. The photographer, dressed in chest waders or swim trunks (weather and leeches permitting), sits towards the rear of the pontoons. Sitting in the water to waist depth offers far more stability than would result from floating on it, which is critically important should a breeze create ripples or waves.

A chicken wire frame is placed over the deck to support a burlap or canvas covering. Camouflage netting, brush, or other vegetation can be added to impart a more natural appearance.

Bass rings or floats (offered by outdoor suppliers like L. L. Bean) or an inexpensive truck inner tube can be used to make a less elaborate float blind. A sheet of exterior plywood is cut in a circular or octagonal shape to outline the circumference of the ring.

In both, the legs supply mobility. It's easier to walk through shallow water than to paddle across deep water, although using swim fins help here. Some blinds can be adapted to fit a small electric motor if long stretches of open water are contemplated, or the blind can be towed by canoe or boat.

Float blinds are ideal for waterfowl, shore, and wading birds, as well as semi-aquatic mammals like muskrat and beavers. In fact, just about anything that frequents water or its shoreline is a potential subject, including very large alligators! When I alluded to lavatory-seeking birds in the introduction to blinds, I had this one in mind. On more than one occasion, herons have landed atop this "lodge." Unfortunately, these birds have the habit of voiding at take-off, with most unpleasant consequences to the photographer.

6. The Kodak blind. Plans for a versatile burlap and angle aluminum blind appeared in "More Here's How" and the "Here's How Book of Photography" published by Eastman Kodak. That basic design can be altered, since its six foot height is unnecessary in many circumstances. I've added a number of additional slots in the vertical pieces of the frame to make it a 4 1/2 and three foot tall blind as the occasion demands.

Other material could be used since a burlap cover makes the blind slightly bulky. Burlap is somewhat see-through, also, and the photographer's outline may be visible when the blind is back-lighted.

The blind is quite portable, but because of its light weight, guide wires or ropes must be added to provide stability in a breeze. I recommend two wires per corner brace. Because of its height, many lens portholes can be made. I have two or three to a side, ranging from just a few inches from the bottom of the blind to a foot from the top. This provides a number of camera angles and perspectives.

Because of its shape and character, the Kodak blind is best used in situations similar to those appropriate for a pop tent.

7. The plywood blind. In areas of strong, gusty winds I use a box-like blind made of 4' x 4' exterior plywood sheets. The blind is heavy, and when folded flat and carried overhead it has on occasion acted like a sail, nearly knocking me off my feet as a strong gust caught it.

In windy, coastal areas, using another blind might be impossible and it is here that the plywood box is especially practical. Guide wires may be required to provide for extra stability, but once in place the blind is secure against all but the strongest winds.

Lens portholes are cut where necessary and a hinged "shutter" covers each when not in use. The roof is lightweight, being composed of a length of cloth stretched across the top and held in place by a few boards.

A lighter, less durable version of the "box" could be made from a refrigerator or

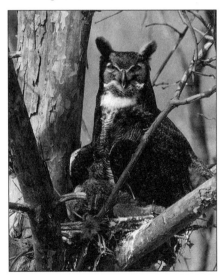

Great horned owls nest from 15 to 70 feet above the ground, usually adopting old crow or hawk nests. This owl and single young occupied a dilapidated crow nest 35' high in a dead pine.

This homemade blind was erected 40' high in a tree adjancent to great horned owls nest. Sometimes conditions require improvisations, as this tiny blind clearly illustrates

Certain national wildlife refuges offer permanent blinds where animals can be photographed. This chachalaca was shot from such a blind at a refuge in south Texas.

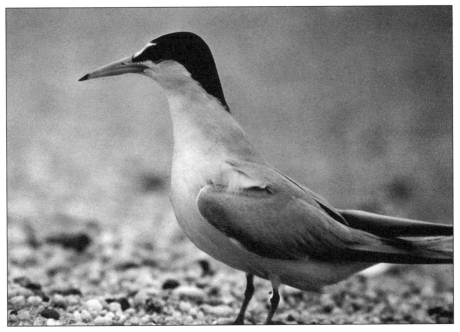

The plywood blind illustrated on page 82, made this photo of a least tern possible under very windy conditions.

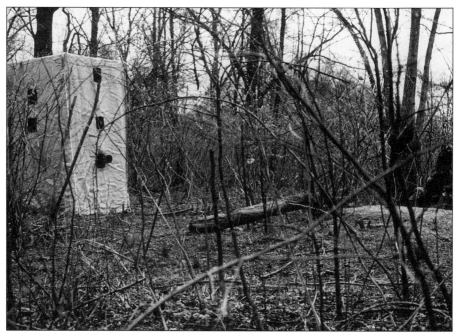

The Kodak blind is handy for bird nests and at feeders. Constructed of aluminum, it is lightweight and easily transported.

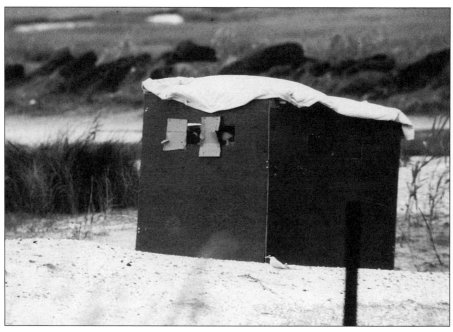

The plywood blind is heavy but extremely useful where wind can be a problem. A cloth roof is used when photographing birds but is unnecessary for mammal work. For some mammal dens, only 1/2 of the blind is needed, provided there's no chance that your subject will circle the blind and discover you.

washing machine packaging box. These would be perfect for subjects that require a slow conditioning process where there's a chance that the blind could be destroyed by vandals. A door, portholes, and handles can be cut out with a utility knife and hinges made by using wire rings or utility tape.

8. Special circumstances. The blinds described above should encompass nearly all of your photography needs. However, for a few rare or elusive subjects, more elaborate preparations than the ones suggested may be necessary.

I mentioned scaffolds and platforms earlier. For subjects found on cliffs or in trees, some type of support is necessary to place the blind within working distance of the subject. It's occasionally possible to purchase a scaffold at a construction site, and many rental companies supply them. A pop tent or similar blind could be placed on top.

A friend of mine with climbing experience and guts devised a hanging blind for use with raptors (predatory hawks and owls). He hangs suspended from a tree limb by a seat harness, with his camera braced by a clamp or"treepod" screwed into the trunk. His blind is an umbrella (with long cloth sides sewed on) mounted above him.

Some elaborate structures have been made to photograph certain subjects. Pit-blinds similar to those used in goose hunting may be required for certain birds and mammals. *Audubon* magazine published a spectacular series of bald eagle photos made by a photographer who stationed himself inside a cement bunker camouflaged by rocks and stones along the shore of a New England lake. It wasn't the type of blind he thought about and built overnight, but the results were well worth the time involved in making it.

Don't be afraid to be innovative when necessary, but bear in mind that the best solution to a problem all too frequently is the simplest and easiest to implement.

## 5. The Decoy Assistant

An assistant is required in situations where your subject may observe you entering or leaving the blind, such as when photographing at a nest or den. Should you attempt to enter alone, the animal probably won't return, since it's expecting you to be somewhere in the area that you last were seen. This is especially dangerous where young are involved since they could suffer through their parents' absence.

Fortunately, most animals can't count. If two people approach a blind and only one leaves (making as much noise and commotion as the two had upon entering), the animal will assume that the area is clear. For best results, the blind should be placed at the photo site days or at least hours earlier so that its presence is no longer considered unusual.

If your photography will be finished in one sitting, then it isn't necessary for the assistant to return when you're ready to leave. However, if you plan on working in the blind at another time, you should arrange to have your assistant return. Most animals won't accept a blind once they've experienced the surprise of having a human pop out of one unexpectedly. The assistant may return at a pre-arranged time, although this can present difficulty if he turns up at a particularly fruitful moment in your photography. It's wiser to arrange some type of signal, either by using short-wave (for those who can afford it) or by opening up a lens porthole and hanging out a white cloth or a flag that the assistant can spot from a distance.

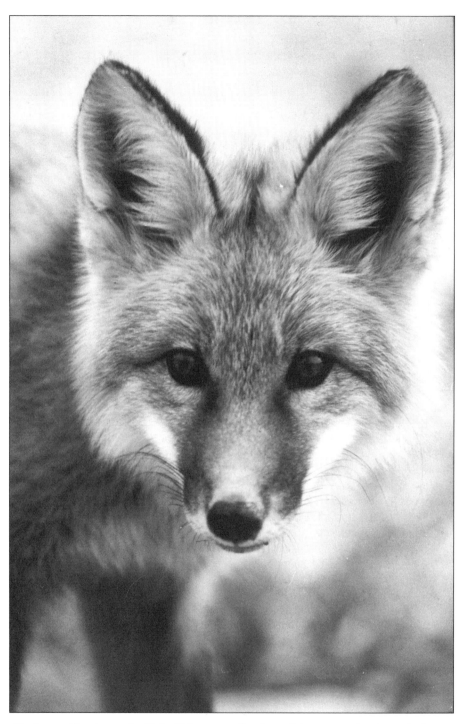

Alaskan red fox 'squeaked in' within twenty-five feet of the camera by the technique described on page 85.

# CHAPTER 9

# Game Calling

An exciting facet of wildlife photography involves calling birds, mammals, and some reptiles in to you. This is done by using a variety of sounds that either stir an animal's curiosity or whet its appetite.

You become the hunted when using these techniques. This may be unsettling to the novice, considering that the coyote he's calling expects food, not a photographer's cameras, when it breaks through the underbrush. In most circumstances, however, the pursuit is quite safe, regardless of the excitement it can offer.

## 1. First Concerns

The photographer and the area around him are the focus of his subject's attention. The approaching animal is seeking food that could be in the clutches of a larger and more dangerous predator. The animal may approach stealthily or, should it be large or very hungry, it may charge in at a dead run. The photographer must remain intensely alert, for when the animal arrives it may remain for little more than an instant.

Full camouflage, including headnet and gloves, is a must and should match the habitat as closely as possible. For best results, a camouflage net (page 78) should be included. Remaining motionless is essential, and the slightest movement could ruin hours of work. Mastery of the calling techniques described next is mandatory and should be accomplished long before your first attempts in the field.

## 2. Calling Equipment

There are three basic ways to produce sounds attractive to wildlife. These include sounds produced by the hand and mouth, by the use of some type of mechanical device, and by playing a tape or record. Each has distinct advantages in special circumstances, as you'll soon discover.

1. Squeaking. "Kissing" the back of your hand or a space between the fingers produces a sharp, high-pitched squeak. The noise is similar to that produced by a wide variety of animals in distress. By making minor variations in a squeak, the cries of hungry birds or lost young, the twittering of mice and shrews, and the terror stricken squeals of a rabbit can be mimicked.

Not only is squeaking effective, it's also the "handiest" call to use. It can be done anywhere without a moment's preparation. Squeaking is one technique every serious photographer should learn to master.

It's easy to produce a good squeak with just a little practice. I found the most effective way is to draw air through a space created between the index and middle fingers. This gap can be widened or narrowed at will to modulate both volume and pitch. The tighter the space through which air is drawn, accomplished by sucking the air in through tightly pursed lips, the shriller the squeak. If the fingers are too close together,

of course, no air will be drawn and you'll pass out before producing a useful sound. Best results occur by wetting both the lips and the gap between the fingers, since this moisture further closes this space, producing shriller notes.

Squeaking works with just about every carnivore and a variety of other animals as well. I've successfully used it on coyotes and foxes, hawks and owls, weasels and raccoons, and a variety of songbirds. Songbirds are attracted out of curiosity, not hunger, and are perhaps tricked into thinking that a predator has discovered a bird's hapless young. Sometimes a dozen or more birds will perch in the surrounding brush, anxiously seeking out the source of the cries.

I've had a couple of shocks some evenings during the nesting season when my squeaks produced unexpected attacks from nearby nesting birds. On one memorable evening, a wood thrush's wing actually brushed my face as it dive-bombed the source of the sound. Quitting shortly afterwards, I stood up and collected my gear, only to scare off a red fox that had been attracted by the call.

Squeak in a series of three to ten notes. If possible, alternate volume and pitch to produce the most agonizing notes imaginable. This is especially useful with larger predators, since the objective is to produce a sound so ghastly that a predator is certain there's an easy meal ahead.

2. Mechanical calls. There's a wide, confusing array of mechanical calls available today. Some operate by shaking or by rubbing companion pieces together. Familiar examples of this type would include the "yelper" cedar boxes, slate calls, and gobbler "shakers" used for turkey hunting. Other "shakers" are made for ducks, crows, and a variety of predators.

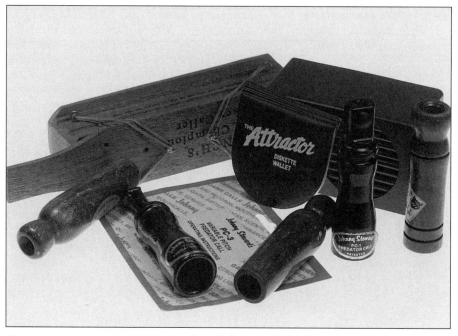

**There are a variety of small, pocketable devises useful for attracting game. Shown here is a turkey box call, Stewart's battery-powered 'attractor,' and an assortment of predator mouth calls.**

## "Winter...is the best season for most types of predator calling, since natural prey is scarcest at this time."

There's an even greater number of mouth calls. Sound is produced when air is forced from the lungs and blown through the call, causing a reed or diaphragm to vibrate. Some of the hundreds of mouth calls include duck, goose, pheasant, quail, dove, crow, elk, owl, and fox calls. Used correctly, some are extremely effective. Others, however, never seem to produce the desired results.

Mouth calls are useful for two reasons. They can produce a far greater number of sounds than would be possible for most people to imitate without mechanical means. Many find them easier to learn to use than to master "squeaking," and nearly all will carry a sound further than that method.

Novices can run into difficulty using any type of mechanical call if they don't know what the call is supposed to sound like. I can't imagine how many foxes I had sent off laughing when I first began my game-calling experiments. Even the best calls are only as good as the person using them.

The best way to learn how to use a mechanical call is through an experienced caller. There are a couple of important points to learn, including how to hold your hands, how often and at what volume a call should be used, and most importantly, exactly how it should sound. Instructional records are also available for many types of calls, but there is no substitute for competent personal instruction.

I like mouth calls over hand-operated types because less movement is required. Although I'm not an expert caller, I've had tremendous success with the PC-3 call produced by Johnny Stewart.

To best use these calls, follow the recommendations made at the beginning of this chapter. It's best to call less frequently rather than too often, and softly rather than loudly. When your subject appears, all calling should stop. It's remarkable how precisely an animal can locate the source of a sound even minutes after it has stopped.

Sometimes a predator will "hang up" just out of camera range. In this case, use a soft squeaking noise through the lips to coax in your subject.

3. Electronic calls. Special game callers are available that play record, cassette, or eight-track reproductions of actual animal sounds. The obvious advantage to this method is it uses real sounds, requiring no special skill from the operator.

Callers that play records are the least expensive, both for the machine and for the records. However, a record may warp in hot temperatures and can crack or break. Eight track players are more expensive, and the tapes, which usually offer four different sounds each, are the most expensive, generally double the cost of a record.

Cassette players are more expensive than the other two, but the tapes are mid-way in price. Like most records, cassette tapes have two calls, one to a side. Some do not, which is convenient in some situations since the tape merely has to be flipped over to continue calling. Cassettes are far sturdier than records, and most callers find them more practical for field use.

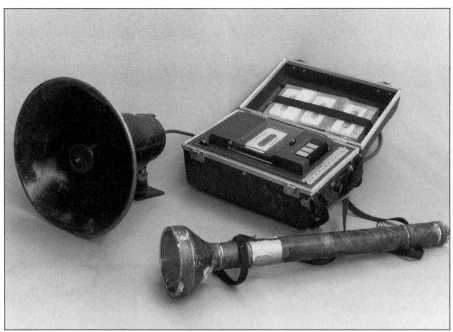

Stewart Electronic Game Caller and loudspeaker are useful for attracting a wide range of animal subjects. The seven cell flashlight is needed for observing mammals at night. It is equipped with a red lens, making the light beam invisible to mammals.

This roadrunner was called in by the squealing bird tape. A "wiggler" (see page 168) was used to attract the bird's attention. I was dressed in complete camouflage, including camou net, only twenty feet from this sharp-eyed bird.

I'm experienced with a Johnny Stewart Game Caller, a cassette machine powered by twelve size "D" batteries. This rugged player produces sounds audible at one half mile, although such volume is rarely necessary. Stewart's products are accepted by many as the industry's standard in quality and performance, and work quite well in the field. Since an electronic caller uses authentic sounds and cries of animals, it should be fool-proof. Unfortunately, it's not. Game callers are frequently misused, resulting in failure that's blamed upon the product and not its user. The greatest mistake in calling is using more volume than is required. In most instances a low volume setting is preferred. Too high a volume actually works against your purpose.

The types of calling are similar enough that the following procedure recommended for predators could be adapted to fit most game-calling needs:

In predator calling, begin the volume quite low. The tape may be inaudible at forty yards to the human ear but a predator can detect sound at five times that distance. Play the tape continuously or stop it after a series of calls, provided that doing so doesn't produce a "clicking" noise as the controls are touched.

After five or ten minutes, stop the tape. A few minutes should elapse so that an approaching predator has time to come into view. If there's no activity after four or five minutes, resume calling. You may opt to use higher volume for a series of calls in hopes of luring more distant predators.

Return the volume to normal within a few minutes so that a predator doesn't "hang up" too far away for a photograph. Generally, predators won't approach a sound that's unnaturally loud. They'll approach to a point, then circle around while they determine exactly what's wrong with the situation. Low volume encourages them to come all the way in.

Spend ten to twenty-five minutes at each calling site. In the East, some callers spend less than ten minutes per stop when calling gray fox. In the West, however, more than one half hour may be necessary to successfully bring in a cougar or bear.

Several precautions must be taken prior to reaching the calling site. If you are using a car, keep the radio off and don't slam the doors or trunk when getting equipment ready. If you work with a partner, conversation should be limited and kept to a low whisper. Be careful that equipment doesn't bang against rocks or tree trunks, and be sure to avoid silhouetting yourself against an open skyline. For best results, wear camouflage clothing and a camouflage net and use the natural cover of the area.

Successful game calling not only depends upon following proper procedures, but also upon the time of year, the species involved, the habitat and local conditions, and the freshness of your batteries. For best results and truest sound, use fresh alkaline batteries. In cold weather, where near-freezing temperatures quickly drain power, use a hand-warmer inside the battery compartment and rest the caller on a foam pad.

Time of year can be especially critical for certain subjects. During the winter, many birds will ignore a distress cry that may have brought in flocks during the summer months. Winter, however, is the best season for most types of predator calling, since natural prey is scarcest at this time.

In areas where the local predator population is high, response to a call may be excellent in any season since the competition for food is intense. In areas where your quarry may be hunted (and many states permit electronic calls for predator or varmint hunting), animals may be "educated" to a call and shy from it.

## 3. Tapes and Records for Electronic Callers

With many manufacturers offering a wide assortment of cassette tapes and

records, selecting the right calls could be both expensive and confusing. Stewart's company alone offers over thirty cassettes for a wide variety of purposes. The following are those I'd recommend for starters, since they offer multiple applications and many interesting opportunities.

1. Owls. Tapes of screech, barred, and great horned owls are very effective. Johnny Stewart has had a great deal of personal success photographing the above species using tapes. He begins his photography preparations before dark, selecting a suitable owl perch. After building a well-camouflaged blind, Stewart prefocuses his lenses and two flash units, then suspends a loudspeaker just out of camera view. Sometimes an hour or more is required, but eventually an owl will come to rest directly above the speaker. The photographs obtained through this technique are excellent.

These tapes should not be used during the owls' nesting seasons. Owls, as well as other bird species, frequently act aggressively when they're fooled into thinking another member of their species has intruded on their territory. A bird and its mate may spend so much time seeking the intruder that their eggs or young may suffer. Some birds are intimidated by a recording of their own call and will desert their nesting territory should a tape of their voice be played.

Owl tapes work well after the owls' breeding season when there's no danger of interfering with the birds' nesting success. Your photography can suffer that short wait.

The screech owl tape is very effective on song birds. Most birds have what could best be called an enmity to screech owls, and large numbers of birds will gather to harass one when it is discovered. Outstanding results for a variety of birds can be obtained with this tape. The proper procedures to follow will be discussed in the chapter on bird photography.

2. Gray fox pup in distress. The gray fox, found throughout much of the United States, is probably the easiest of all American predators to game-call, at least between April and October.

Some excellent fox callers depart from the procedure outlined earlier on predator calling and play this tape at full volume. It's been their experience that during the summer and early autumn months, the instinct to respond is greater than the sense of caution any unnaturally loud volume should produce.

Red foxes, in contrast, are best called in by a mouth call, perhaps coaxed along with a little hand squeaking. Unfortunately, both species respond best between dusk and dawn, presenting photographic challenges that will be addressed in Chapter 16.

3. Cottontail rabbit. The screams and cries of the cottontail are useful with everything from hawks, owls, and weasels on up to cougars, bears, and wolves. For best results, this all-purpose call should be played at infrequent intervals with long silences between each sequence. Follow the procedure outlined on pages 85-86 for the best results.

4. Songbird and other bird tapes. Other than the owls, there are very few records or tapes devoted to one particular bird species. Collections of bird songs and calls are available, however, and are intended to be used as aids in bird identification.

In the past, some birders and photographers had taped selections from these records to use in the harmful practice of drawing out desired species. Some very rare birds can sometimes be lured into the open by a recording of their call. Others, however, simply slip away, intimidated by the imagined intruder. As I warned in the discussion of owl tapes, the potential harm to the bird far outweighs the need of any photographer. Please don't abuse your calling skills and your photography enthusiasm by using a

Scores of different birds will investigate the whistles of a screech owl. Unlike other methods of photographing birds in summer, this method offers little risk to the birds.

This scissor-tailed flycatcher was attracted to the Stewart screech owl tape when the loudspeaker was placed in an open pasture. It remained for only twenty seconds before satisfying its curiosity and flying off.

Red-winged blackbirds nest in colonies yet manage to defend a small area of territory. This habit can be exploited by a photographer.

By placing a silhouette decoy near a red-wing's favorite perch, the male may be enticed to come close enough for a suitable portrait. Once investigated, the decoy is usually ignored.

method that could harm your subjects. Similar (and far safer) results can be obtained by using the screech owl tape.

6. Squealing bird (woodpecker). This tape works with a number of birds in a manner similar to the screech owl tape. I've had great luck with roadrunners, especially when using a "wiggler" (page 168). It's also useful for a variety of predators, and is supposed to be especially effective on bobcats.

7. Baby javelina (collared peccary). The peccary resembles a wild pig, although it's only distantly related to one. The cries of the young of this southwestern mammal work with coyotes, bobcats, and probably cougars, as well as adult javelinas which may respond in large numbers to defend their young.

Bumping across a javelina herd crossing a road or trail is probably the best way to obtain javelina photos with this tape, provided the photographer works quickly enough. Pick a clear area for the loudspeaker, camouflage yourself, and start the tape. Results may be immediate. These large, very wild-looking "pigs" can certainly raise a photographer's pulse when snorting and squealing just a couple of dozen feet away.

8. Elk and moose. During the fall rut, these tapes can be used to attract bulls, sometimes across fairly large distances. Bulls in the rut are excitable and potentially dangerous, and it's entirely possible for a photographer to get himself into a great deal of trouble. I'd strongly recommend that you position yourself near a large, climbable tree when working with these large hoofed mammals. Because of the potential danger, a mouth call may be more practical to use, since they're far less bulky to carry if a quick escape becomes necessary. Golden Eagle Archery makes an excellent mouth call using a diaphragm and hollow tube, and although it may be difficult to learn, practice produces an excellent collection of elk sounds. At any rate, with moose and elk, caution is a most serious consideration.

There are a wide variety of other tapes, ranging from cat and mouse to crow and deer. You may wish to experiment with these as well. Undoubtedly, some of these tapes will work very well at certain times for certain subjects.

The tapes described above, however, are the essential ones. They work, and depending upon the section of the country I'm visiting, some or all of these are carried along inside my tape box.

## 4. Final Concerns

The more you know about game calling, the greater your chances of success. Current and back issues of hunting magazines frequently carry articles on predator calling, and these are an excellent source for tips that can be applied to photography. Some contain real scare stories. One that comes to mind involved a hunter who was nearly knocked unconscious when a cougar he'd called in swatted him across the back of the head. Although many of these articles involve hunting, they nonetheless convey the excitement of this interesting facet of field work.

With the possible exception of working with birds, game calling is frequently a matter of luck. The desired animal may not be present, the wind might not be right, or someone may have preceeded you days earlier armed with a rifle. Any number of factors can influence and hamper your attempts.

For best results, game calling cannot be a one-time effort. The cost of a player and tapes would discourage this, of course, but you could lose your initial enthusiasm after a couple of unsuccessful attempts. Don't. Keep trying, and when you succeed, you'll see the results were worth it.

A 200mm macro lens's 4X magnification offers a large image size while providing a comfortable working distance from this three-foot long Mohave rattlesnake in the Arizona desert.

# CHAPTER *10*

# Close-up and Macro Photography

A number of wildlife subjects must be photographed at distances inside the closest focusing point of a normal lens. There are a variety of ways to do this, ranging from simple, inexpensive close-up lenses to more costly bellows, extension tubes, and macro lenses.

Macro photography involves making film images at or near life-size. For the wildlife photographer, it opens up an entirely new world of subjects and fine detail. It's certainly one of the most neglected fields, yet it offers greater opportunity for variety than all the other types of wildlife photography combined.

## 1. Magnification Ratios

Macro lenses, extension tubes, and some zooms and telephotos frequently have a set of numbers marked on their barrels. These numbers are written as ratios (1:4; 1:3; 1:2; 1:1) and express the object's size as compared to its film image. A 1:1 ratio represents an image that's life-size. It may appear larger than life-size when you're looking through the camera, however, since the viewfinder offers some degree of magnification for focusing.

A 1:2 ratio represents a film image 1/2 life-size. The numbers in the ratio are not reversible, with 2:1 representing something far different from 1:2. When a number larger than one appears first, the film image is larger than life-size. Thus 2:1 means the image is two times life-size. Four times life-size is 4:1, while 1:4 is 1/4th life-size.

Most macro lenses focus to 1:2 by having longer than normal focusing barrels. Nearly all macros will extend to 1:1 with the addition of an extension tube. Zoom macros and some close-focusing mirror telephotos also offer magnification ratios around 1:4.

## 2. Problems

Close focusing always reduces depth of field. The extremely short lens-to-subject distances involved with macro photography shorten depth even further. Wide open, depth may be less than one millimeter. Stopped down to the smallest aperture, depth would be considerably increased but might still be shallower than many subjects require.

Obtaining depth of field is difficult with macro equipment since many of these accessories cut down on the amount of light reaching the film plane. When using a bellows at full extension, for example, 3 full f-stops may be needed to compensate for the reduction in light. Undoubtedly this would reduce depth of field too much, making it more desirable to shift to a much slower shutter speed. This, of course, has its own problems, since it increases the chances of image blur.

Large image magnifications, either produced by long lenses or short lens-to-subject distances, not only have shallow depth of field but are especially prone to blur

from movement or camera vibrations. At close distances subject movement is exaggerated, as is any vibration-induced movement in the camera. Obtaining an exact, sharp picture with macro equipment can be quite difficult.

The only practical solution to these problems is to use electronic flash. A flash's bright light permits small apertures for maximum depth of field, while its short duration freezes any motion.

When using flash, however, it's wise to mount the camera on a tripod. Not only will this eliminate any further camera movement, but it will also permit a more accurate composition and focus than a hand-held camera would. Various size extension tubes or bellow units can be used to obtain large magnifications while preserving the quality of the lens. The dual cable release mounted on the camera and bellows is required to permit automatic operation of the aperture.

### 3. Close-up Lenses

Resembling filters, these auxiliary lenses screw onto the front of a lens to provide close focusing. The distance scale on the lens no longer applies, since focusing to infinity is impossible with a close-up lens attached.

These auxiliary lenses are most common in three diopter strengths. A lens of +1 diopter increases the close-focusing ability of the lens in use by the least amount. A +2 diopter permits closer focusing, while a +3 diopter lens increases this ability the most. Diopter lenses of +1, +2, and +3 can be used alone or in combination to permit extremely close focusing distances. Individual lenses of up to +10 diopter strengths are also available, but they are far less common.

Close-up lenses are the least expensive of the macro accessories. Just one lens (or an entire set of three) may cost from ten to thirty dollars, depending upon the

Double element close-up lenses like Nikon's T series permit close focusing without the light loss common to many close-focusing accessories. Optical quality is excellent, although depth of field is shallow as it is with all close-up equipment.

manufacturer. Unlike many other macro accessories, no correction for exposure is required. This makes close-up lenses more convenient for the rare camera today that lacks a behind-the-lens meter, since a hand-held meter reading would still produce the correct exposure. Any focal length lens that will accept a screw-in filter will accept close-up lenses, although finding one beyond 72mm in diameter may be very difficult.

An advancement in accessory close-up lenses has been the introduction of an optically sharp two element lens. Nikon's 4T, 5T, and 6T lenses permit increasingly shorter lens-to-subject distances and work extremely well with zoom lenses.

Conversely, inexpensive close-up lenses can compromise your lens's optical quality. A top grade lens with fantastic resolution will produce a less satisfying image if shot through one or more close-up lenses of inferior glass quality. As with all close-up accessories, of course, depth of field is also reduced.

## 4. Extension Tubes

As their name implies, tubes "extend" the close-focusing range of a lens. Lacking any optics, these hollow tubes preserve the image quality of the lens in use. Tubes can be used with any lens to extend its minimum focus. The long 50mm tube that permits 1:1 magnification when used with my 100mm macro lens is also used with my 400mm to extend its minimum focus to approximately six feet, an ideal distance for some small birds and reptiles.

Extension tubes are generally sold in sets of three. My set offers a combined tube length of 60mm composed of 11, 18, and 36mm sections. Many macro lenses offering 1:2 magnification are sold with companion tubes to extend the focusing down to 1:1.

Extension tubes offer some inconvenience since sections must be added or removed to work varying distances. Usually the distance scale of a lens is no longer applicable and focusing to infinity is impossible.

**This black racer was photographed with an 80-200mm zoom lens coupled with a 50mm extension tube at a 1:3 magnification. A small flash mounted on Kirk's bracket provided the illumination.**

Extension tubes reduce the amount of light reaching the film. Generally there's a one f-stop decrease for a tube half the length of the lens it's paired with, but this will vary for special lenses. In natural light, determining an exposure isn't a problem with a behind-the-lens meter, but could be with a hand-held meter or when calculating for electronic flash lighting. The tubes' instruction sheet will provide the proper exposure compensation guidelines. You could also calibrate the light reduction value by metering off a gray card, first with the normal lens alone, then with various combinations of tubes. Record the exposure differences obtained in each case.

Since extension tubes come between the camera and lens, the automatic operation of the camera diaphragm or full aperture metering may be affected unless the tubes are made by your camera manufacturer. Tubes are sold in either manual or automatic sets. Manual tubes would require you to stop down the aperture to the correct f-stop prior to exposing the film; automatic sets do not. Either type can be used on both the automatic or manually operated cameras.

Focusing an extension tube can be done in two ways. The focusing barrel of the lens can be turned, or the entire camera-tubes-lens system can be moved to and fro with the lens set at infinity. On tripod-mounted cameras, this could require sliding the tripod back and forth across a floor, making exact focusing difficult. In studio conditions, smaller subjects or their bases could be moved instead.

## 5. Bellows Systems

A bellows is one of the more expensive and versatile macro accessories. Looking something like an accordion on rails, a bellows offers continuous coverage throughout its close focusing range without the inconvenience of adding sections, as extension tubes require. Like the extension tubes, the quality of the lens in use is preserved through the hollow, lens-free bellows.

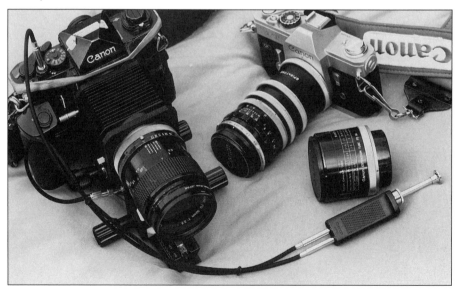

Bellows units typically provide greater magnification than do tubes, and over a continuous range. Those with automatic aperture couplings are also more expensive and heavier. Some operate only via a dual cable release, a cumbersome item to fool with when working in the field.

A bellows unit is heavier and more cumbersome than other macro accessories. The accordion-like section may be made of leather, cloth, or a synthetic material and it may puncture or rip under certain field conditions.

Bellows units also reduce the amount of light reaching the film plane. Because of the large lens-to-camera distances possible, light reduction is even greater than with extension tubes. A three or four f-stop compensation is not unusual at the higher magnifications.

Higher magnifications are possible, too. One-to-one ratios are standard, while as large as 10X is possible with special short-barrel lenses. A "short barrel" lens lacks a focusing collar and must be mounted on a bellows to be focused.

Critical focusing on a bellows is accomplished in one of three ways. Once the approximate magnification is found, focusing can be made by adjusting the lens-to-subject distance. Minor focusing adjustments can also be accomplished by changing the lens-to-camera distance, although too much will change the magnification ratio. For final, precision focusing, the entire camera-bellows-lens assembly can be moved as a single unit. In this way there is no danger of changing a desired magnification ratio. Better bellows systems have a separate rail track for this.

Bellows operate either manually or in automatic aperture systems. As with extension tubes, manual bellows require the aperture to be stopped down by hand prior to the exposure. Automatic bellows may close down the aperture via a dual cable release with one plunger attached to the shutter button and another to an aperture-operating mechanism.

A bellows system offers the same problems as other macro accessories. Depth of field is quite shallow, light reaching the film is reduced, and image blur is increased with any vibration or movement. The easiest and most practical solution to all of the above is through the use of an electronic flash.

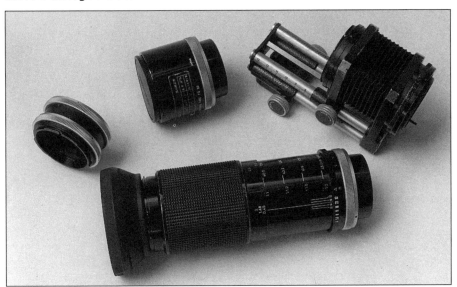

Illustrated are three macro systems. In the upper left, two tubes are shown; on the right, a Novoflex dual track bellows; and on the bottom, a 100mm lens focused to 1:2 magnification. All offer automatic exposure coupling.

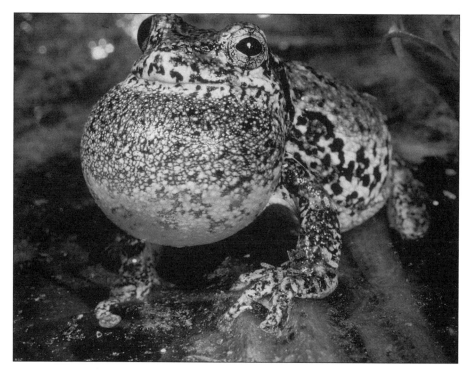

Two flash units mounted on a dual flash bracket illuminated this singing gray treefrog deep in a south Michigan swamp. I wore a headlamp to assist in focusing while my hands worked the camera and lights.

Although all three of these Canon macro lenses will focus at least to 1:2, the working distance and angles of view for each differs. For simpler compositions and more comfort and safety when filming biting or stinging subjects, choose the 200mm macro over the 50mm.

## 6. Macro Lenses

For its versatility and ease of use, I'd recommend a macro lens as a first macro accessory. Macro lenses offer all of the features of conventional lenses in addition to close focusing into the 1:2 or 1:1 range. Focal lengths vary, with typical macro lenses being 50mm, 90mm, 100mm, and 200mm in length. Long focal length macro lenses at the same image do so at an increased subject-to-film plane distance, not lens-to-subject. This provides a more comfortable 30" working distance for a 1:2 magnification ratio versus 18" for a 100mm and a mere 9" for a 50mm macro lens. This 1:2 ratio on a 50mm provides less than four inches between lens and subject, which may be close enough to disturb many macro subjects and which could be extremely hazardous to the photographer if filming rattlesnake portraits!

Macro lenses are slower than conventional lenses, but small apertures are required in macro photography and a fast lens is useless.

Many zoom lenses offer "macro" capabilities, but these rarely go beyond 1:4 magnifications. However, macro zooms do offer sufficient versatility to present the economy-minded photographer with an attractive option.

Full aperture metering and automatic diaphragm operation are standard with most macro lenses. Some do not reduce the amount of light reaching the film plane, making exposure metering and the use of higher f-stops easier.

Macro lenses are the easiest and most effective macro accessory to use in natural light, although flash might enhance many photos. Macro lenses are generally recommended for use on extension tubes and bellows to provide the sharpest image detail.

## 7. Lighting

Unless a high speed film is used, most macro photography is challenging to do using natural light. Specifically, bellows and extension tubes reduce the light enough that some sacrifice, either in shutter speed or f-stop must be made to obtain a proper exposure. Natural light is easier to use with a straight macro lens because less light is usually lost to extension. However, if the light is low, and/or if small apertures are required for maximum depth of field, electronic flash illumination may be the most practical alternative.

The advantages of using electronic flash were discussed in Chapter 7. Flash freezes movement while permitting the smallest f-stop possible. However, using just one flash can create some problems with shadows.

For macro photography, I'd suggest adopting some of the techniques described in Chapter 7. Either dual flash (using key and fill lights) or diffusion techniques offer the most practical methods to reduce or to eliminate shadows. A ring flash (page 61) is helpful for some types of macro photography.

Because of the very close flash-to-subject distances involved in macro photography, a flashmeter is useful to determine the uncorrected exposure reading. The flashmeter's suggested f-stop is then reduced to that needed, determined by the light reduction factor of the accessory in use.

For example, if two flash units twelve inches from a subject give a combined light value of f32 on a flashmeter, and a bellows was used requiring opening up the lens three f-stops, the proper lens aperture would be f11 (f32 to f22, one f-stop; f22 to f16, two f-stops; f16 to f11, three f-stops).

Exposures can also be determined by tests, but this is valid only if you'll be using a particular flash and lens combination at a fixed position each time it is used. If you plan on using a macro-flash bracket, ringflash, or flash gunstock or dual flash bracket

system, you'll be using the same combination for most of your shooting and exposures should be fairly consistent, once determined.

## 8. Basic Equipment Recommendations

I've divided this list into two sections, one suggested for a beginner and another for more advanced photographers. Photographers who foresee a great deal of macro photography may elect to use the second list as the basis of their equipment selection.

1.  Basic Equipment for Beginners:
    Camera body with behind-the-lens metering
    Normal 50mm lens, or zoom macro lens
    Extension tube set
    One flash unit with manual capabilities or TTL flash
    Tripod

2.  Advanced Equipment:
    50mm macro lens
    100mm or 200mm macro lens
    Bellows unit, preferably with automatic diaphragm control
    Two flash units with manual capabilities or dual flash with TTL capabilities
    Flashmeter
    Flash gunstock or bracket brace

**A dual lighting setup was used to capture this Arizona funnel-weaving spider. Two flashes reduced troublesome shadows.**

A 100mm macro lens was used for this ground-level portrait of a Texas earless lizard. The lizard was contained within a plexiglass studio box, but the narrow angle of view of the macro lens eliminated any distracting cage walls.

This natural-appearing barking treefrog was photographed in a home studio. Diagrams for lighting arrangements can be found on page 108.

# CHAPTER 11

# Studio Photography

Some animals are secretive, spending their time beneath rocks, soil, leaf litter, or other cover. Others are extremely wary and flee at the first sign of disturbance. Some are extremely small, yet are difficult to observe close up. Many common animals may practice unusual behaviors difficult to observe in the field.

For these reasons, you may be required to bring your subjects indoors to photograph under controlled conditions. Doing this should not be an excuse for avoiding the difficult or unpleasant aspects of some forms of field work. Instead, it should be done as a worthwhile way to obtain photographs and document activities nearly impossible to do in the field. Quite realistic-looking work is possible in studio, provided a number of precautions are followed. I doubt if this matters to the animal, if it is kept safely and comes to no harm. However, it certainly can make a difference in the photography. Although everyone would like to photograph wildlife in the field, some animals may require a studio setup to achieve usable results.

In this chapter I'll offer a number of suggestions for both in-field and home studio set-ups. However, I would recommend doing as much as possible in the field, where both props and subjects are found, and where the animal can be released as soon as the photography is complete.

## 1. Precautions

Whenever a wild animal is disturbed or handled, there's the danger that some harm could come to it. It is the responsibility of the photographer to see that his animal subjects suffer no ill effects through their temporary association with him.

In the chapters that follow on photographing various types of animals, studio tips and general precautions are made when applicable. These sections should be read with special care by any photographer thinking about handling wildlife. Improper technique or ignorance can injure or kill an animal. Any photograph isn't worth that price.

## 2. Field Studios

If possible, work with your subjects in the areas you find them. There are advantages to this. There is little if any preparation of habitat required and the subject can frequently be left undisturbed until a few moments prior to shooting. The animal can be immediately released when finished, so no concern for its welfare is needed.

To aid in some types of field photography, I've constructed a "studio box" made of plexiglass. This trapezoidal box can be placed practically anywhere, confining subjects up to the size of chipmunks to an area of approximately three feet square. That's generally large enough to include small plants, rocks, logs, or other features of the habitat. A rectangular opening in front permits the entry of the 100mm macro lens I use in conjunction with the box. For fast-moving animals, I place a black cloth that slips

into a frame that borders the opening. A slit is made in the cloth just wide enough for the lens.

A less expensive version that's occasionally useful is made by removing the front and back of a cardboard box. Escape routes are limited to two directions, or just one if a pane of glass is placed in the rear. "Habitat" props must be positioned inside the box. I've found this make-shift version helpful on trips where it can be set up on top of a desk or table.

### 3. Home Studios

Keep a home studio set-up as simple as possible. I use a table-type arrangement in the center of a room. The size of this "table" varies with the subject. For smaller subjects (insects, salamanders, and small reptiles), I use a 2' x 2' plywood sheet. Larger reptiles and some mammals require a 5' x 5' platform. The area around the table should be fairly clear on at least three sides for positioning the camera and flash units and to give you some room to maneuver or to chase after uncooperative subjects.

Some animals move very quickly and must be confined in some way. Frogs and some fast-moving salamanders may dart off a table and onto the floor before being recaptured. There they can pick up lint, dust, or hair that will cling to their moist skins and ruin a photograph. To prevent this and to provide for an easier recapture, I may photograph amphibians over a bathtub filled with an inch of water. The moist-skinned amphibians benefit from an occasional dip and remain free of debris while doing so. Small mammals are far more difficult to recapture. To prevent mice, shrews, or weasels from escaping, I use another version of the "studio box" (see illustration below).

Like the cardboard "studio box" described previously, this wooden structure is open-ended both front and back. Plexiglass sheets can be placed on tracks; one large

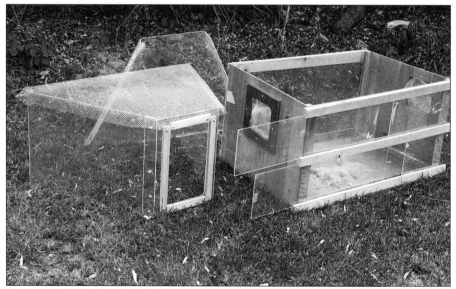

**Two types of "studio box" described in the text are illustrated. The plexiglass model on the left is ideal for many field situations. The larger wooden version permits small mammal photography indoors.**

sheet makes up the back end of the box. The front has two tracks to permit either the top or the bottom section to open independently. The plexiglass for the front is over-size, and extends a number of inches out from both sides. I've cut each section off-center so that a lens can be inserted anywhere along the track. Unless an animal leaps through the space directly above the lens, it is safely confined inside.

Larger animals may require an entire room for a proper studio set-up. Caution is necessary, however, for even a "pet" wild animal may become confused and panic when placed in an unfamiliar situation. The animal may move about with such energy that a normal room would be left in shambles. For larger animals, the room should be clear of everything but the essential camera equipment and props to prevent unnecessary damage or harm to the animal.

## 4. Props

Effective studio re-creations of an animal's habitat should be as simple as possible. Actual habitats may be filled with hundreds of objects - rocks, logs, vegetation, etc., but when an animal is isolated by a longer focal length lens, relatively little of this may appear within the picture area. In studio photography, the subject should appear "wild," yet do so without adding elements of confusion or clutter to the photograph. For example, the presence of an entire pine tree can be implied by the use of one thick branch within the picture area.

Simplicity is the key. It is important, however, that the scene look natural, not barren and artificial. A good studio photograph should be indistinguishable from one taken in the wild, although the studio example may be "cleaner" (free of obtrusive elements that could detract from the subject).

I've used this technique in nearly all of my studio set-ups. When photographing a tarantula in my studio, a mixture of stones, small rocks, sand, and dirt was spread across a small 2' x 2' table. A cholla cactus skeleton and some larger rocks form the scene's background. Pieces of twig and dried grass were dropped haphazardly across the area, giving a natural appearance simulating a desert floor.

The barking tree frog on page 104 is another example. It is a simple photograph composed of a frog on a branch, with a few leaves draped in the background. A sketch of the mechanics of the photograph reveals its simplicity.

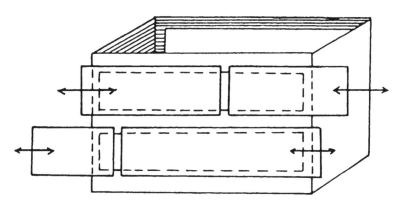

**The studio box is an effective way to both detain and photograph small subjects like mice, shrews, and other small mammals.**

A simple arrangement is always best, even with animals that live in a confusion of growth. The meadow vole, or meadow mouse, lives among grass roots and stems, a veritable jungle from this little rodent's point of view. This "jungle" can be implied from the vole's level by uprooting a few thick grass tussocks and positioning them inside the studio box. Hopefully, these few examples will enable you to form ideas of your own. There are as many techniques and arrangements as there are subjects. It only requires you, the photographer, to study an animal's habitat and discern the key elements. By placing these in a studio set-up, a realistic re-creation of the habitat is accomplished.

## 5. Posing the Subject

The position, attitude, and appearance of the animal is extremely important. The animal must look alert and alive, not sleepy or fearful. An animal confined to a cage may soil itself, therefore it's important that it be groomed prior to any photography. I've already mentioned the problem of fuzz or lint adhering to an amphibian's moist skin. This can also happen to reptiles, with material sticking to the spaces between scales. A careful visual inspection of a specimen prior to looking through the camera viewfinder will eliminate this problem.

Some animals hunch down into obvious defensive postures when they feel threatened. Herptiles (the reptiles and amphibians) frequently do this. A bit of coaxing may be necessary to perk up the animal. Sometimes gentle probing with a finger or light pole is necessary with herptiles to elevate the head to a natural position. Birds and mammals may look sleepy or bored when confined, but making a few odd noises or quickly moving your hand may bring them to temporary alertness.

I've had little problem with aquarium subjects and arthropods (the joint-legged animals like spiders and insects) as long as they remained healthy.

Sometimes it's very difficult to capture a natural-looking pose. Attitudes may look good through the viewfinder when you're preoccupied with arranging lights and focusing, but may look just the opposite when the film is developed. You must be able to recognize a natural pose.

To be able to recognize a "good" pose, it's important to have a definite idea in mind. Ideally, you should anticipate the particular look, pose, or posture that you hope to capture on film. You might not end up with what you had anticipated, but in having that awareness, you will be attuned to recognizing an excellent shot when it's offered.

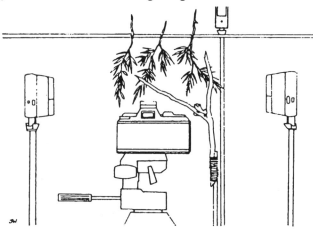

*"For larger animals, the room should be clear of everything but the essential camera equipment and props to prevent...harm to the animal."*

Patience is important, and good photographers wait for those times and opportunities; all too frequently the novice or the less talented photographer does not.

It certainly helps to familiarize yourself with examples of the best wildlife photography and the poses and compositions used. Nature magazines are excellent reference sources, as are some of the large coffee table books.

There's probably no better way to obtain a "mind's eye" picture of an animal than to observe it. For some animals this can be done in the field, but for others this must be done in captivity. On several occasions prior to a photography session, I'll study the animal for varying lengths of time. The animal grows accustomed to me and loses its initial fear while I make mental or written notes on various poses and behaviors. Sometimes an animal will do something especially striking, and although the camera wasn't ready, I'll know the animal could repeat that action. With that in mind, I can wait for the animal to oblige me when I am prepared, and sometimes it actually will.

### 6. Backgrounds

The background in a studio photograph is particularly important. If it looks artificial (as forest patterns in many commercial portrait studios do), it will be viewed as such.

Small diurnal (daytime) animals should be "framed" against their surrounding habitat. This is far more convincing than trying to recreate a sky-line effect. Rocks, logs, vegetation, or a combination of the three can be used to imply that the habitat is sweeping into the background. This is easiest to do if the camera lens is slanted downward, rather than attempting a photo from the subject's level. For nocturnal (night-active) animals, the easiest background to use is a black cloth. Care must be taken that a flash doesn't strike the cloth, otherwise the background will appear gray.

Don't try to recreate a blue sky. It rarely looks real and is usually easy to spot as artificial.

Some animals will not adjust to captivity or studio conditions. Every individual is different and even members of the same species will vary in their amount of cooperation. If the animal is hyperactive, don't subject it to stress with continuing attempts at photography. Release the animal and collect another. You'll be surprised at the tremendous difference in "personalities" shown by "simple" salamanders or lizards!

### 7. Lenses

Certain focal lengths are better for studio work than others. Small, close-focusing telephotos or macro equipment are preferable because of their limited angle of view. Normal 50mm and wide-angles are less practical because their large angle of view may create difficulties in excluding extraneous objects from the background.

Ideal studio length lenses range between 80mm and 200mm. A zoom covering these focal lengths would be ideal, especially if it has close-focusing capabilities. Depending upon my subject, I use either 100mm or 200mm macro lenses. These small telephotos offer a pleasing tightness of composition that makes creating a natural looking habitat much easier.

## 8. Lighting

Natural or artificial light can be used in the plexiglass studio box when it's used outdoors. I prefer natural light with this box since I can see any reflections on the glass and deal with them immediately. The Texas earless lizard on page 134 was photographed in this manner.

Inside, where most studio set-ups will occur, photographers have a choice of photo flood lamps or electronic flash. Flood lamps should not be used because of the excessive amount of heat they produce. Animals will quickly grow uncomfortable under a flood light, and cold-blooded animals could die. Flood lights are especially dangerous with amphibians because the heat could desiccate them.

Electronic flash is the only practical method of illuminating animals in the studio. It offers no problems with heat, and once the lighting techniques outlined on pages 64 through 67 are mastered, the flash can do exactly what you expect of it.

Sometimes there is a tendency to use more flash units than are necessary. That's all right for illuminating backgrounds, but it is not for illuminating the subject's head if that is facing the lens. No more than two light sources should be visible as reflections inside the animal's eyes. If there are, it will look unnatural. Magazine editors routinely discard such photos.

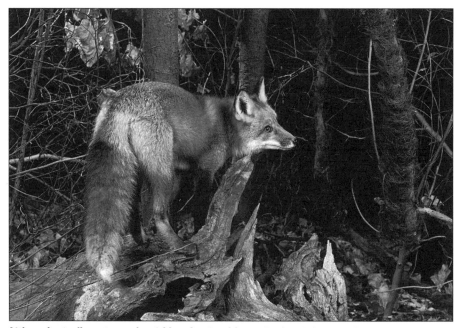

Although studio setups should be simple, this set looks elaborate. A large tree stump, branches, and 7' sections of dead snags suspended from open beams of a garage were the key props to recreate a forest environment.

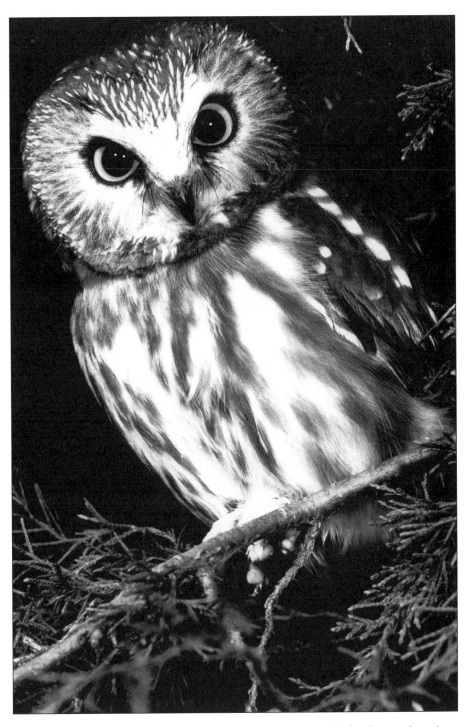

Nocturnal birds are fairly easy to shoot in the studio because the background can be dark. Using strong backlighting helped to create the illusion of sunlight streaming onto this owl's shaded perch.

## 9. Equipment Useful for Studio Photography

1.  Basic Essentials:
    SLR camera body
    A close focusing 80mm to 200mm zoom telephoto or 100mm macro lens extension
        tube set or 2-element close-up lens
    Electronic flash
    Tripod

2.  Advanced Accessories:
    200mm macro lens
    Two or more electronic flash units with manual TTL capabilities
    Flash meter
    Light stands to mount flash units upon
    Dalebeam (see page 128)

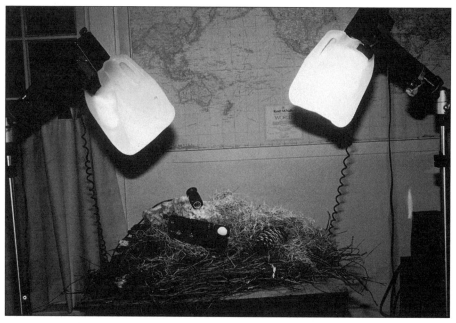

**Table-top studio setups are easy to make and offer the photographer the conve-
nience of working in a standing position, not stooped over or lying down. The plastic
milk containers are an inexpensive way to scatter light and diffuse shadows that can
be caused by flash.**

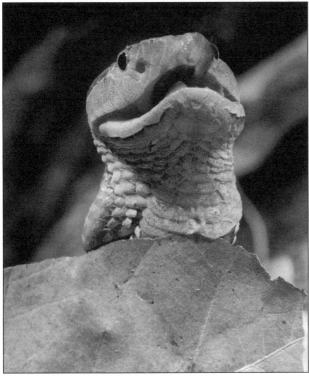

Working with an animal in the studio gives the photographer a chance to study and to attempt to capture on film behaviors difficult to record in the wild. This copperhead was relaxed enough to kill and swallow a mouse 15" in front of my lens. The close-up in the second image is the mouse's tail, not the snake's tongue!

# CHAPTER 12

# Aquarium Photography

The most practical method of photographing fresh-water aquatic animals is under studio conditions. Outstanding photographs are possible in the field, of course, provided that the water is clear and the camera is protected by an underwater housing. This involves such specialized gear and considerations that it will not be included within the scope of this book. Marine environments, in contrast, often provide clear, shallow water and a diversity of subjects demanding location shooting that in-field shooting would be the rule, not the exception. Specialized gear, be that underwater housings for traditional cameras or special amphibious cameras like Nikon's Nikonos, would be required.

A wide variety of subjects can be photographed inside tanks ranging in size from tiny 2 ounce mini-tanks you can make yourself to giant 55 gallon aquariums. These subjects may range from tiny organisms like daphnia (water fleas), mosquito larvae, fairy shrimp, and aquatic insects accommodated by the mini-tanks to hellbenders, game fish, or turtles in the larger tanks. Opportunities are nearly endless, with a wide variety of frequently overlooked subjects to be filmed.

**The larvae tiger salamander was photographed in an aquarium using a setup similar to that illustrated on page 118.**

Relatively few photographers delve into this subject. For this reason alone it's worth exploring further, since the potential for uniqueness is readily available for those who wish to pursue this aspect of photography.

## 1. Problems

Many problems can arise in aquarium photography. Some of them include reflections on the aquarium glass, murky water, and subjects that swim in an erratic manner so that accurate focusing and framing seems impossible. Fortunately, each problem can be solved, making this no more demanding than any other aspect of photography.

## 2. Reflections

Glass can reflect anything before it, although that's usually limited to the shiny parts of the camera, the photographer's rings or wristwatches, and the light from the flash.

Polarizing filters eliminate reflections by restricting the light passing through the camera lens to a single plane. This decreases the exposure, since less light reaches the film. An underexposure would occur if the aperture was determined by the flash-to-subject distance alone, since the "filtering out" of much of the subject's light by the polarizing filter is not considered in this method.

Using a gray card will help determine the correct exposure. The card is held in front of the aquarium and a meter reading is taken without the polarizing filter in place. A bright light (such as the beam from a slide projector) may be required to obtain sufficient light indoors to activate the meter. Record the f-stop, turn off the light, and place the polarizing filter on the lens. Remove the gray card from the front of the

**Polarizing filters have many uses. In the field, of course, they will accent clouds against a blue sky. In studio, a polarizer will eliminate reflections upon glass in aquarium photography.**

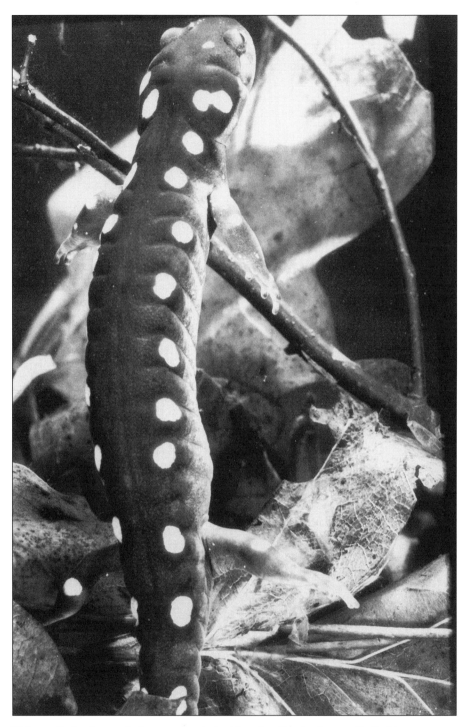

This spotted salamander's movements inside a 5 gallon tank were limited by a second pane of glass two inches behind the first. The leaves present in the background were actually behind the second glass.

aquarium and rotate the filter until all reflections on the glass have disappeared. Without touching the filter, reposition the gray card in front of the aquarium again, turn on the light source, and take another exposure reading. A smaller f-stop will result. The difference between the two f-stops is the light reduction value caused by the polarizing filter. It's important that the filter is not turned further, since this will affect the light reduction value. Once this value is determined, however, the lens can be opened up the required number of f-stops after the flash-to-subject distance is checked. It's not uncommon for a polarizing filter to require opening up a lens 1 1/2 to 3 f-stops, and for this reason, short flash-to-subject distances or more powerful flash units should be used.

Another way to eliminate reflections is to place a black cloth screen between your camera and the aquarium. Make a slit in the middle of the screen for the lens. Although effective, this method can be cumbersome since the photographer may have to move around the screen whenever he wishes to adjust a light or move a specimen.

Using both methods together virtually guarantees an absence of reflections on the film. For serious aquarium photography, you may wish to employ both techniques at the same time.

## 3. Water Clarity

Clear water is essential for crisp images. Silt or mud floating through the water will soften an image to the point where it literally disappears. These particulates can come from a number of sources. The water may have been dirty, even though a superficial inspection had not indicated this. Sand, gravel, or stone used to line the bottom of the tank can cloud the tank when water is added. Plants, rocks, or other items added to the tank will also have the same effect.

To obtain clear water, collect if from a clean source. For the health of the specimen it should come from the area where the animal was collected, although with aquatic turtles and some other animals this isn't necessary. If the water is turbid, set it aside in a spare tank for a few days. After the particulates settle, the water can be transferred by siphoning or careful bailing.

As I mentioned previously, gravel or stone can cloud a tank. Prewashed gravel available at pet stores eliminates most of this problem, but the gravel rarely appears natural. River stone, found below most small riffles at any stream, looks natural but is very dirty. A number of rinses may be necessary to thoroughly clean the stone of silt and mud. All props should be washed before being placed inside the aquarium. This step can be eliminated, however, if the props are placed behind the tank. In the finished photograph, it's impossible to tell whether it's inside the aquarium or not, provided that the props receive sufficient illumination.

## 4. Limiting Movement

Aquatic organisms can move virtually anywhere. They may move in any direction so rapidly that photography seems impossible. It's fairly simple to limit some of this movement. Although little can be done to control vertical or horizontal moves, the subject can be confined to a relatively small area of depth. This is accomplished by slipping a thin pane of glass inside the aquarium behind the front glass (see illustration, page 118).

Buy a pane that's only a millimeter or two smaller than the inside measurements of the aquarium tank. Most aquariums today have plastic frames that overhang the tank's interior. Notches can be made in this frame with a small saw at widths just

slightly larger than the animal. A number of notches can be cut to accommodate specimens of various sizes, or two panes of glass can be used at once to contain more than one specimen in different portions of the tank. These partitions, as well as the front of the tank, must be completely free of lint, dust, or water spots in order to obtain a crisp photograph.

Vertical movement is more difficult to limit. A glass rod or a dowel can be used to prod an animal into the approximate area, although there's no guarantee it will remain there. A better solution is to patiently wait until the subject moves into the proper area. With electronic flash, a tripod-mounted camera isn't necessary, and some authors recommend hand-holding the camera for flexibility. I prefer to use a tripod with the pan and tilt controls kept loose. This permits easy movement over a limited area with little chance of changing the polarizing filter's setting in relation to the glass.

## 5. Lighting

Electronic flash is the only practical light source for most aquarium set-ups, since small apertures are possible and subject movement can be stopped.

Positioning the flash in front of the glass is important. For best results, there should be approximately 45 degrees between the path of the flash's light beam and the front of the aquarium. In this way, any bounce-off will be directed far out of camera range. The flash unit cannot be mounted on or close to the camera, since direct flash would reflect off the aquarium and back into the lens, spoiling the photograph.

Aquatic subjects are illuminated from above in nature, and over-head lighting should be used in studio. For even, natural-looking light, fill-flash should be used to illuminate the sides of the subject facing the camera, otherwise a light directly overhead will produce unnaturally dark shadows. The flash can be positioned above the tank by means of a studio lightstand (see illustration), a tripod, or even by simply resting a flash lens downward upon a pane of glass covering the tank. If the flash is angled slightly towards the rear, any objects placed in the background will be lit as well.

I like to use three flash units in aquarium work. With a unit on either side of the camera as well as above the tank, I'm assured of even front fill-in lighting regardless of the position of the subject.

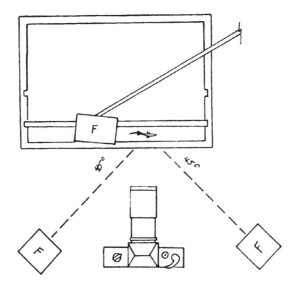

## 6. Determining Exposure

Flash units must be placed on manual with the exposure calculations based upon the flash-to-subject distances. Usually, the overhead flash will be closest, and it will be this flash that determines the required distances for the fill-in flashes. For the most natural effects, there should be a 1/2 f-stop difference between the key (the overhead flash) and fill lights. You may have to run a test roll to be sure. The aquarium glass, water and suspended particulate matter will all reflect (or absorb) some light and you may lose a half f-stop in a five gallon tank of 'clear' water.

If the flash units have equal guide numbers, then the fill lights should have a slightly longer flash-to-subject distance, unless they are equipped with variable power ratios. I like to use more powerful units for my fill lights, maintaining the necessary balance by positioning them much farther away from the subject than for the key light. This greater distance provides more even fill-in coverage.

One flash alone used in front lighting at a 45 degree angle will produce satisfactory results. TTL flash systems are perfect for this, since the sensor will determine the correct amount of light regardless of the presence of a polarizing filter. More natural lighting, however, occurs with multiple flash setups.

Always record your flash exposure calculations and the position of the units. Bracket for safety and record the flash-to-subject distances, the various f-stops, and any accessory used. By doing this, a workable system will be developed that can be used in the future.

## 7. Suggested Equipment for Aquarium Photography

SLR
100mm macro or equivalent medium focal length lens with close focusing abilities
Polarizing filter
Tripod
Gray card
Two or three electronic flash units (manual mode)
Slave units
Light stand
Aquariums of various sizes fitted with plastic frames
Thin glass panes for inside tank

Don't overlook the commonplace as you seek more exotic creatures. It's a sad fact that very few photographers take the time to work on backyard robins, gray squirrels, cottontail rabbits, or even earthworms, but such subjects are as interesting and exciting as any lion, tiger, or bear!

# SECTION IV
# THE WILDLIFE

The dual flash holder, page 58, proved perfect for shooting this seventeen-year cicada as it completed its metamorphosis to a winged adult.

# CHAPTER *13*

# Insects and Other Arthropods

An arthropod is a joint-legged animal possessing a hard outer shell (exoskeleton) and lacking a backbone. This group comprises the most abundant organisms on earth. Insects, the six-legged members of the arthropods, number at least one million species, and it is entirely likely that there are ten times that many. Other familiar members include spiders, crustaceans like crabs and lobsters, and the multi-segmented and multi-legged centipedes and millipedes.

With such a varied group, opportunities for photography are virtually limitless. Arthropods can be photographed in the field or in studio, but because of their small size, either method presents unique challenges.

To simplify the reading, I'll refer to insects rather than use the stuffy term "arthropod" when referring to the group. The information, however, can be applied to all in most situations.

## 1. Equipment

Macro photography is generally necessary, although with larger species, lenses of 1:3 and 1:2 magnification can be used. To avoid redundancy, I suggest you review the

**Photographed at the spider's level, this studio photograph was made with three electronic flash units and a 100mm lens.**

discussion of equipment found in Chapter 10. Flash is helpful for subjects of all sizes, although natural light and medium shutter speeds can be used with tripod-mounted cameras for some larger subjects like lubber grasshoppers, ghost crabs, and others. These typically move more slowly than do the smaller varieties.

Even relatively skittish dragonflies, damselflies, and butterflies are approachable at dawn, especially if the night was chilly. On clear nights a dew may settle, and your insect specimens may be covered with a mantle of jewel-like dew drops. Very slow shutter speeds are possible in the dim early morning light, provided a tripod is used and the camera mirror locked up to prevent vibrations. Work fast, for within an hour of dawn the warming temperatures, evaporation of dew, and the first day's breezes will make slow shooting almost impossible.

## 2. Finding Specimens

It's not necessary to travel far to locate insects. There'll be a few thousand species in any nearby field. Sharp eyes and patience, or the use of either a light aerial net or a heavy muslin sweep net will provide enough specimens to keep you busy for years. Nocturnal insects are easy to collect by stretching a white sheet out on a line and illuminating it with a flashlight or lantern. Insects will be attracted to the light and come to rest upon the sheet.

A couple of good field guides will not only identify species, but will also provide valuable information on natural history and collecting methods. Since the variety is so large, it's wise to limit yourself to a couple of groups for starters. In that way a few techniques can be developed and mastered without overwhelming you.

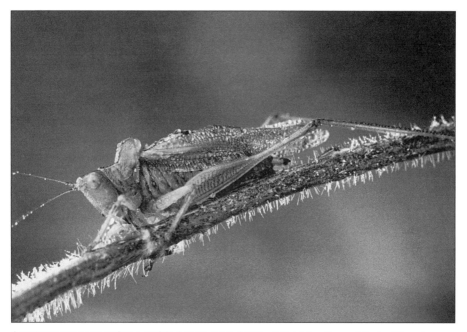

A 200mm lens set at f11 provided sufficient depth of field for the subject without providing detail in a distracting background. Within a few minutes of this exposure the sun rose sufficiently high to create a wind, making a slow exposure with natural light impossible.

*"Even relatively skittish dragonflies, damselflies, and butterflies are approachable at dawn, especially if the night was chilly."*

## 3. Field Photography

Field photography is the most practical and preferred method for such insects as bees, wasps, butterflies, and dragonflies. Working in the field provides many opportunities to include colorful vegetation in the picture. Butterflies are best photographed in this way. A short telephoto with extension tubes, or a macro 200mm, will permit fairly large images without alarmingly close lens-to-subject distances. In contrast, small insects are quite difficult to work with in the field. The magnifications required make problems with movement nearly unavoidable. This movement can be caused by the insect, the wind, or the photographer, and can cause ruinous blurs.

Excellent quality is possible with the larger insects (such as those mentioned above) with 100mm and 200mm macro lenses in conjunction with flash equipment. Flash can be used to create needle-sharp images without black backgrounds, provided that a balance is struck between natural illumination and the flash. To do this, take an exposure reading with the camera set at 1/60th or the fastest synch speed possible with your camera. Noting that f-stop, find the one required for the flash-to-subject distance. Usually the two f-stops won't match and provisions must be made to reduce the flash's output to more closely approximate the value of the natural light. This is easy with a variable power ratio, since the unit can be dialed down to the necessary f-stop. If the flash lacks a power ratio, diffusion material may be necessary to reduce the unit's intensity. Bracketing would be required under those circumstances.

To prevent ghost images caused by a moving subject, the flash and the natural illumination's f-stop should not be identical. The flash should overpower the natural light by approximately 1/2 to 3/4 of an f-stop. The flash-illuminated subject will appear brighter, giving the photo some snap while bringing out the insect and separating it from the background. This technique is best used on windless days, however, because of the slow shutter speeds necessary with most flash-synched cameras.

## 4. Studio Photography

Working under controlled conditions in the studio has definite advantages when photographing insects. Not only can lighting be controlled, but annoying problems like wind-induced movement can be eliminated. Uncomfortable ground-level work isn't necessary if a small table is set up at a comfortable height and a habitat is constructed.

The narrow angle of view and the extremely shallow depth of field produced by macro equipment makes composition simple. Backgrounds do not have to be elaborate, frequently being little more than a few sprigs of vegetation set far enough back so that they remain out of focus.

High magnifications are possible in the studio since vibrations, movement, and other factors that could cause image blur can be controlled. Flash is required to insure depth and to freeze all movement. A tripod is another necessity for high magnification work.

I'd also suggest using a flashmeter to check on your exposure calculations. Then adjustments can be made for the light reduction value of the macro accessory in use. Very often the flash units will be closer than the minimum two or three foot distance setting on their manual exposure calculator dials. Without a flashmeter, exposure must be extrapolated (which can be very inaccurate), or determined by dividing the guide number by the flash-to-subject distance (page 52). In either case the true value of the light can be more easily determined when a flashmeter is used.

## 5. Props

The insect's natural habitat should be duplicated as simply and accurately as possible. Because of the shallow depth of field, frequently just one prop may be required to simulate a natural scene. Stephen Dalton's photographs of flying insects, which appeared in his books *Borne on the Wind* and *Caught in Motion*, are excellent examples of simple studio set-ups that are visually appealing.

To illustrate, I've photographed larger arthropods like fidler crabs on a table-top measuring 18" x 18", using some mud and a dozen stalks of rotting marsh grass as the habitat. A fast-moving ghost crab was taken in a similar situation using some sand and a few chips of shells to recreate a beach scene. I've already described the tarantula photo's preparations in Chapter 11.

Live plants make excellent props. It's not necessary to uproot and replant vegetation in the studio, since it would probably die anyway. Instead, simply place the plant in a jar or bucket of water to keep it fresh for a few days.

As I stressed in Chapter 11, it doesn't matter what a set-up looks like as long as it produces the proper results. A table top covered with plants sitting in coffee jars may look odd, but it may be just the trick for obtaining the photographs you need.

This crab spider was illuminated with a single flash supported by a Kirk flash bracket. The close working distance between flash and spider reduced shadows that may have otherwise contrasted with the spider's legs.

## 6. Single Flash Photography

Because of the close flash-to-subject distances involved, one electronic flash can be used in insect photography. The lighting should be diffused or bounced, however, since these techniques soften and reduce shadows, especially if you're using a flash more than two feet from your subject. The direct light of a distant flash functions just like the sun to produce sharp shadows that resemble extra legs. If your flash is within two feet of the subject the flash's intensity will be scattered, casting increasingly softer shadows as flash to subject distance decreases.

Automatic flash can be used, provided the flash sensor remains pointed at the subject and the flash set for a particular f-stop. In that way, the lens aperture can be adjusted to compensate for any light reduction value from the macro accessory used. Off-camera flash and remote sensors are easier to use this way.

TTL flash can work very well, provided that the flash's sensors will work within short flash-to-subject distances. There's also the danger that a hotshoe mounted TTL flash will miss, firing above the subject. This is very possible when using a 50mm lens. Off-camera flash may eliminate both problems, since the flash could be held at the minimum working distance.

## 7. Controlling the Subject

Flying insects can be a problem in the studio. Unless you intend to photograph them in flight, you'll probably prefer that they remain relatively still.

Insects are cold-blooded, and they can be placed inside a refrigerator to cool down. This makes them torpid, and they may appear lifeless. For this reason I avoid this technique.

Flying insects can be contained within a workable area by using the plexiglass "studio box" described on page 96. Because of the size of the box, the electronic flash units must be positioned on the outside, although this produces no problems once the glass walls are checked for light reflections.

For additional control, the insect may be kept beneath a jar within the studio box until a few seconds prior to shooting.

Securing the insect beneath a jar works with other arthropods as well. A baby food or peanut butter jar would be large enough for most specimens. Equipment can be set up, lenses focused, and flash-to-subject distances checked while the animal is safely confined "on site."

Of course, there's no guarantee that when the jar is lifted the insect will stay. It may require a number of attempts before you obtain exactly what you want.

## 8. Flying Insects

A flash or camera triggering device is now available that will permit capturing a subject at a precise instant. The device, called a Dalebeam, is the size of a cigarette pack. It operates camera or flash when an infrared light beam (it can also be triggered by sound) is interrupted.

When an insect (or other animal) breaks the infrared beam, an electrical impulse fires the camera and/or flash. Although one Dalebeam can be used, this would require a little more preparation and specimen control than if two are. With two Dalebeams, the infrared light beams can be pointed to intersect at a spot where the camera lens is focused.

Hopping or flying insects can rapidly travel the short distance covered by the camera's depth of field and angle of view. A flying insect might pass beyond the

intersection point by the time the camera shutter opens. To eliminate this, keep the camera shutter open by setting it on Bulb or Time. When the insect breaks the light beam, the flash will expose the picture. Of course to do this, the photography must take place in a darkened room. A very faint red light could be used to see by for very short periods, provided the lens aperture is set to its minimum opening.

You could wait a very long time for a flying insect to haphazardly cross the point of intersection of two light beams. To increase your chances of this happening, a flight tunnel should be used. The insect is released at the bottom of the tunnel, which is then blocked to prevent its escape. The only exit is at the other end where, hopefully, the insect will choose to fly, not walk, out. The tunnel should be wide enough to provide the insect with enough room for flying, but not so wide that controlling the direction of the flight path becomes difficult. A tube from a paper towel roll is large enough for most varieties. Clear plastic tubing of various widths can be used for a variety of insects. It's sold by the foot and can be purchased at any hardware store.

Don't be disappointed if your subject decides to walk, rather than fly, the length of the tube. Repeated attempts may be necessary before the insect flies in the proper direction to intersect the beam.

For best results, manual flash units with variable power ratios should be used. At low power the light is emitted at short durations. The Sunpak 544 or 622, for example, flashes at 1/20,000th of a second, which is fast enough to freeze most insects in flight.

A small aperture could be used when the flash is positioned close to the subject. This is important in order to achieve the greatest depth of field, since there's no guarantee which part of the insect will intersect the light beam.

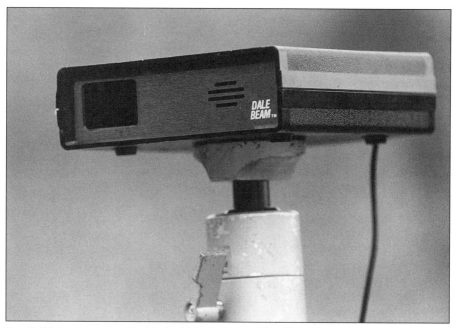

The Dalebeam is an invaluable tool for photographing flying insects and other seemingly impossible to capture subjects. It can be set to trigger a flash when a subject breaks an infrared light beam.

Dalton's classic insect photographs show what can be done. It's possible for you, too, provided you have the equipment and patience. Dalton exposed hundreds of frames on some insects before he captured what he wanted, and although you can achieve outstanding results, don't expect to do so at the cost of only a few rolls of film.

Dalebeams are available through their manufacturer. They can be ordered by contacting:

Protech
5710-E General Washington Drive
Alexandria, VA 22312

## 9. Suggested Equipment for Insect Photography

1. Basic Essentials:
   SLR camera
   80-200mm zoom with closeup or extension tubes
   Extension tube set
   Manual flash unit or TTL flash
   Tripod

2. Advanced Accessories:
   100mm macro lens
   200mm macro lens - for butterflies
   Bellows
   Two or more manual flash units, or TTL flashes with appropriate cables
   Dalebeam (one or two)
   "Plexiglass studio box"
   Slave units for each additional flash

Photographs of venomous reptiles have a strange appeal, perhaps due to the danger supposedly involved. A responsible photographer, however, should equally consider his safety and the well-being of his subject when photographing.

# CHAPTER 14

# Photographing
# Reptiles and Amphibians

Reptiles and amphibians are similar in many ways. They share superficial resemblances and are often considered collectively as a group called the herptiles.

Reptiles are dry skinned and scaly, and most species spend the majority of their time on land. Unlike amphibians, reptiles are not tied to the water for reproduction. Familiar members of this vertebrate class in North America include alligators and crocodiles, turtles, snakes, and lizards.

Amphibians have smooth or moist skins. Most cannot tolerate dry conditions for more than a few hours and require water for reproduction. Many amphibians undergo a metamorphosis from an aquatic to a terrestrial form. Salamanders, newts, frogs, toads, and treefrogs comprise the common North American representatives of the class.

## 1. Finding Herptiles

Herptiles are secretive. For the average person, encountering one may be limited to listening to the sound of a frog splashing into a pond or seeing a snake slither across a path or road. Reptiles, at least, are intelligent enough to be truly wary and can be quite difficult to find.

**Treefrogs, like this spring peeper, are relatively easy to discover when calling at their breeding ponds in spring. Some individuals are remarkably tolerant of a flash firing only inches away and will continue to call despite that disturbance.**

Amphibians are not as elusive, but because of their shy habits they must be uncovered from their many hiding places.

Some generalizations for discovering herptiles can be made. Most salamanders are found beneath rocks or logs or in large groups at their breeding ponds. Frogs and toads are most commonly seen at night. They can be located near water by spotting the reflection of their eyes in a flashlight or headlamp beam. They are most abundant during breeding, when males vocalize to attract mates.

Amphibians are best handled with wet hands to prevent any injury to their delicate skins. They should be kept cool and moist. An ideal temporary container for most amphibians is a jar padded with a few layers of damp paper towels. Some amphibians are completely aquatic and must be maintained in a water-filled container. The water should be aerated either by means of a pump or by periodically blowing air in through a straw. Reptiles should be kept warm (75-85 degrees Fahrenheit) and dry, unless the species is aquatic. Although reptiles bask in the sun, they nevertheless regulate their body temperatures by moving into the shade whenever necessary. Captives exposed to direct sun even for a few minutes may overheat and die. For this reason, reptiles are best kept in a warm but shaded area. A cloth sack (such as a pillowcase) that can be tied into a knot is a good temporary container for snakes and lizards. Turtles require a box or bucket because of their powerful clawed limbs. Poisonous reptiles should be left in the field. Amateurs with little experience with these potentially lethal animals may risk disaster. Most snakebites in this country are the fault of the victims, and many of these result from people attempting to touch the snake in some way. Although bites are rarely fatal, they can be excruciatingly painful.

Alligators and the very rare crocodiles should be treated with the greatest respect.

**A 300mm telephoto lens was used to obtain a large image size of the normally wary red-eared turtle.**

A bite from either could cause serious injury; a lash from their powerful tails could break a leg. They should be photographed from a safe distance using longer than normal lenses.

Lizards are commonly seen sunning, although their camouflaged patterns make them difficult to see until they dart for cover. Many can be captured by slipping a noose attached to a long pole or fishing rod over their heads. Snakes may be found sunning but are more frequently encountered beneath cover. When hunting for snakes or other herptiles, always return rocks, logs, and other shelters back to their original positions. Looking for specimens is not an excuse to destroy habitat. A wildlife photographer should be a conservationist first.

In the warmer months, snakes may be seen crossing roadways at night. It takes a little practice to separate the sticks from the snakes when seen through a car's headlights, but with experience it becomes easier. This is an ideal collection method because many different species can be found, the environment isn't disturbed and the animal can be released to a spot that's safer than a road. Check state laws before doing this, however, since poachers collecting for the pet trade have made this practice illegal in some areas.

Semi-aquatic turtles can usually be found sunning along banks or upon rocks or logs. Frequently quite wary, turtles slip into the water at the first sign of danger. A canoe and a long handled net may be needed for water turtles. Land turtles are very easy to catch but are much harder to find. They're most commonly seen wandering about after heavy rains.

Many herptiles, like this prairie rattlesnake, can be photographed effectively from an angle of 45 degrees, since this is the perspective most people see them.

A different, but extremely effective, perspective is obtained by shooting at your subject's level. This works because it offers a view we normally do not see, and implies an intimacy normally not had with creatures so low to the ground.

## 2. Perspective

People literally look down upon most herptiles. Unless one bumps into a treefrog or an arboreal snake, it's rare to meet a herptile face-to-face. For this reason, photographs taken at a pitch between 30 and 60 degrees are acceptable in duplicating most people's perspective.

For more dramatic photographs, shoot at the subject's level. In the field this may require lying down upon your belly (or kneeling, if you're using a waist-level viewfinder). This can be uncomfortable, wet, or even very dangerous at times.

I'll never forget the western diamondback rattlesnake that continually advanced in its formidable S-shaped pose as I attempted a ground-level photo. Assistants are invaluable then, and mine repeatedly warned me when the snake got too close, since distance was difficult to judge through the viewfinder.

In studio, obtaining eye-level shots is easy since a table or platform can be elevated to a comfortable working height.

## 3. Lighting

Sunlight is not only potentially dangerous to herptiles, it is not an attractive lighting source, either. It creates harsh shadows on lizards and snakes, and reflects unpleasant highlights off the skins of many amphibians.

If I must photograph herptiles in natural light, I prefer to do so under cloudy bright conditions (where the sun is obscured by light cloud cover) or in open shade. Cloudy bright is best, since there's sufficient light to permit the use of small apertures. Light shadows are cast, which gives the animal a dimension of depth.

Shutter speeds are rarely a consideration with herptiles, provided a tripod-mounted camera is used. Herptiles in motion are very difficult to photograph, but still specimens are easy. Practically any shutter speed is possible then, provided, of course, the herptile doesn't choose to slither or hop during the exposure.

Motion won't be a problem with flash photography, which is ideal for illuminating herptiles. Many effects can be produced by referring to pages 66 through 67. Amphibians are best photographed through diffused light. Direct flash using key and fill lights is fine for most reptiles.

The dual flash gunstock described in Chapter Seven, or a single flash bracket, are ideal for flash photography in the field. The Great Plains toad was photographed in this way.

## 4. Containing the Subject

Herptiles can try your patience. Some are naturally camera shy and will dart off or burrow at the first opportunity. It's instinctive for herptiles to seek cover, and photographing them can be difficult unless tricks are used to provide the animals with a sense of security.

Many salamanders will settle comfortably beneath a jar lid or a small box. Clear plexiglass or window glass also works to calm the animals while they remain visible to you. Either method also works with snakes, although larger and more spacious shelters are needed. Most herptiles seem to prefer dim light. This is especially true with amphibians. Care must be taken with salamanders and their reptile look-a-likes, the lizards, so that their tails aren't broken. If grasped by the tail, it may break or twist off. Incomplete specimens rarely make attractive subjects.

Toads are the easiest to work with in the field or in the studio. They move too slowly to present any real threat of escape. All that's usually needed to contain a toad is to place

a cupped hand over the animal for a few minutes. When the hand is removed, the toad usually stays in place for a few seconds. Sometimes toads go into a hunching defensive posture and must be gently nudged beneath the chin in order to assume an alert position.

Frogs are difficult because of their leaping prowess. In the field, I usually use the plexiglass studio box to contain specimens. In studio, I secure the area as best I can. Like toads, frogs will usually respond to the cupped hand trick after a few attempts.

Treefrogs are even more of a problem, since their prodigious leaps can take them anywhere. In studio, it is important that any hot lights are beyond the range of a treefrog, since these amphibians will jump virtually anywhere.

Turtles are surprisingly difficult to photograph. Turtles retreat deep into their shells if frightened, but, should they decide to "run for it," they move with surprising speed. Water turtles can be photographed in shallow water where escape routes can be covered. They're frequently uncooperative subjects, and rarely remain still if placed upon a rock or log. For this reason, I've tried to limit my work with aquatic species to filming wild turtles in the field. The results always look the most natural, even if the opportunity to do so is less frequent. Land turtles are a little less frustrating. They can sometimes be kept within an area by offering them food.

Average-size snakes can be kept quiet beneath a shoebox or pie-plate. They'll freeze in position if a cupped hand is kept over their heads for a few minutes. I've had surprisingly good luck on a number of occasions offering snakes food, which they've readily taken. This not only contained them within a desired area, but offered action sequences as well.

Unless a lizard is photographed with a small telephoto, I've found it almost impossible to shoot lizards afield without the aid of the plexiglass studio box. In fact, it was with these subjects in mind that I constructed the box. Lizards move in spurts,

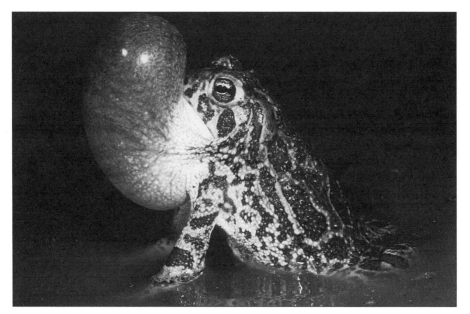

**A 100mm macro and Kirk's flash bracket and TTL flash were used to expose this Great Plains toad during courtship. The working distance was only eighteen inches away, but the toad was obivious.**

remaining motionless one moment, darting with lightning-fast rapidity the next.

As I stated earlier, venomous reptiles should be left alone. Quite frequently, rattlesnakes, copperheads, and cottonmouths will freeze in position, offering excellent chances for photographing them in the field. If harassed, most will assume a defensive posture. Snakes can't strike more than half their length, so remaining the snake's length away is safe. Snakes don't have to be coiled to strike or bite, however, so foolish risks should never be taken, regardless of the animal's position.

## 5. Field Photography

Breeding amphibians can provide one of the most interesting and accessible herptile subjects. Frogs and toads are often oblivious to anything but the finding of a mate at this time, and may ignore a photographer completely. Since most of this activity occurs at night, flash is necessary. Focusing the camera is easily accomplished if a headlamp is worn. Don't buy the type of lamp sold in backpacking stores, since these small lights (powered by rechargeable nickel-cadmium batteries) are too dim to be useful. A powerful nine volt battery-powered lamp is much better. These are available in most sporting goods stores.

The float blind described in Chapter 8 is an excellent way to approach wary water turtles. This method can be used on amphibians and snakes also, provided that the water is deep enough for you to move about in.

Close-focusing telephotos or long 300mm or 400mm lenses with extension tubes attached, are fine for lizards. Many lizards will permit an approach to within six or eight feet before darting off. This is close enough for a longer lens to obtain a useful image.

Snakes usually remain still if discovered, and for this reason they can be photographed with shorter lenses than those needed for lizards or turtles. Don't approach too closely, however, or you will alarm the snake and cause it to seek cover.

## 6. Studio Photography

Many herptiles require studio work, and others would benefit from the controlled conditions this permits. Few herptiles require special confinement in the studio, although the adjacent area must be escape-proof for the faster snakes and lizards.

Some photographers lose patience with uncooperative subjects and place them inside a refrigerator to lower the animal's body temperature. This does slow them down,

**Snakes, salamanders, and other fast-moving uncooperative subjects will frequently relax if kept under shelter like the lid of this film box. When I removed the lid, the long-tailed slamander remained still long enough for me to obtain several photographs before it darted off.**

but I do not recommend this practice for anything but a few types of salamanders. Cool temperatures and sudden chilling can be harmful. It results in photographs where the animal looks droopy and cold. Some species of salamander, however, are active in very low temperatures and may actually cooperate and look best when kept around 50 degrees F. Mole salamanders, like the Jefferson's, are excellent examples.

Herptile work requires patience. It also helps to spend some time with the animal prior to photography, since it may grow accustomed to you and lose its initial fear. Although I don't recommend refrigeration, I would suggest keeping the studio temperature cool rather than warm. I'm not implying chilling the animal; I'm merely stating that warmer conditions make herptiles more active. This can create unnecessary problems when attempting to pose a subject.

Fluorescent lights are ideal for illuminating the studio. They are bright enough for focusing, yet they are cool and won't heat up the area.

Strong backlighting is not effective on most herptiles. Minor backlighting, however, will set the subject off from the background.

Since herptiles have large eyes, care must be taken that only one or two flash units are reflected in the eyes. Remember, more than two light sources rarely look natural.

## 7. Venomous Reptiles

Given the opportunity, I suspect most wildlife photographers will attempt to photograph these fascinating animals. For this reason, I'll offer a few suggestions that hopefully will keep you out of trouble.

There are three types of venomous reptiles in North America. For the nature photographer I think the most dangerous one is the coral snake. Coral snakes are related to cobras, with a lethal bite that affects the nervous system. They are shy, secretive snakes that want nothing more than to find shelter. They are uncooperative subjects, requiring a real effort to contain. For this reason, corals are dangerous. Because they rarely bite, a frustrated photographer may be tempted to detain a specimen by hand. Although normally docile, the snake can bite. Patience and caution are mandatory when working with coral snakes.

Few photographers will encounter a gila monster, one of only two venomous lizards known. They are rare everywhere, but are most frequently found in Arizona where they're protected by state law. Unless you possess a special permit, it is illegal to capture a gila monster for photography. Slow-moving and nocturnal, gila monsters can be safely photographed in the field with small telephotos and electronic flash.

The pit-vipers make up the third and largest group of venomous American reptiles. Rattlesnakes, copperheads, and cottonmouths comprise the group and are responsible for the vast majority of poisonous reptile bites each year. Strangely enough, however, they're probably the safest of the three to photograph, provided that simple common sense precautions are followed.

Usually, pit-vipers remain motionless when discovered. If disturbed, most attempt to crawl off, but many do so by first assuming a defensive pose, their necks cocked to strike. When motionless, or when backing up to a log or ledge in an S-shaped arch, most pit-vipers are fairly easy to photograph via 80mm to 200mm zoom lens.

Occasionally a pit-viper just won't cooperate by remaining still. Like the coral snakes, such a specimen is especially dangerous because of the impatient and unsafe methods you may use to try and detain it. Don't. Let it go its way, for an agitated snake, your own frustrations, and quite likely adrenaline-pumped behavior are three ingredients that can too easily result in an accident.

## 8. Suggested Equipment for Herptile Photography

1. Basic Equipment

    SLR with behind-the-lens metering

    80mm to 200mm single focal length or zoom lens, either with close-focusing capabilities or used in conjunction with extension tubes

    Manual or TTL electronic flash

    Tripod that can get wet. Gitzo Safari Model, for example

    Boxes or jars to contain a specimen and calm it

2. Advanced Accessories:

    100mm or 200mm macro lens

    Studio light stands

    Two or more manual flash units

    Flashmeter

    Dual flash bracket or gunstock

    Plexiglass studio box or equivalent

    Chest waders

    Tripod that can get wet

    Snake hook or pillstrom tongs

    Fishing rod or pole for lizard noosing

    Slave units

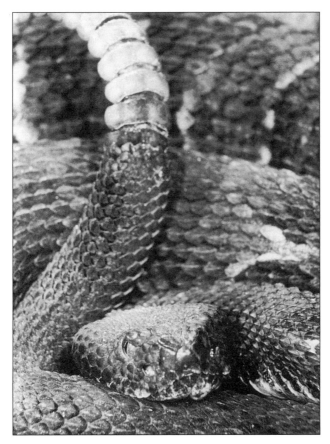

Many of the accessories recommended on this page were used for this portrait of a timber rattlesnake. They included three manual flashes, two slaves, light stands, a 100mm macro lens, and a snake hook.

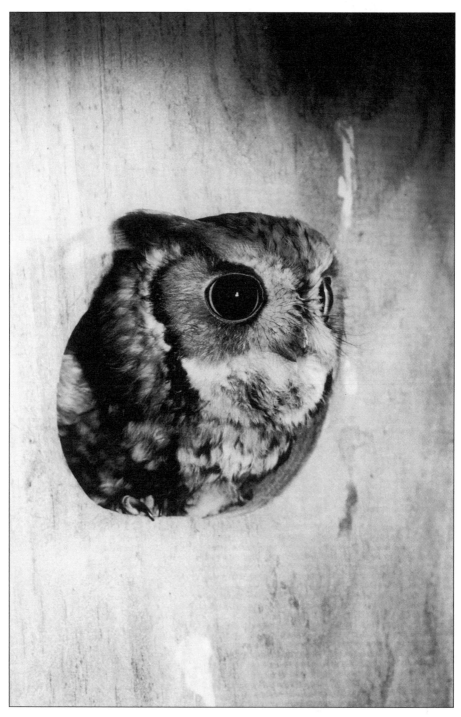

When this screech owl left its nestbox, it broke the invisible infrared beam of a Dalebeam placed along the edge of the box. An electronic flash was placed on either side of the nest to provide even illumination.

# CHAPTER *15*

# Birds

Some facets of bird photography are available to everyone, even those with limited equipment. Most bird photography occurs in the field, requiring both luck and skill in many circumstances. It offers work that is both fun and frustrating. Because birds have the ability to avoid man as few other creatures can, special techniques or tricks are necessary to get close enough for a good size image. This makes bird photography one of the most challenging pursuits.

## 1. Finding Birds

Birds are everywhere. Unfortunately, it's not an easy matter to get close to these wide-ranging animals. Birds are intelligent and wary, and some, quite rightfully, distrust man.

In protected areas where both man and bird are commonly found, birds grow tame and discover that friendly humans can be a source of food in the form of handouts. A surprising number of species have learned this. Songbirds, woodpeckers, chachalacas, bobwhite, pelicans, ducks, geese, and gallinules are just a few of the many I've seen around campgrounds or picnic groves waiting for tidbits of food. In the Everglades, this habit was carried to an extreme when a red-shouldered hawk snatched a freshly purchased T-bone steak wrapped in clear cellophane out of a grocery bag. Fortunately, I was able to scare off the raptor, saving my dinner.

Backyard bird feeders are a fine place to start bird photography. Feeders can operate through every season and attract a far greater variety of birds than would be possible through the fall and winter months alone. More than likely, birds that have been fed year-round will nest nearby, which provides additional photo opportunities. Many people develop their backyards into mini-sanctuaries by planting vegetation that offers natural food and cover for birds and small animals.

National Wildlife Refuges were originally established to provide habitat for migratory birds. Most refuges have hiking trails and auto routes where birds are accustomed to traffic and allow people to approach closely. Many refuges offer wetlands particularly attractive to waterfowl and shorebirds. A few preserve entire ecological units where a tremendous variety of native animals and plants can be found. Photography is enhanced even further at some refuges where bird feeders and photography blinds are located.

James Lane's birder's guides identifies various exceptional birding areas where photography is also possible. Pettingill's *A Guide to Bird Finding (East and West of the Mississippi River)* is another source. Not only are these books helpful for finding birds, they can also be used for other types of wildlife that share the area.

Any wild area, be it an extensive track of timber or a vacant suburban lot, has its bird population. Excellent work can be done close to home using many of the techniques

outlined on the pages to follow - it's simply a matter of getting out there and photographing.

## 2. Considerations and Ethics

It is very important that a bird photographer not jeopardize the safety or nesting success of his subjects. Although this is critical at nests, it's also very important at feeding areas, roosts, and other locations where birds congregate. An overly zealous photographer can cause irreparable damage. Never create stressful situations for your subjects. Work with the birds only as long as they remain unconcerned by your presence. The late Fred Truslow, perhaps America's greatest bird photographer, cautioned that when a bird's trust is lost, it's rarely regained. Birds can be quite trusting, too, and will permit surprisingly close approaches or engage in unusual activities close by provided that they're not frightened.

## 3. Bird Nests

Photographers have an unfair advantage at a bird nest because of their subject's instinctive need to return to the nest. In most birds this instinct is quite strong, although for some just one disturbance can cause desertion.

Birds are least tolerant of intruders while the nest is being built and during the first stages of egg incubation. After the young hatch, birds are more firmly attached to the nest area. Photographers should always wait until the young hatch and are approximately half grown in order to lessen any chance of nest desertion.

A good photographer won't permit a desertion to occur. A photo blind or remote camera setup should be positioned some distance from the nest and slowly advanced to the shooting location. If this is done over a period of days, most birds will grow accustomed to the setup and view it without suspicion. If, however, the bird grows nervous when the blind is moved closer, the effort should be abandoned.

Photo blinds aren't always necessary, and I believe nest photography is one of the few areas where remote camera work is practical. To accustom the bird to the camera, set up a model of the camera and tripod a few days prior to the photography. A small box and aluminum can could represent the camera lens, another box or pie plate could represent your flash, and a "tripod" made of long poles (perhaps wrapped in aluminum foil) can substitute for the actual piece. Each day this assembly can be moved closer to the nest until it's placed in the proper position. On the day of the photos, the equipment replaces the model.

Use a power winder or motor drive to advance the film automatically to minimize disturbance to the birds. Many state of the art cameras have built in winders, although many of these require special accessory cords. Although a camera can be 'hard-wired' to your position, an easier way to trip the camera would be to use a remote release. Two types are available, infrared and radio. Infrared remotes require a clear line-of-sight between transmitter and receiver, which may be difficult if there's thick foliage. A radio remote doesn't require as clear a view, but the operating range will be limited in direct proportion to the amount of intervening vegetation.

If your camera lacks a winder or motor drive, you'll have to advance the film by hand. Since most remotes require a motor, if your camera lacks a drive or motor you'll have to trip the shutter via an air cable release. You'll also have to advance each frame by hand, which will quickly disturb your subjects. I wouldn't advise doing this more than twice at any nest; otherwise you'll risk nest desertion.

The Dalebeam (pages 128-129) can also be used at a nest. One unit can be placed by the nest or two can be used to catch birds in flight as they fly in and out. For precise positioning of flying birds, two units should be used. There could be a little problem in positioning the bird within the picture area if there's a lag between the time the bird trips the light beam and the camera shutter opens. If this is long, the bird could fly out of the picture, especially with close lens-to-subject distances. If the image size is small, there's more leeway for capturing a pleasing composition, not just photographing the back end or the wing of a passing bird. At night, for owls, the shutter can remain open until the bird trips the light beam.

Harrison's *A Field Guide to Birds' Nests* is an excellent source book for nests. Another is the comprehensive collection of *Life Histories* of American birds written by A.C. Bent in the early 1930's (reprinted by Dover Publications, New York).

For obvious reasons, the easiest nests to photograph are those found on the ground. However, many ground nesters use heavy cover (the common yellowthroat, for example) where obtaining a clear view of the nest is difficult. Vegetation should not be ripped out or cut away to accommodate the camera. Any modifications to the nest site should be done by tying back obtrusive vegetation. When the photography is completed, the foliage can be returned to its proper position. This precaution applies to birds nesting above the ground as well.

Those nesting high above the ground are the most difficult to photograph. In many cases, a remote setup is best since the camera and flash units alone must be positioned near the nest. If a scaffold or platform to support a photo blind is made, it should be

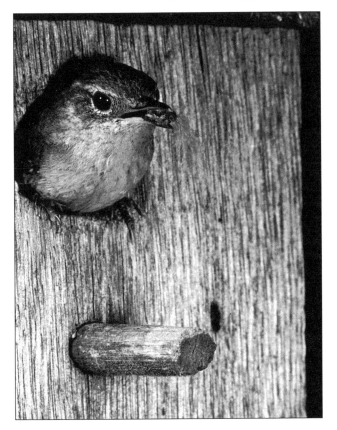

Although bird nest photography can be stressful and disruptive, backyard species habituated to man, like this house wren, may not be bothered by a blind and flash units placed close to the nestbox. Care must be taken that the bird's routine is not disrupted, which can be determined by making careful observations before setting up any equipment.

erected in small stages so that the birds adjust to the structure and are not kept off the nest for long periods of time.

Getting up to high nests can be the most difficult problem. Telephone pole climbing spikes and a safety belt (available from some hunting supply companies), long ropes, or "climbing" tree-stands used by bowhunters are three methods that could be used. The climbing treestands are probably the safest method and require the least amount of physical strength, but are difficult to use on fully limbed trees. Ropes offer the greatest versatility and agility to a climber, but require some strength as well. A rope can be set in place by throwing or shooting (via a slingshot) a stone tied to a thin line over an upper branch. When the stone drops, the line that was tied to the stone can be used to tug up progressively heavier string until the climbing rope is eventually brought up and over the branch.

Climbing spikes are a fair compromise between the two methods. They require less strength than rope climbing and are usable on more types of trees than a tree stand. Spikes can be dangerous, however, because the sharp points can slip out of the wood. Spikes sink far easier into legs than they do into trees.

Birds of prey deserve special precautions. Rarer than most birds, the raptors cannot afford nesting failures because of unthinking photographers.

Raptors can be dangerous, too. Goshawks and other hawks aggressively defend the nest, and it's not unusual for a gos to rake the head or back of anyone venturing within its nesting territory.

Owls are even worse. Although retiring by day, owls become flying tigers at night. Even the little screech owls will fearlessly attack trespassers to the nest site. The large great horneds can do considerable damage. Europe's foremost bird photographer, in fact, lost an eye through the attack of a nesting owl.

Photographers specializing in birds of prey frequently wear safety glasses and helmets. Many wear several layers of shirts or jackets that enable them to take the slashes of a bird's raking talons.

## 4. Game Calling

Many birds can be attracted by the use of the screech owl tape described on page 95. It's a universal tape, one that is useful on rare as well as common species, attracting them without jeopardizing their nesting success.

Total concealment is required when calling. Birds are looking for a little screech owl, not a human, and they'll quickly leave if they detect the latter. Camouflage clothing, headnet, and the versatile camouflage netting should be used in conjunction with natural cover.

Placement of the speaker is very important. Birds will land directly above the speaker if there's no other nearby perch. If there is, the birds will perch there instead. For this reason, I try to position the speaker in a clearing whenever possible. If there isn't a perch there, I'll make one.

The tape should be started at mid-volume in order for it to be heard at some distance. After the first birds arrive, the sound can be reduced. I position the tape player by my feet where the toe of my shoe can move the volume control, thus minimizing my movement. As more birds arrive, the volume can be reduced until it's barely audible.

Since stillness is required, the lens should be positioned and prefocused where birds are expected to land. I keep both my hands on the tripod-mounted camera; one holds and focuses the lens, and the other operates the shutter button. A motor drive or power winder will make advancing the film much easier, since no movement on your part is required.

> ## *"Raptors can be dangerous, ...hawks aggressively defend the nest, and it's not unusual for (a hawk) to rake the head or back of anyone venturing into its nesting territory."*

The tape may be even more effective with a realistic carving of an owl. In nature live screech owls are literally mobbed when discovered by small birds, and something akin to this could happen with a realistic decoy. In any case, maximum activity rarely lasts longer than twenty minutes, and birds are rarely fooled twice in the course of a few days. The tape can be used again one-half mile from the first calling site.

Hawks, owls, roadrunners, and a few other species respond to predator tapes like the squealing bird or the cottontail rabbit. The volume should be adjusted in a manner similar to that used for the screech owl tape. Coincidentally, on a winter night these tapes are very effective with owls.

Predatory birds are more intelligent and wary than most other species. Besides complete camouflage, some type of lure may also be required. A wiggler (see Chapter 16) or caged mice (see below) may keep a predator in an area for a number of minutes. There is an added benefit. Since the bird's attention is riveted upon the lure, the photographer has more freedom to move.

## 5. Caged Mice

To capture a raptor's attention, have a caged mouse in view. A small 6" x 6" x 6" cage holding one or two lab mice can be made of 1/4" hardware cloth. The wire clearly reveals the mice while keeping them safely inside.

A number of years ago an island in Lake Ontario experienced an invasion of northern owls, bird-watchers, and photographers. Along with many others, I traveled north, quite aware that competition for photographs would be intense. I returned from a day's shooting with satisfactory results, however, because those sleepy-looking great gray and hawkowls suddenly grew alert when they spotted mice upon the snow.

Raptors will accept a free meal, and if you seek feeding or hunting photos be sure to use a natural prey species. Although a gray or burrowing owl may relish a white lab mouse just as much as a wild meadow vole, photos made using the former won't be especially attractive or convincing. A widely published photo of an arctic owl swooping down upon a gerbil, native to the Middle East desert, comes to mind as a classic example of what not to use!

## 6. Decoys

Some photographers have success using decoys. In many cases the decoy needn't be realistic, since birds respond to special marks, not the total bird. Provided those points are emphasized, even a crude-looking decoy can work.

I've successfully used this technique on redwing blackbirds by using a simple plywood cutout. The essential point, the red and yellow epaulets of the courting male, was emphasized, eliciting a response from other males despite the "rival's" two-dimensional form.

145

Decoys for other species can be as crude. Geese, for example, decoy in to silhouettes and rubber tire halves. "Flocks" of white diapers work for snow geese.

The more realistic, however, the greater the chance the decoy will work. A friend successfully photographed a rare male harlequin duck by employing a realistic model of a hen. Others have used sandhill crane, loon, shorebird, crow, and diverse other species successfully.

Some duck hunters use "confidence decoys" to impart a realism to their decoy spread, since certain wary species wouldn't be present if the area weren't safe. Inexpensive but quite realistic-looking plastic gulls, egrets, coots, and herons are offered in many sporting goods catalogs. These decoys are useful for waterfowl and other birds when using the float blind (see next section). Mounted atop the blind, the decoy will not only impart confidence in your disguise, but may also serve to attract some species. With that in mind, only use the great blue heron decoy when attempting to photograph great blues. Herons are aggressive and may intimidate other species. To attract the greatest variety of birds, use a smaller egret or a gull decoy instead.

## 7. Using the Float Blind

The float blind makes eye-level photography of waterfowl possible. For ducks and other wary species, the blind should be well camouflaged and must move quite slowly when near a bird. Sudden, unnatural movements spook birds, and for best results, the blind should be kept still. Let the birds swim into you. Confidence decoys will help, as will a few duck decoys, although these could be difficult to set up from inside the blind. Decoys attached to the blind could tangle on branches or floating logs, and for this reason I'd restrict their use to open water.

**The float blind described on page 79 allowed me to obtain this goose-eye's view of a Canada goose guarding a smallpond near its nest site.**

Baiting waterfowl for hunting is illegal, but there are no restrictions against this for photography. If possible, anchor the float blind at a bait site and have a decoy assistant drop you off. When he leaves, the birds will quickly return since they're accustomed to the presence of the blind.

An assistant is also helpful for transporting the float blind if great distances across open water are required. The blind could be towed along behind a canoe.

Some birds, like grebes, nest on little floating islands, and a permanently anchored float blind and a decoy assistant will greatly assist you when photographing these species.

## 8. Flash Photography

Electronic flash is ideal for some bird feeder and most nest work. Although birds may be alarmed during the first few exposures, they grow accustomed to the flash quickly and learn to ignore it.

Either manual, automatic, or TTL flash units can be used at feeders. Nests, however, may be deep within brush where foreground foliage could fool an automatic unit's sensor. For this reason, and the fact that multiple flash setups are best for nest work, a manual or TTL unit is advised.

Multiple flash is necessary because one unit alone may cast sharp shadows across limbs, leaves, or birds. Two units, in a key and fill-in effect, won't. Most TTL flash systems will require special cords to maintain TTL capabilities however.

A third flash may also be advisable. Many nest photos are unattractive because they appear to have been taken at night. This type of underexposure results if the background foliage is far behind the nest, beyond the range of the flash units. Some photographers have used cloth or paper backdrops close to the nest to create a day-like

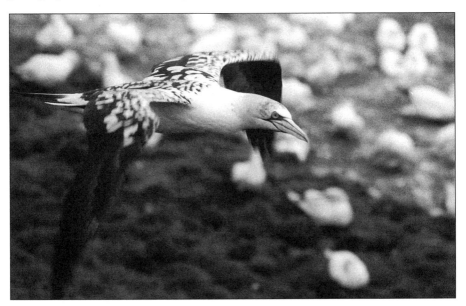

Regardless of shutter speed, it's almost impossible to obtain a razor sharp image of a frame-filling flying bird with a camera that is stationary. The bird simply flies too quickly across the film plane. To preserve sharpness, I followed this northern gannet by panning. This will also allow you to use a slower shutter speed and smaller aperture, giving you a little extra tolerance in sharpness.

effect. Usually this only detracts further, as the photograph appears to have been taken in a studio.

A third flash can lighten up the background. This flash may be positioned some distance from the subject and the other flash units.

This will require a slave tripper or, in rare circumstances, a slave relay (page 56). The flash-to-subject distances and flash-to-background distance for the respective units should be fairly similar so that nearly identical f-stops are needed. In every case, the background should not be brighter than the foreground.

Positioning the camera to include foliage and limbs, rather than empty space behind the nest, will also eliminate this problem.

Large cloth backgrounds could be used, provided they're some distance behind the nest and will not intimidate the bird. That may not be easy. A flash should illuminate the backdrop, and a longer focal length lens should be used to throw it far out of focus. This technique should only be used where natural backgrounds are too far away for illumination by a third flash. Otherwise, a "night" shot is unavoidable. There is a tremendous risk in attempting this, since your subject may be too cautious or stressed to return to the nest. If you try this, observe the nest for hours prior to placing the false background so that the times between nest visits, or feeding periods, can be determined. Then, when the background is erected, you can quickly assess whether the birds have accepted it or not.

## 9. Flying Birds

Capturing birds in flight is one of the most exciting and challenging aspects of wildlife photography. This can be done manually (occasionally requiring consummate eye-hand coordination) or electronically (through the use of a Dalebeam or similar device).

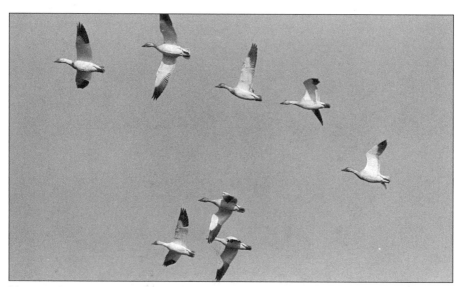

It's sometimes easier to prefocus to the approximate distance or image size you desire and allow your subjects, like these snow geese, to fly into focus. At this distance, the 'trap focus' mechanism of some autofocus cameras would work, exposing the film before the birds fly out of focus. Trap focus mechanisms won't work on subjects close to the camera, since the camera's reaction time will be too slow for the distance a bird would travel.

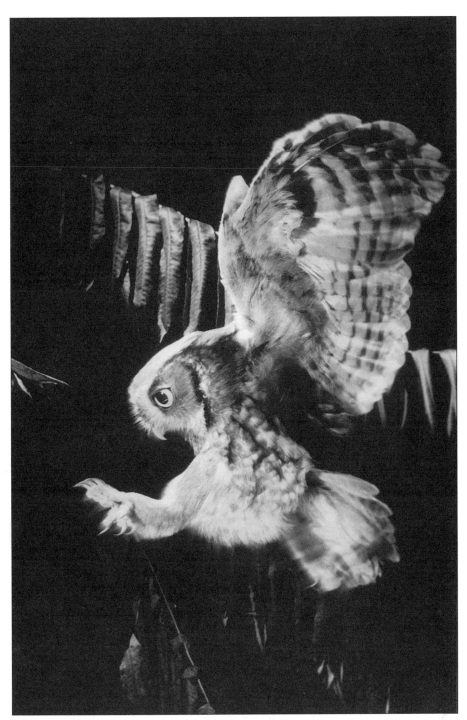

Sophisticated devices like a Dalebeam are mandatory for setups like this. It'd be nearly impossible to anticipate or react quickly enough to capture a screech owl as it returns to its nest hole at night. By allowing the bird to make its own picture, by crossing an infrared light beam, multiple photographs of a difficult subject can be made.

Most coastal areas have their collection of begging gulls, and these large birds are perfect for practicing focus skills. Gulls are among the easiest birds to photograph in flight and frequently will hover overhead waiting for handouts. A 100mm or 200mm lens (or a zoom) is generally all that's required, since short distances are the norm. Smaller lenses, such as 50mm and wide-angles, can be used, but because of their large fields of view it's difficult to isolate one individual. Flocks overhead are dead give-aways for the manner in which the photograph was taken.

Other birds are more difficult. It's nearly impossible to catch most small birds in flight without the aid of mechanical or electrical camera triggering devices. Use of the Dalebeam for that purpose will be discussed in the following section.

Birds are most easily photographed if they're flying parallel to the film plane, flying overhead, or along well-established routes. The larger the bird, the easier it is to keep in focus since the subject's easier to see and flies more slowly in relation to its size than do smaller birds.

Capturing flying birds on film has become considerably easier with advances in equipment. In the late 1970's the state of the art lenses in bird photography were those offered by Novoflex. Novoflex lenses are fast focusing lenses which focus by applying or releasing pressure to a pistol grip. Focusing from infinity to the lens's minimum distance can be done in the time it takes to flex or relax your hand. Unfortunately, Novoflex lenses are relatively slow, and it may be difficult to determine when a subject is critically sharp. Further, the pistol grip elevates the lens-camera assembly above the tripod, creating potential instability. Despite this, the cost of Novoflex lenses has more than tripled, making them a very costly lens.

Bird feeders and backyard bird houses are one of the easiest and most accessible spots to begin the challenge of bird photography. Birds will quickly become accustomed to strobes or blinds, and, if the feeder is in your backyard, you'll be able to practice frequently.

Fast lenses may be a more practical solution. A 300mm f2.8 lens has a number of advantages. Not only are the lenses extremely useful in traditional photography, especially in low-light situations, but the image brightness also makes focusing easier in every lighting condition. At f2.8, depth of field is minimal, and there will be no question if the flying bird is in focus. Assuming you actually expose the film at f8 or f5.6, you'll also have a small amount of leeway in accurate focusing due to the increased depth of field at these smaller apertures. These smaller apertures will require slower shutter speeds, of course. Panning is required, since even 1/1,000 speeds won't freeze a flying bird if it nearly fills the frame. To preserve sharpness, panning is mandatory.

Autofocus lenses are another solution. This method requires centering some part of the subject within the autofocus sensing area, which may or may not be difficult. Frequently it's so difficult to capture sharp flying birds that a centered composition won't matter, but trouble can arise if the sensor 'locks' onto a wingtip rather than the head or your bird.

Autofocus cannot accomplish the impossible, and if a bird follows an erratic path, as a black skimmer or swallow is apt to do, accurate focusing is impossible. State of the art autofocus cameras offer track focusing modes where the camera's mini-computer tracks the speed of a subject and continues focusing even after the camera's shutter is tripped and the mirror flips up. This system works, most of the time, and if you're extremely serious about flying bird photography, you may wish to consider one of these autofocus cameras.

**Black-headed grosbeaks, along with Hepatic tanagers and Acorn woodpeckers, frequented this large hummingbird feeder for sugar water. In desert areas, a water source, or a ripe half grapefruit or orange, will attract a large variety of birds for photography.**

## 10. Using the Dalebeam for Birds

The Dalebeam (pages 131-132) makes flight shots of small birds possible. Since birds are free-flying, getting one to fly through the point of intersection of one or two infrared beams could be a matter of luck. Prior observation to its use, however, may make this a little easier, especially if you work at a bird feeder or a nest where flight routes are frequently established.

In natural light, the Dalebeam can be used without the aid of flash, although a time delay could occur between the time the light beam is broken by a bird and the camera firing. This is because of the mechanical operation of the camera. To decrease the chances of missing a picture, you could direct the camera towards the flight path, rather than perpendicular to it. A small image size, as opposed to tight cropping, would also permit more leeway.

The use of flash in a natural light situation produces the possibility of ghost images. The flash should be close enough to the subject so that the aperture used overpowers that f-stop required for the natural light. One or more flash units may be needed in the background, however, to illuminate that area to avoid the "night-time" effect described on page 154. Unless a flash with a large Guide Number is used, close flash-to-subject distances are required with variable power manual units dialed down to their lowest power for shortest flash durations.

At night, of course, the camera could be left on Bulb or time exposure with the shutter open until the bird trips the flash.

## 11. Bird Feeders

Reference to the opportunities available at bird feeders was made in Chapter 8 and

**Wild birds on man-made feeders can look very unnatural. To bring back authenticity, erect a branch or natural perch that the birds may use before hoping onto the bird feeder.**

elsewhere in this chapter. A backyard feeder is one of the few places where you can obtain photos while occupied with another task. Earlier, I stated my preference for using photo blinds for the creative control this permits. However, other methods have definite advantages when you can't afford the time a blind requires.

Some photographers shoot through a lens porthole cut into a wall or a covered window. Others shoot directly through window glass. This can be done provided the glass is clean and free of any optical distortions that would ruin an image. The obvious advantage to doing this is that the camera can be used whenever an opportunity arises. A lens porthole, on the other hand, may be inconvenient since constant peeks through the camera's viewfinder may be necessary to check for birds.

Some windows are placed where obtaining a shot in this manner would be impractical. For such homes, the camera could be operated remotely. A powerwinder or motor drive would be especially helpful, since multiple exposures could be made without the photographer returning to the camera. A shutter-priority automatic camera is useful when shooting in natural light, since the camera can adjust for changing light levels. With manual cameras, you would be limited to constant lighting conditions or to electronic flash.

There are a couple of options if you operate the camera remotely. An autofocus camera on an automatic mode may solve exposure and focusing problems, assuming that the bird is within the auto-focus area. Compositions made in this way could be repetitive, if not monotonous. A Dalebeam could be used in a manner similar to those described previously. You could trip the camera instead, by using one of a variety of remote devices. There are wireless systems involving radio transmissions or infrared light beams for distant work. For close distances, remote cords can be used in

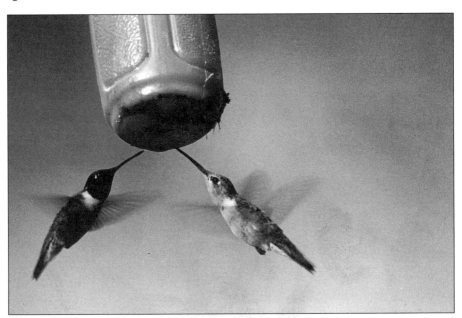

**Hummingbirds are exciting backyard bird subjects. They are readily attracted to bright objects or to clear bottles containing colored water, to sip sugar water. In natural light it's difficult to stop the action of a hummer's rapidly beating wings. With flash, you can, but be careful not to create an unnatural black background.**

conjunction with many powerwinders and motor-driven cameras. If film is advanced manually, an air cable release can be used. These look like standard cable releases except that a large air-filled bulb replaces the plunger apparatus of the typical cable release. This is the least expensive remote accessory and comes in lengths up to approximately fifty feet.

Long lenses are not necessary for remote work, since camera-to-subject distances are much closer than if a blind is used. Zoom lenses or small telephotos between 80mm and 200mm are best.

Shoot at the subject's level, if possible. A table-top tripod could be used for ground-level feeders. If a background is distracting, manipulate the field of view in some manner. Perhaps the easiest way to do this is to point the lens at a downward angle.

Prefocus the lens on a spot you can observe from inside the home. Allow some space around the target area to provide some latitude in composition. If an electronic flash is used close to the target area, small apertures and sufficient depth of field won't be a problem. In natural light, use the slowest shutter speed you can afford to maximize depth. Most birds can be shot at 1/250th, although some (doves, quail) may permit 1/125th on occasion.

Unless you like the effect, avoid using obvious man-made bird feeders. Use natural-looking areas instead. Logs, rocks, even bare spots in a lawn will give a realistic appearance to your photographs. Vegetation can be planted, or branches set in place to provide perches birds may use during your photography.

Besides bird seed, water will attract your subjects. As with feeders, try to keep the water source natural-looking for best results.

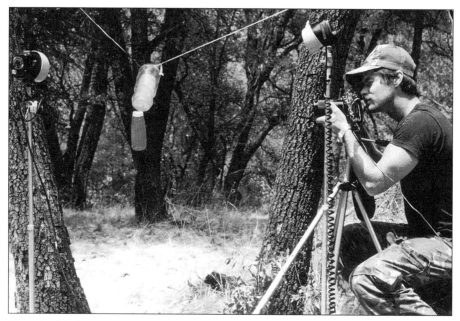

**Hummingbirds are fearless and will return to a feeder even with a photographer and his gear closeby. A blind is not required. Move slowly, paying attention to your hands, and the birds will continue feeding undisturbed.**

*"Aggressive and fearless, hummingbirds quickly accept the presence of a photographer near their feeding site."*

## 12. Hummingbird Feeders

Hummingbirds make spectacular, exciting subjects. They are fast-moving, capable of zooming forwards or backwards at astonishing speeds. Aggressive and fearless, hummers quickly accept the presence of a photographer near their feeding site.

It's very easy to attract hummingbirds for photos. Commercially made feeders or home versions using red plastic or clear glass are readily accepted by these active birds. Sugar water (colored red if placed in clear containers) in a one part sugar, three parts water ratio will nourish hummers. Sugar substitutes will not, and using an artificial sweetener will starve these birds.

Variable powered manual units will freeze most of the movement in the wings, as will some automatic units placed close to the subject. Cameras can be operated by remote releases, by a Dalebeam, or by hand with equal ease. Use a lens between 80mm and 250mm, since long focusing distances aren't necessary.

Natural light can be used, but usually the splendid iridescence of a hummer's feathers won't be as bright as with flash illumination. Not even the fastest camera shutter speeds will freeze the hummer's wings, although blur in this case is not unpleasant. Many modern cameras offer flash synchronization speeds of 1/250th and TTL flash, enabling a thinking photographer to stop the hummingbird's action by flash while balancing the subject's light with the ambient background. At 1/250th the chance of distracting ghost images will be minimized.

In the West, it's easy to attract hummingbirds to campsites with a feeder. I'd suggest that if you are camping in one location for a few days, set one up. Chances are very good that one or more hummingbirds will find it and provide you with some photo opportunities.

## 13. "Grab Shots"

Perhaps more than with any other animal, birds can be photographed without prior preparation if the right lens is handy. I call these opportunities "grab shots" because you must take them when you can get them. Carrying a camera, long lens, and tripod afield, you can obtain excellent photos, provided birds are in the area and luck is with you that day. To help it along, sit quietly in "birdy" areas or attempt slow stalks, methods that work with some birds on certain days.

Many birds can be photographed through a car window, as the magpie illustrates. Follow the procedures outlined on pages 50-51 and 78 for best results.

A knowledge of bird behavior and some stalking ability will help in your attempts to get close to birds. Stalk by moving very slowly; appear disinterested if the bird is watching. Sometimes it works.

### 14. Falconry Birds

For some people, photographing a falconer's hawk or falcon will be the only way to obtain shots of these magnificent birds. Licensed falconers live in every state, and some give demonstrations where photos (or a contact) can be made. Depending upon the falconer's cooperation, you may be able to photograph birds flying, perching, or protectively guarding a kill.   Most falconers are reluctant to remove the leather jesses attached to the bird's legs. If so, head shots and upper body portraits with small telephotos may be your only option. If a bird is placed on a natural perch, however, the jesses may be concealed and a wild-looking photo can be made.

Find out exactly what's permissible before working with a bird. Falconer's love their charges and may become extremely upset should you do something that could annoy or excite their birds.

### 15. Rehabilitated Birds

Some concerned individuals are licensed to care for injured birds. Some birds are so badly damaged that they cannot return to the wild. These birds may provide an opportunity for studio work not normally possible with protected species.

Use some imagination when doing this. Your host may place a "pet" owl upon a photogenic pine bough just as readily as upon the back of a chair, provided you suggest this to him. Methods similar to those suggested for herptile photography can then be used.

Nearly all species of birds are protected by state and federal laws, and it is illegal to capture specimens for studio photography. Since it is difficult to duplicate the natural appearance of most outdoor bird scenes, studio attempts would probably be unsatisfactory in any case.

**A road-killed arctic ground squirrel served as bait for this black-billed magpie photographed from an open car window in Denali National Park, Alaska. Rue's Groofwin or Bushnell's car window mount works well for a sturdy support when filming from a car.**

## 16. Suggested Equipment

For the Beginner:
    SLR with behind the lens metering (shutter-priority or manual)
    Long telephoto lens (300-400mm)
    Tripod
    Electronic flash
    Air cable release

2.    For the Advanced Photographer:
    Powerwinder or motor drive
    Dalebeam for flight or remote work
    Remote releases or cords
    Manual electronic flash units with variable power ratios
    Slave units
    Flashmeter
    For the field: photo blinds, climbing treestand, pole-climbing spikes,
      or climbing rope
    Game caller or tape player
    Screech owl tape
    Wire mesh cage for mice
    Confidence decoy when using float blind
    Bushnell Car Window Mount or Rue's Groofwin

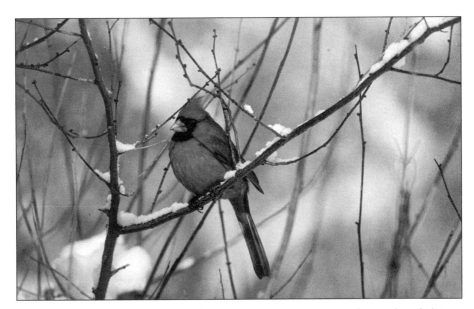

**An established bird feeder will see increased activity after a snowfall, and you'll be treated to some of your most attractive images. Dress warmly in order to remain in the blind for as long as the light lasts.**

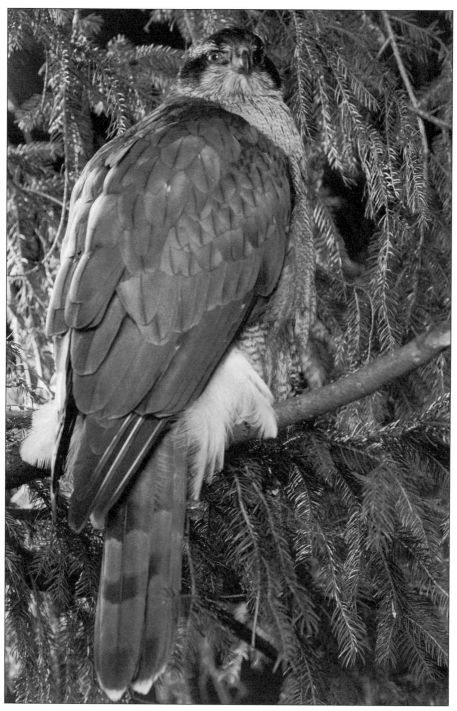

A falconer's goshawk may be an interesting subject anywhere, but it's even more striking when filmed against a simple natural background.

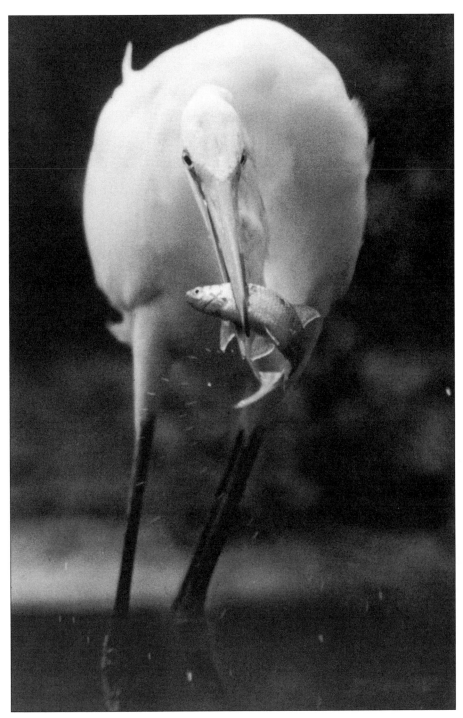

Dramatic behavior photographs can be made with a little pre-planning. I set up a
blind at an active feeding area, erected some confidence decoys, and waited. I was
rewarded by an egret catching a number of fish only yards from my camera.

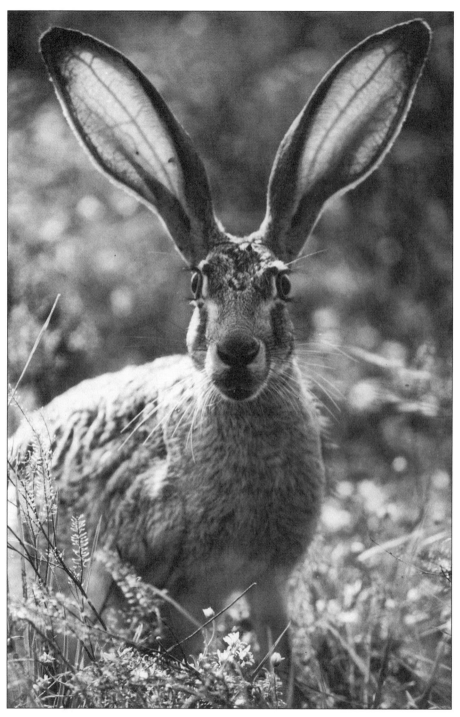

This blacktailed jackrabbit was photographed from a jeep window. The image is arresting because of the backlighting that highlights the fur and creates a translucency to the animal's huge ears. It was taken with a 400mm lens.

# CHAPTER *16*

# Mammals

Adaptable, fast-moving, and intelligent, mammals are the most challenging wildlife subjects. Because of their native intelligence, expressions, and personalities, mammals offer some of the most appealing photographs possible.

## 1. Finding Mammals

Most people encounter few mammals. These occasions may be limited to feeding park squirrels or spotting game through a car's headlights. Small mammals are the prey for a wide variety of larger animals and must remain inconspicuous to survive. Larger species may have economic value to man and must avoid him. For these reasons, obtaining photographs can be difficult.

Mammals are as close as the nearest wild area. Shrews, moles, and mice occupy any vacant acreage. Although difficult to photograph in the field, outstanding results are possible in the studio.

Mammals accustomed to man are found in most parks and many picnic areas where many of them seek handouts. State and national parks offer the greatest variety of subjects, since elusive game species are protected and have lost most of their fear of man. Nevertheless, wherever mammals are found, a variety of tricks may be required to obtain a photograph. These methods will be revealed in the sections to follow.

## 2. Considerations

Concern for the animal's welfare should be first in mind. Mammals should not be subjected to stress at a den or burrow where young could suffer, nor should a waterhole be worked so frequently that animals not be allowed to drink.

Some mammals are best photographed in a studio, but unlike reptiles, wild mammals may not calm down in captivity. A frightened mammal may rub its nose raw or injure itself in another way when it attempts to escape. To prevent this, a studio should be set up prior to the capture of an animal. Then photographs and the release of the captive can be quickly accomplished.

Game animals protected by state regulations may only be live-trapped during the legal trapping season in some areas. Some states require special collecting permits for use with nongame species.

Mammals can be dangerous, and a moose or grizzly bear offers a far greater threat to your safety than any venomous snake. In fact, grizzlies and polar bears are North America's most dangerous animals. They are strong, agile, and smart, and taking any risks with these potentially dangerous creatures could be suicidal. Unfortunately, accidents do occur, and regardless of where the blame lies, the offending bear is usually eliminated.

During the autumn rut, hoofed mammals are dangerous, too. A moose could kill

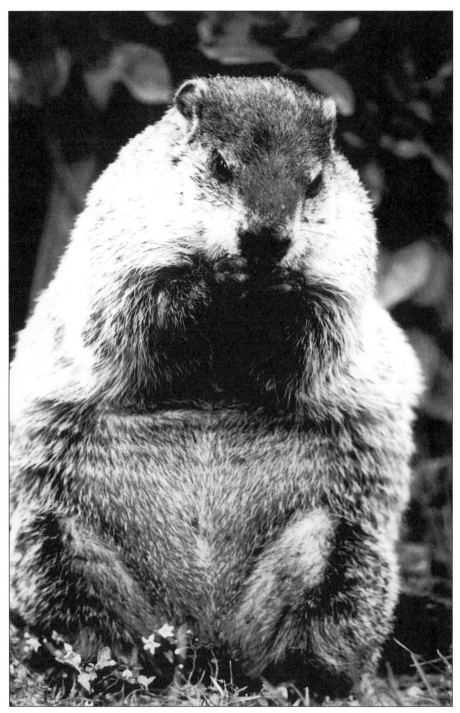

For years groundhogs would feed in the lawn behind my mother's house. Baiting one part of the yard with diced apples, I erected Rue's ultimate blind nearby and watched from a window. When a groundhog discovered the apple, I headed for the blind. The rodent left, but returned just a few minutes after I settled into the blind. The sound of a motor-driven camera ten feet away never bothered the animal as it fed.

a man with a blow from its huge forefeet. A whitetail buck can fatally gore a man.

Game calling has resulted in frightening experiences for some people. Callers have been bitten and knocked down by the animals they've attracted.

Hand-feeding "tame" animals can lead to painful bites. Most mammals have sharp teeth and powerful jaws, and there's always the possibility that an animal could have rabies.

For these reasons, personal safety and common sense are necessary.

## 3. Feeding Stations

Most mammals will regularly visit an area that provides food. Deer and other hoofed mammals are attracted to corn feeders, hay, and salt blocks. Omnivores can be brought in to table scraps. At the Southwestern Research Station in southern Arizona, for example, raccoons, coatis, skunks, peccaries, deer, and others visit a station nightly to feed solely on table scraps.

Carnivores, especially those whose range is limited by young in a nearby den, may frequent an area baited with meat scraps or inexpensive canned dog or cat food.

Photography can be accomplished in a number of ways. If a feeding station is within sight of the home, it can be photographed through a window with a long lens or by means of a remote cord, tripod-mounted camera, and short telephoto.

If it is in the field, a permanent blind or camera trap can be employed. Blinds can be conspicuous since the animals will grow accustomed to it.

## 4. Baits

Baits are useful for wide-ranging carnivores and scavengers that locate their food by smell. This technique was discussed in some detail in Chapter 8 (page 73).

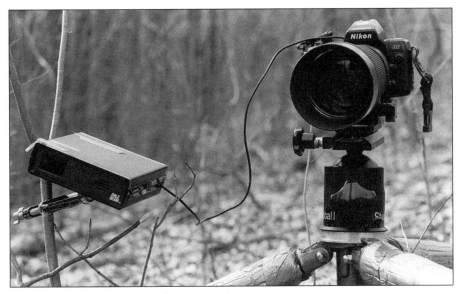

**Game trails or feeding stations are places you can try unmanned photography with a Dalebeam. But be careful! Playful bears, bad weather, or vandals can quickly destroy everything you've used.**

Besides an inconspicuous blind, some type of scent may be needed to mask a human's odor. One of the easiest to use is Skunk Screen, a product which only produces a potent smell after drops from two separate bottles are mixed.

A "blimp," a sound-deadening device used in motion picture work, may be required with predators. Blimps are bulky-looking camera "silencers" that reduce or eliminate the normal sounds of camera operation. Very few manufacturers offer them.

One can be made by wrapping the camera body in layers of foam rubber, with special channels cut out for the hands to reach the camera controls. Duct tape or tough nylon string wrapped several times around the blimp will hold the foam in place.

You may wish to consider a blimp for predator calling. Especially in hunted areas, a skittish predator will leave at the first unnatural sound.

To lesson the chances of being seen or heard by these wary subjects, place the blind as far away as possible and use a longer (300mm or 400mm telephoto) lens. A motor drive is very useful since one blast of four to six frames may be the one and only photo opportunity.

## 5. Camera Traps

Unmanned photography at feeding stations or bait sites can be accomplished by the Dalebeam (discussed previously) or by camera "traps." An inexpensive version can be made using a mousetrap. Russ Kinne's *The Complete Book of Nature Photography* gives plans. Briefly, the trigger bar and mechanism of the mousetrap is removed, with the bar being remounted on the opposite end where the killbar rests. This sturdy wire bar is bent at a small angle and used to cock the killbar an inch or so off the trap. A cable release is positioned beneath the killbar. When the trigger is pulled, the killbar snaps down and depresses the cable release.

Unfortunately, this device only works for one photo. Kinne describes other methods which employ electrical components that could permit multiple exposures.

There's an obvious risk in leaving expensive gear unattended. Someone may discover it and steal your equipment. Weather could change unpredictably and ruin it. Curious mammals, such as coatis, raccoons, or bears, may investigate and destroy the mechanism. Bears are notorious for this.

Besides the threat to equipment, there's no control over the quality of the photographs. Because the camera may be unattended for long periods, a power source of an electronic flash could be drained by the time the camera is fired. Flash bulbs may be more practical under those circumstances, but the relatively long duration of that light will result in image blur if the animal moves. There's no guarantee what position the animal will be in, nor its size - a mouse and a deer require different compositions.

For these reasons, camera traps may prove impractical to you. More productive and rewarding work can be done from a nearby photo blind in most cases.

## 6. Red Lenses

Nocturnal animals can be observed using a flashlight equipped with a red lens, since most mammals cannot detect the red wavelengths of light. Some species are completely unaffected by the light, even when using rheostat-equipped flashlights with a beam turned to its brightest setting. Others must be observed through a dimmed light or along the outer edges of a beam.

Since light passing through the red lens is significantly reduced, focusing through a camera may be difficult. It may prove easier to prefocus the lens on an area and use

the red light only as an aid for observation. Smaller focal lengths and faster lenses can be used in conjunction with a red light.

With longer telephotos, it may be necessary to focus on the animal's eyes if the body is indistinct. Eyes in focus will be sharp pin-points of light. Those that are not will be soft blurs resembling glowing coals.

It should be understood that the red light is only used for observation and focusing, not for the exposure. To avoid red eye effect when using flash, keep the unit some distance from the camera. For subjects thirty or more feet away, this may require holding the flash at arm's length, mounting it on a lighstand, or having an assistant point it in the proper direction. Otherwise the angle of parallax may be too small, reflecting the light from the eyes to the camera and creating the red eye effect.

### 7. Mammal Nests and Dens

Blinds and remote devices can be used to photograph mammal dens and nests. Although blinds require a great amount of patience, they offer far greater creative control. Since mammalian metabolism is much slower than that of birds, visits to the dens by the parents will be less frequent, and many unproductive hours may be required in order to witness a few seconds of activity.

Blinds should be positioned over the course of days. The haystack mentioned in Chapter 8 illustrates this. Some carnivores may require that a blind be placed far from the den area because of the terrain or their wariness. In such cases a supertelephoto is the only practical solution.

Carnivores and some others will require a decoy assistant, since these animals will usually observe the den area from a distance and stay away until they feel it's safe to return. More than two people may be required, or the use of a vehicle, since wily canines may notice the difference if only one person leaves when two had originally entered the den site.

Remote devices can be used, but these work much better with birds than with mammals unless limited to those that live in trees. Terrestrial mammals may wander over a large area, making it very difficult to determine from a distant observation point just when an animal is properly positioned. Dalebeams or camera traps permit unmanned photography, although this leaves the posing completely to chance.

### 8. Predator Calling

Predator calling is one of the most exciting techniques for photography, and frequently the only practical method to photograph wild carnivores. The preparations and techniques for this were described in some detail in Chapter 8.

Although this pursuit is usually safe, special concern must be given when in bear

country. It's the opinion of some game-calling hunters that a few of the black bears they've shot had every intention of coming all the way in to the call. Perhaps the hunters overreacted, considering their objective. Black bears are normally shy and can be bluffed down. The grizzly (and polar, should you be that far north) cannot. They are too large and aggressive to be sanely worked by calling unless you are inside a heavy steel cage. My greatest worry when game calling in Alaska was that a grizzly might be just over the next rise and be attracted to the call. Except for freak occurrences, however, no other American predator should be cause for serious concern.

Mention was made in Chapter 8 of the practicality of mastering the hand-squeak. This can be used to creae interest when a predator is seen. Also, I usually carry a mouthcall inside my gadget bag. Whenever I enter suitable country, I'll generally give a few blasts on a call and wait a few minutes before continuing. Sometimes it pays off.

Calling is best in parks and refuges where predators are protected. I seem to remember my blunders best, and one that always comes to mind occurred in Big Bend National Park. Spotting a pair of gray fox, I "squeaked in" one of the two within twenty feet. The fox remained in clear view, circling me for five minutes, frequently standing atop a rock overlooking the desert floor below. I had been searching unsuccessfully for rattlesnakes and, disgusted, had placed my camera gear on a rock downslope. It was within view as the gray fox danced about me.

Regardless of the location, however, calling is the best in winter when prey is scarce. It may be effective the first time you call near a den site, since predators may seek an easy meal for their young. Usually this only works once with the adults, although the young may be fooled repeatedly the first few weeks they are out exploring. In arid areas in the dry season, call near a waterhole. A predator may be resting nearby.

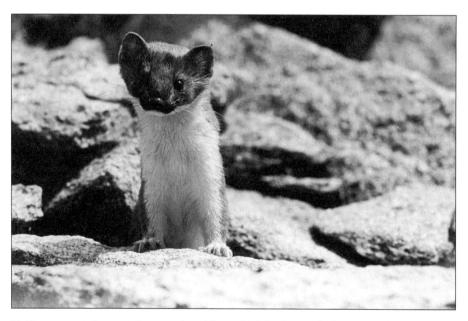

**Making a mouse's squeak on my hand brought this short-tailed weasel within camera range as it hunted pikas in the Colorado Rockies.**

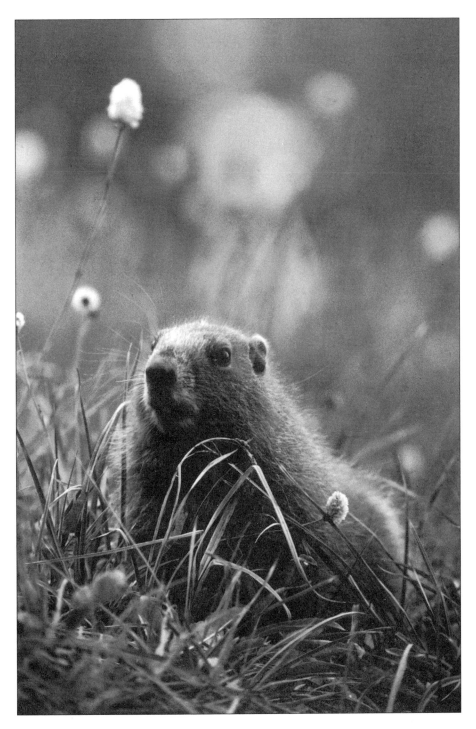

Fragile tundra habitat in popular parks requires photographers to remain on trails. Under these conditions, position yourself at a likely-looking location and wait for the animal, such as this Olympic Marmot to come to you.

Predators are active at night, but except in the hottest months, most can be called in during the day. Best results will occur in early morning.

Since photo opportunities may be brief and rare, a motor driven camera would be helpful. A blimp will help in certain circumstances as described on page 164. Novoflex, Auto-focus, or fast 2.8 telephotos are advisable to increase your chances of obtaining good pictures.

## 9. The "Wiggler"

Predators may stay out of sight when called. Some can be coaxed in by squeaking, but others expecting to find food may simply circle the area and leave.

The late Johnny Stewart solved this problem by constructing a device he dubbed a "wiggler". It's a shoe box sized radio receiver equipped with a small motor inside. Upon the command of transmitter, the motor bobs a feather. A predator sees this and runs to investigate.

A simple version of a wiggler can be made using a few dowels and fishing line. By fashioning a simple lever, a feather could be raised or lowered whenever the line is pulled. Unless thin plastic tubing is used as a guide, however, this device may be impractical in heavy cover because the line may tangle and pull brush.

## 10. Other Lures

Some photographers have success using mounted animals such as rabbits to bring in predators. Since motion, not form, attracts a predators attention, a wad of cotton or wide strand of ribbon should be tied on the animal loosely enough so that it will sway in a light breeze. On occasion, coyotes have attempted to run off with stuffed jackrabbits used in this way.

Pigeons can be used as bait. They can be safely kept if placed inside a wire cage or attached to a tall light pole by means of string tied to a soft leather harness. The string leads from the pigeon to the pole and to the photographer. A light pull on the string causes the bird to flap its wings, and a steady pull will raise the bird up to the top of the pole should the predator rush in.

One or two chickens can be used in a similar fashion. An 18" x 18" x 12" wire cage provides enough room for a few bantam hens. If the cage is placed near the loudspeaker, or in a clearing if mouth calling, the bait will draw out reluctant predators. Although these methods work, I've yet to meet anyone who has tried doing so.

Provisions must be made for the bait's safety. If a predator appears able to catch the bird, it should be frightened off. Not doing so would be unethical and cruel.

## 11. Buck Rattling

During the rut, whitetail and mule deer bucks can sometimes be brought in by simulating the sounds of bucks fighting. A hefty pair of antlers are needed, although these shouldn't be too difficult to find if enough hunters are asked. An antler is grasped in each hand and clashed together. Vegetation can be banged and the earth pawed and scraped with the antlers to produce a realistic sound.

This technique seems to work best in the Texas hill country, although hunters and photographers have had success in other areas. This is determined by the time of year (the rut must be on), the number of buck in the area, and their experience in fighting. Areas where there are few deer or a high harvest, resulting in few bucks living from one year to the next, are generally poor for this.

Each fall and winter, most hunting magazines and special hunting annuals carry a few articles on the subject. I'd suggest you read a few of these for the tips and variations in technique they offer.

## 12. "Habituated" Mammals

Large hoofed mammals in the national parks may be habituated to man and completely ignore him. Close approaches can be made without causing the animal alarm. A large animal should not be approached too closely, however. A grazing or cud-chewing herbivore may be unconcerned by your presence only to a critical point. Beyond that, the animal will either flee or fight.

Most hoofed animals will flee. However, in a park where they have lost their fear of man, an animal, especially one in rut, may attack instead. You simply cannot push an animal that far. A 140 pound deer can cause severe injury. A moose, elk, or bison can be far worse. Moose and bison are especially dangerous not only because of their size, but because they're frequently found in open areas far from climbable trees.

You'll know you're too close by the animal's actions. It will become alert, with both ears directed towards you. Grazing or chewing will stop. Some will nervously stamp a forefoot or paw the ground. Occasionally, they'll toss their heads into the air and snort.

Frequently, backing off returns the animal to its relaxed state. Sometimes the animal will continue grazing and actually approach you, coming much closer than it was when originally upset. There's an important distinction here. Approaching an animal may appear threatening or aggressive to it, although if you remain still and the animal moves closer to you, it may not feel threatened. Let the animal decide exactly how close it wishes to be.

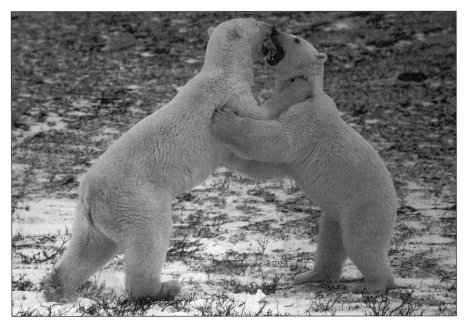

**Habituated animals are among the most rewarding to photograph. These polar bears are accustomed to the tourist-laden tundra buggies on the shores of Hudson Bay and pay no attention to the dozens of cameras firing closeby.**

169

## 13. Photographing Beggars and Thieves

Many mammals in protected areas seek handouts. Raccoons can be a real nuisance at campsites, looting it of anything edible at the first opportunity. Ground squirrels in some parks will chew through tents and packs to reach stored food. Bears not only destroy equipment in their quest for food, but occasionally kill people while doing so.

I wouldn't recommend feeding animals when in bear country. Black bears will destroy an unattended campsite; some may even do so while you're there. Grizzlies will, too, but these large bears offer a far greater threat.

It's not a wise practice to feed wild animals outside a feeding station or bait site. Handouts are rarely as nutritious as wild fare, and generally all that's spared are bits of junk food. Animals grown accustomed to this diet may not store needed fats for winter; predators may lose their hunting skills.

Nevertheless, people will feed animals at camp and picnic grounds and a photographer can take advantage of the opportunity when it happens. Even when fed the most unnatural-looking items (such as popcorn or white bread), a wild-looking photo can result if correctly timed. Don't shoot the picture when the food is visible. Wait until it's nearly finished and the paws cover it (with small mammals), or until the last morsel is inside the mouth.

If you do feed animals at camp, use natural foods like shelled peanuts or sunflower seeds. Not only do these present a more natural photograph, but they're also more nutritious.

Food can be placed under cover or hung just out of reach, requiring the animal to pause for a moment before making off with its treat. I've done this on a number of occasions after returning to camp to find that a raccoon has nearly destroyed the unprotected area.

Long focal lenses and close focusing may be required for photographing campground raiders, since chairs, tents, or tables may be near the animal. Tight compositions exclude these, and a wild-looking photo results.

## 14. The Float Blind

The float blind described on pages 79 and 137 can be used for semi-aquatic mammals and those frequenting a shoreline. Canoes and rowboats also work, but these provide less stable camera supports. Many land mammals do not associate danger from water and will allow a surprisingly close approach from an open canoe.

## 15. Live-Trapping Mammals for Studio

It is almost impossible to photograph some small mammals in the wild. Shrews, moles, various mice, and others are too elusive to permit practical field photography.

Check state regulations before collecting specimens for the studio. Game animals such as weasels and mink may only be live-trapped during trapping season in some states. Nongame species may be unprotected, or they may be afforded complete protection and require a special photography or collecting permit.

There are a number of live-traps on the market. The best known are the Havaharts, which are useful for mammals ranging in size from chipmunk to raccoon. Sherman traps are excellent for smaller species. Most activity occurs at night and traps should be checked each morning. If they are left open through the day, each trap should be checked in the evening as well.

## 16. Studio Arrangements

Small mammals are escape artists and must be confined in some manner. For indoor work I use a wooden "studio box" as described on page 107-108. Outdoors, for non-burrowing species, I use the plexiglass box instead.

Larger mammals may require small rooms or large, spacious cages. A floor area at least 5' x 8' is necessary for an animal that's a fox-size, although larger areas permit better work. Rectangular rather than square enclosures are preferred, since backgrounds are easier to create within the deeper space.

Unless fairly elaborate preparations are made, most indoor set ups are limited to animals no larger than a bobcat or fox. Animals the size of a deer or cougar might require hundreds of square feet and many props for realism. It can be done, but it involves a tremendous amount of time and work.

## 17. Studio Backgrounds

Mammals are more excitable than other studio subjects and cannot be detained safely by hand, as a frog or nonvenomous reptile may. For this reason, backgrounds and props should be limited to provide few opportunities for cover. Simple but realistic backgrounds can be made with a weathered log, rock pile (perhaps separated from the animal by glass), grass tussocks, or other materials. In this manner, eye-level shots of small mammals are possible.

Larger animals may require shooting at 30 to 45 degree pitch to solve the problem with backgrounds. Nocturnal animals can be photographed upon a black background, but this can't be done too frequently or your photographs will appear staged.

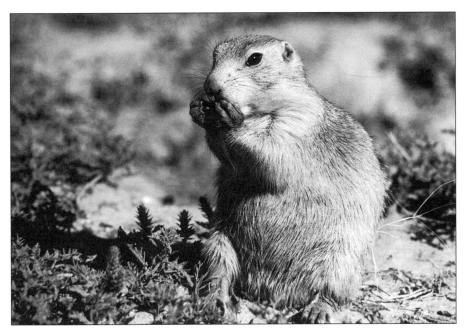

**Despite laws prohibiting it, many people feed animals in state and national parks. Don't contribute to this problem. If the only subjects available are beggars, time your photographs so that unnatural-looking foods are not visible. Popcorn and prairie dogs shouldn't be in the same photograph.**

In any case, the impression of natural clutter can be conveyed by a few judiciously placed props. Study the scene inside the viewfinder, make the necessary adjustments, and introduce the animal. If it doesn't destroy all of your work in the first five minutes of freedom, you may be lucky enough to get your photos.

## 18. Lighting Inside the Studio

More than two flash units may be necessary to illuminate large studio areas, especially if a daytime scene or special lighting effects are desired. Remember, however, that the front of the animal should only be lit by two flashes if there's a danger that more would reflect in its eyes. Manual units are necessary in multiple flash setups, and a flashmeter will prove invaluable when determining the correct exposure.

## 19. Field Illumination

Obviously, diurnal mammals are most easily photographed with natural light, although fill-in flash can be practical at short distances. Although this may require a slow synchronization, 1/250th or less, the lightened shadows and sparkling eyes the fill-in flash produces may be worth the trade-off.

Fast shutter speeds are required for moving mammals and fill-in flash would be impossible. Motionless animals, however, may be so still that any shutter speed can be used. Shutter-priority automatics are useful for fast-moving subjects in changing natural light situations.

When working with a Dalebeam or camera trap, one or more flash units may be necessary. When using either of these techniques with diurnal subjects, an aperture-priority automatic may be preferred since the camera will select the fastest shutter speed possible if you set the lens at its widest opening. Provided you retrieve the camera before it grows too dark, there's a good chance you'll obtain decent exposures in natural light.

Nocturnal mammals must be photographed with flash. Remember to avoid red eye by maintaining sufficient distance between the flash unit and camera lens. Tele attachments and special telephoto flash heads permit fairly long focal length lenses.

## 20. Backlighting

Backlighting is effective with many mammals because their fur glows when illuminated from behind. Unless a silhouette is desired, expose for the shadowed area. This will overexpose the highlights, of course, but usually this effect is pleasing. If the highlighted area is extensive, bracket or average the exposure to insure best results.

## 21. Wire Enclosures

Some animals may be photographed within large fenced-in enclosures. This practice, similar to photographing in zoos (which is not included in this book), may be your only opportunity to shoot certain animals. A surprisingly large number of wild-looking photographs which appear in nature magazines are obtained in this way.

The biggest problem with this is eliminating background fencing. In hilly terrain, this can be done by shooting upwards at an animal or from above. Long lenses at their widest aperture should reduce depth of field sufficiently to make a fence in shadow disappear. It may not if the fence is sun-lit, since the bright fence pattern will be visible as a patterned, unnatural blur.

Personal safety is important when working with larger animals. If the animal feels

> **"Some game farms rent stock to photographers and film companies. For a standard price, you may have an animal and a trained handler at your disposal."**

threatened, as it may with a stranger, it may attack out of fear. From personal experience I know I'd rather be inside an enclosure filled with venomous snakes than in one with a frightened, excited fox. I'd suggest having the animal's owner or handler nearby in case an emergency arises.

## 22. Trained Mammals

Unless you are extremely lucky, you will have few opportunities within your lifetime to photograph some rare mammal species or to document some unusual behavior in the wild. Many of the dramatic wildlife sequences depicting common or elusive animals shown on television are, in fact, staged.

Some are not, of course, and are the hard-earned work of dedicated field men, but the vast majority of that type of footage results from the use of trained or captive animals.

Some game farms rent stock to photographers and film companies. For a standard price, you may have an animal and a trained handler at your disposal. This usually doesn't come cheaply, and $200 to $500 or more may be charged for one day with a cougar, for example. Some professionals, expecting to realize ten times that figure in sales, can willingly afford that price.

I'm not mentioning this to discourage you from attempting to photograph elusive subjects in the wild. I'm simply being realistic, presenting the simple option that's available. It's discouraging to think that hundreds of hours spent game calling or baiting may result in a one minute encounter with a cougar when another person can afford to pay $1,000 and have two or three big cats at hand for an eight-hour day.

Although I've photographed lions, tigers, leopards, cheetahs, African wild dogs, timber wolves, and other elusive predators in the wild, I've never seen a cougar in the wild! America's big cats are elusive, no doubt, because those that presently exist have survived predation by man. The cougar, or puma, appearing on the cover of this book was, in fact, taken at a friend's game farm in Florida. Is this cheating? Perhaps, but unless one uses dogs and runs an endangered Florida panther to the ground, treeing the exhausted and panicked cat, there's virtually no other way to film a cougar in Florida.

Nothing will ever beat the thrill of seeing a wild cougar, of course, but it's very difficult to beat the results that a few hours spent with an animal in an enclosure or a trained animal on location can accomplish. I doubt very much if the opportunity for filming a wild cougar or bobcat will improve in the years ahead.

## 23. Suggested Equipment for Mammal Photography

1.  For the Beginner:
    SLR camera (Depending on the situation, manual or either of two automatics
      may be best)
    100mm and 400mm lenses or the zoom equivalents
    Electronic flash
    Tripod

2.  For the Advanced Photographer:
    Two or more flash units
    Motor Drive (or powerwinder)
    Novoflex lens
    Flashmeter
    Slave units
    Game caller and tapes
    Red lens flashlight
    Camouflage netting and clothing
    Floatblind
    Scents such as Skunk Coverscent or Skunk Screen
    Studio box
    Assorted live-traps
    Blimp

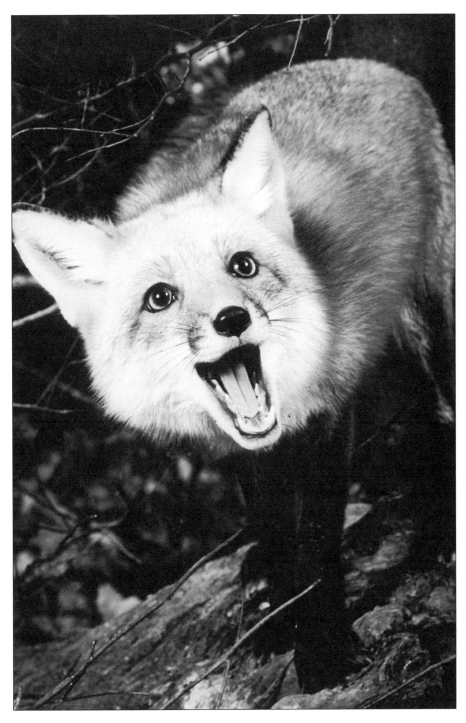

One evening with a trained or pet mammal may result in photographs normally requiring hundreds of hours in the field. Purists may frown upon this technique, but it's used by many professionals at least some of the time.

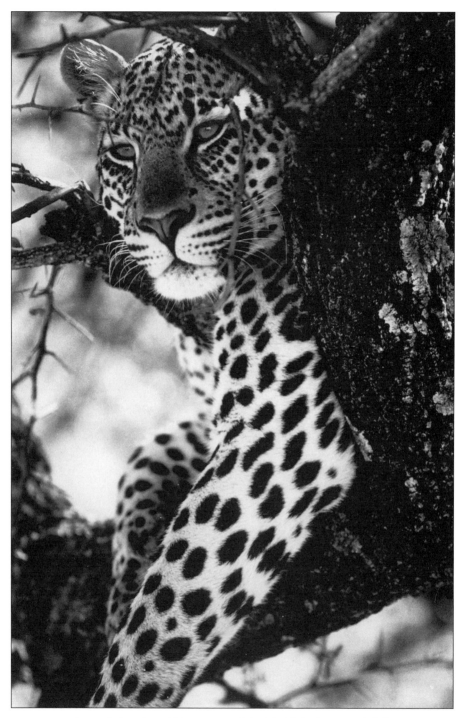

A photographic safari to East Africa is one of the highlights to any wildlife photographer's experiences. Game is plentiful and easily approachable, with most photographs made from the comfort and safety of a safari van.

# SECTION V
# FINAL POINTS

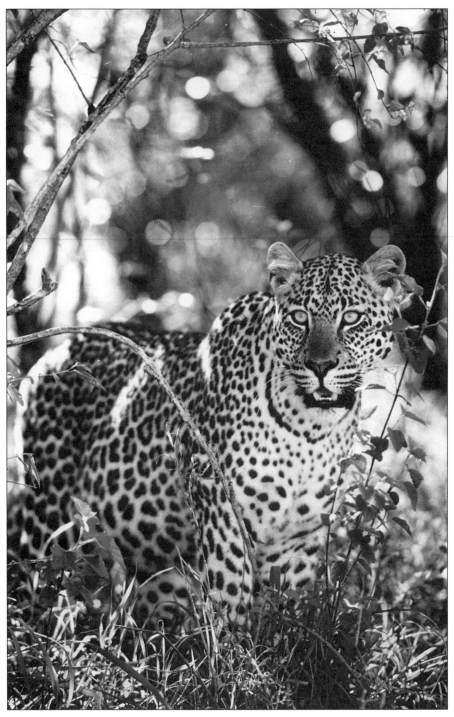

The ultimate prize of an African safari is the leopard, the most elusive of Africa's big cats. This large male stood at the edge of a small wooded thicket less than thirty feet from our van.

# CHAPTER *17*

# Final Considerations

Hopefully the preceding chapters have given you the critical essentials to successful wildlife photography. Those points, delivered in an outline form, should provide you with the point of departure to study and experiment on your own. As with any hobby or skill, practice does make perfect, and the more frequently you can pursue wildlife, the more likely you are to achieve outstanding results.

## 1. Advancing Further

Any activity can become boring or repetitive if the novelty is lost, or if the levels of accomplishment reach a plateau. Although wildlife photography offers a vastness of subject matter rarely found elsewhere, there can be a tendency to stick to one subject or one method, and to trap yourself into a style or technique that ultimately lessens your enthusiasm.

There are a number of ways that you can avoid this. Set goals for yourself. Although roaming the countryside with camera in hand can be fun, you're more likely to produce quality photos if you have a specific subject in mind. If nothing else, doing so will allow you to determine what gear you should be carrying that day. It may also sharpen your eyes, keying your senses for your quarry. Setting goals also allows you to concentrate some time on researching your subject, whether that is to determine the time of year a bird is likely to nest or the feeding habitats of an obscure water turtle.

Attempt new techniques, and when doing so, be systematic and methodical. I frequently sketch out the lighting, the flash setups, and the camera position when attempting a difficult, new subject. I write the data down, for invariably I'll forget what my thinking was from the time the film's exposed until the time it's returned from the processor. Doing this, I can analyze my mistakes and make corrections.

Read and look. There is a wealth of good books available on photography, and your reading shouldn't be restricted to that solely devoted to nature or wildlife. There's information to be gleaned from reading about human portraiture, or electronic flash how-to, or glamour or product photography, or any number of other topics that may inspire you and motivate you to apply that technique to your own type of shooting. Admittedly, not all photography books make for great reading, but generally all sport images that are motivational and from which you can learn.

Study the periodical nature magazines which frequently showcase the most outstanding examples of nature photography. Attempt to analyze the method in which a photograph was taken, whether that was with natural light, fill-flash, or full flash, or what lens was used and which perspective chosen. Watch for eye-highlights and background clues to lighting and lens choice. I've frequently been inspired by an image which I've 'copied' when shooting an entirely different subject.

Don't become bogged down with equipment. My recommendations in this text

stress technique, not equipment, and I'd strongly advise you to master whatever gear you own before adding more. Sometimes a particular piece of gear is absolutely essential for successful shooting, and the more tools you own the more 'jobs' you'll be able to master. However, I've seen a fair number of photographers who were so overloaded with gear that their photography was preempted with deciding what camera, lens, or filter to use, while a less well-equipped photographer contented himself with the gear he had and, making the most of it, got the shot.

Consider taking a photo workshop or photo tour. You may find that some of your most enjoyable times, and rewarding photography, is made on either. It's not hard to drag yourself out of bed in the predawn when you know everyone else in your group is doing likewise. It's more difficult to accept the mediocre, as you may be tempted to do when you're bored or uninspired, when you watch a colleague working hard and striving to do his best. There's a subtle sense of competition, at times, that coaxes one into trying harder.

Workshops and tours are great arenas in which to share knowledge, not only about equipment and technique but also concerning the best locales to visit. A good tour or workshop should position you into the best places for photography, freeing you from the sometimes wasteful time spent scouting. Many photographers spend their entire vacations on such trips and, within a few years, many of these have outstanding portfolios of diverse subjects that would have been virtually impossible to have amassed by a solo effort.

As you may know, I teach photo workshops throughout the United States and lead photo tours to both North America and overseas destinations. I've certainly benefitted

**Few wildlife photography destinations can rival the excitement and diversity of Kenya. Photography is done from the windows or roofs of tourist vans. Shop for safaris where the number of participants per vehicle is limited to four, otherwise you may not have room for your gear or to shoot.**

*"Workshops and tours are great arenas in which to share knowledge, not only about equipment and technique but also concerning the best locales to visit."*

from the experience of sharing information with other photographers, and I know, first hand, the energy experienced when shooting with a group.

## 2. Equipment Resources

Throughout this text, I've cited examples of equipment or gear that will make your wildlife photography more productive. Some of this gear is available at local sporting goods or photography stores. Much of the gear, however, is not. A few are specialty items that receive little advertising or publicity, yet are outstanding and an absolute must for wildlife photographers. You may wish to consider some of the following:

L.L. Rue Enterprises, 138 Millbrook Rd., Blairstown, NJ 07825. The Rue catalog offers a number of excellent items. I'd strongly recommend the Rue Photo Vest, especially if you like to carry a lot of gear within a vest. It's sturdy and roomy, and makes the perfect 'carry-on' for air travel. Rue's Ultimate Blind is lightweight, portable, and erects in seconds. Although it's not easy to move the blind when you're inside, and you must work from a sitting position, its advantages far outweigh these shortcomings and it's my blind of choice. Rue also offers a 'quick and easy' strobe bracket that's perfect for small TTL or manual flash units for hand-held macro photography. An extremely useful accessory is the Groofwin Pod for shooting from a car window. The Pod allows filming from a tripod head or from a beanbag resting on the platform, and provides an exceptionally stable shooting support. Although I rarely use gunstocks, Rue offers an excellent one for situations where using a tripod is difficult or impossible.

Protech, 5710 - E. General Washington Dr., Alexandria, VA 22312, is the current distributor for the Dalebeam. As mentioned in a number of chapters, the Dalebeam is an invaluable tool for remote and high speed flash photography. I've used one or two Dalebeams on a number of occasions and each 'project' has resulted in major sales. The beam has allowed me to capture wildlife behavior that would be absolutely impossible any other way. It is definitely worth its price.

Jack Wilburn, Nature's Reflections, PO Box 9, Rescue, CA 95672, produces the teleflash bracket recommended in Chapter Seven. Wilburn produces a number of teleflash brackets with fresnel lenses capable of increasing a flash's guide number by a factor of three or four. Although designed primarily for teleflash techniques, the fresnel lenses also save on battery drain in providing flash power at shorter distances or smaller apertures. Mounts are available to attach to different gun- or camera stocks, including a lightweight, sturdy model designed by Wilburn, and to mount directly upon a tripod.

Kirk Enterprises, RR #4, Box 158, Angola, IN 46703, offers a number of excellent, high quality custom accessories. My Gitzo 320 tripod is outfitted with Kirk's custom short center post that provides a rock-solid mount for my ball head, and costs just a few dollars more than Gitzo's less practical version. Kirk also specializes in macro flash brackets for single and dual flash photography and in custom quick release plates for Arca and Bogan tripod heads.

Johnny Stewart Game Calls, Inc., PO Box 7594, 5100 Fort, Waco, TX 76710, produces a full line of tape players and high quality animal sounds that are extremely useful for game calling. Their inexpensive continuous disc player, called 'The Attractor,' produces a low volume and short duration call that's designed expressly for photographers and bird-watchers. I'd recommend starting with their screech owl, barred owl, screaming bird, and cottontail rabbit tapes. With these you'll have a good chance at bringing in owls, song birds, road runners, raptors, and mammalian predators.

Optech Corporation, Toronto, Canada, M3B 2T5, makes a great Cam Support designed for video recorders that works amazingly well with 35mm cameras equipped with 300mm lenses or smaller. The camera is braced by an adjustable chest support and held in place by a sling and shoulder support which holds the system snugly in place even while hands free.

Bushnell Optical Company, 2828 E. Foothill Blvd., Pasadena, CA 91107, offers an inexpensive car window mount that's suitable for lenses equipped with a tripod collar. Without this, unfortunately, shooting will be limited to a horizontal format.

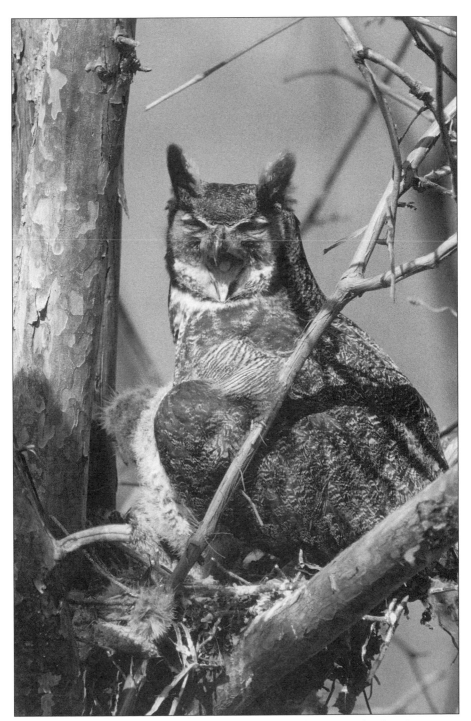

A photo blind was required to obtain this relaxed portrait of a yawning female great horned owl. Once in place, a blind is a great help in obtaining photographs, but extreme care must be exercised when erecting it so as to not disturb or scare off your subject.

## Requesting Further Information

Over the last number of years I've had the wonderful opportunity to photograph throughout the United States and in wild areas on five continents. Most of these experiences have been shared with participants of my photo workshops or tours. I firmly believe that these shooting opportunities are the best method to truly increase your photographic skills, giving you the chance to observe, ask questions, share ideas, implement new ideas, and continually practice techniques. Years of trial and error, costly mistakes, and simple inertia can be eliminated via a workshop. As an added benefit, there is no better way to meet new people and forge new friendships with like-minded photo enthusiasts.

My personal travel schedule has settled into a fairly regular routine of East African photo safaris in late-summer, Argentinean photo tours in November, Yellowstone photo tours in January, south Florida wildlife photo tours and workshops in February, and late spring and summer photo workshops to Yellowstone and the Pacific Northwest. The periods between are occupied with bi-annual trips to India, the Galapagos Islands, Australia, and Alaska, and weekend photo workshops held in Pennsylvania and New Jersey.

If any of these workshops or exotic photo tours appeal to you, kindly fill out the form on page 191 and I'll send you the relevant information. While you're at it, please feel free to write and offer your personal comments regarding this book. I'll be doing others, and any feedback you have would certainly be appreciated.

Thanks, and I hope to be meeting you in the field some day soon.

# Index

# Joe McDonald's Workshops

**Please Detach this Page**

Name: _____

Street or Route: _____

City, State: _____ Zip: _____

Phone # (optional):_____

Please place a check mark where appropriate:

☐ I'd like you to contact me when you're in my area.

☐ I'm interested in small group, personal tutorials on field photography.

☐ I'd like information on your seminars and workshops.

☐ I'm especially interested in the following:

Safaris and Photo Tours

☐ Kenya Photo Safari                    ☐ Kenya and Gnu Migration

☐ Argentina and Patagonia Photo Tour    ☐ Yellowstone's Winter Wildlife

☐ South Florida Wildlife Photo Tour     ☐ India's Project Tiger Safari

☐ Galapagos Islands Photo Tour          ☐ Australian Photo Safari

Photo Workshops

☐ Everglades (Feb.)                     ☐ Yellowstone in June

☐ Rainier and Olympic Nat. Parks (Aug.) ☐ Great Smokies (Sept.)

☐ Complete Nature Photo Course (June)   ☐ Electronic Flash and Studio
                                           Nature

☐ Weekend workshops on Wildflowers, Shorebirds, Fall Foliage, etc.

Return to:

Joe McDonald
Wildlife Photography
RR#2 Box 1095
McClure, PA 17841

# Books from Amherst Media

## Basic 35mm Photo Guide
Craig Alesse

For beginning photographers! Designed to teach 35mm basics step-by-step—completely illustrated! Features the latest cameras. *Includes:* 35mm automatic and semi-automatic cameras, camera handling, f-stops, shutter speeds, composition, lens & camera care. $12.95 list, 9x8,  112 p, 178 photos, order no. 1051.

## Don't Take My Picture!
Craig Alesse

How to photograph family & friends for the point & shoot photographer! Over 100 photos. *Features*: how to point & shoot your camera, how to get great shots, snapping fantastic group shots, photographing celebrations & special times, taking self-portraits, jump shots, special portraits and more. $9.95 list, 6x9, 104 p, order no. 1099.

## The Art of Infrared Photography
Joseph Paduano

A complete, straightforward approach to B&W infrared photography for the beginner and professional! Includes a beautifully printed portfolio! *Features:* infrared theory & precautions, use of filters & focusing, film speed & exposures, night & flash photography, developing, printing & toning. $17.95 list, 9x9, 76 p, 50 duotone prints, order no. 1052.

## Build Your Own Home Darkroom
Lista Duren & Will McDonald

This classic book shows how to build a high quality, inexpensive darkroom in your basement, spare room, closet, bathroom, garage, attic or almost anywhere! Full information on: darkroom design, woodworking, tools & techniques, lightproofing, ventilation, work tables, enlargers, light boxes, darkroom sinks, water supply panels & print drying racks. $17.95 list, 8 1/2x11, 160 p, order no. 1092.

## Into Your Darkroom Step-by-Step
Dennis P. Curtin

The ideal beginning darkroom guide. Easy and fully illustrated each step of the way. From developing your own black & white negatives to making your own enlargements. Full information on: equipment you'll need, setting up the darkroom, developing negatives, making proof sheets, making enlargements, special techniques for fine prints. $17.95 list, 8 1/2x11, 90 p, hundreds of photos, order no. 1093.

## Make Money with Your Camcorder
Kevin Campbell

A complete guide, fully illustrated with over 100 photos and diagrams. Completely up-to-date with the latest techniques and equipment. *Includes:* the business of video marketing, how to get started and where the money is, equipment, editing, how to buy equipment. Includes a full set of business forms: invoices, releases, storyboards, shot sheets & more! $17.95 list, 8 1/2x11, 160 p, order no. 1125.

## The Wildlife Photographer's Field Manual
Joe McDonald

The classic, inclusive reference for every wildlife photographer. Complete technical how-to including: lenses & lighting, blinds, exposure in the field, focusing techniques & more! Tips on sneaking up on animals and special sections on close-up macro photography, studio and aquarium shots, photographing insects, birds, reptiles, amphibians and mammals. Joe McDonald is one of the world's most accomplished wildlife photographers and a trained biologist. $14.95 list, 6x9, 208 p, order no. 1005.

## The Freelance Photographer's Handbook
Fredrik Bodin

A complete and comprehensive handbook for the working freelancer. Filled with how-to and examples. Chapters on marketing, customer relations, inventory systems for stock photography, portfolios, plus special camera techniques to increase the marketability of your work. $17.95 list, 8 1/2x11, 160 p, order no. 1075.

### Camera Maintenance & Repair
Thomas Tomosy

A step-by-step, fully illustrated guide by a master camera repair technician. Sections include: general maintenance, testing camera functions, basic tools needed and where to get them, accessories and their basic repairs, camera electronics, plus numerous tips on maintenance and repair. $17.95 list, 8 1/2x11, 160 p, order no. 1158.

### McBroom's Camera Price Guide
A totally comprehensive annual including: all 35mm cameras, medium format, exposure meters and strobes. Based on camera condition. Easy reference with the history of many camera systems. A must reference for any camera buyer, businessman or collector! $19.95 list, 8 1/2x11, 224 p, order no. 1163.

### Infrared Nude Photography
Joseph Paduano

A stunning collection of natural images with wonderful how-to text. Over 50 rich duotone infrared images. Photographed on location in the natural settings of The Grand Canyon, Bryce Canyon and New Jersey shore. $18.95 list, 9x9, 80 pages, over 50 photos, order no. 1080.

### Big Bucks Selling Your Photography
Cliff Hollenbeck

A must reference for any pro or beginner. Packed with information from a successful pro. *Features:* setting up a profitable business, what photography sells, successful portfolios, stock images, planning your business, computerization in your business, plus samples of agreements, contracts, releases and more! $14.95 list, 6x9, 336 p, order no. 1177.

### Basic Camcorder Guide
Steve Bryant

For everyone with a camcorder (or those who want one)! Easy and fun-to-read. Packed with up-to-date info you need to know. *Includes:* which camcorder is right for you, how to give your videos a professional look, tips on caring for your camcorder, plus advanced video shooting techniques and more! $9.95 list, 6x9, 96 p, order no. 1239.

# Ordering & sales information:

Write Amherst Media for a free catalog of over 100 books and videos about photography and videography.

**Dealers, distributors, & colleges** send, call or fax to place orders. Call/fax 716-874-4450. For price information contact Amherst Media or an Amherst Media rep. Net 30 days.

**Individuals**—if possible, purchase books from an Amherst Media retailer. *To order direct:* send a check or money order with a note listing the books you want and your shipping address. U.S. & overseas freight charges are $2.50 first book and $1.00 for each additional book. NYS residents add 8% sales tax.

Prices are in U.S. dollars. Payment in U.S. funds only.

All prices, publication dates and specifications are subject to change without notice.

**Amherst Media**
418 Homecrest Dr.
Amherst, NY 14226 USA
phone/fax 716-874-4450.

# FIELD NOTES

# *FIELD NOTES*